The Body in
Three Dimensions

"Our doubts are our traitors"
— Shakespeare

for mark: to help you keep things in perspective, to remind you not to "flip out" & to wonder if the cover is depicting "getting it in the a**!" 🙂
♡ JS.

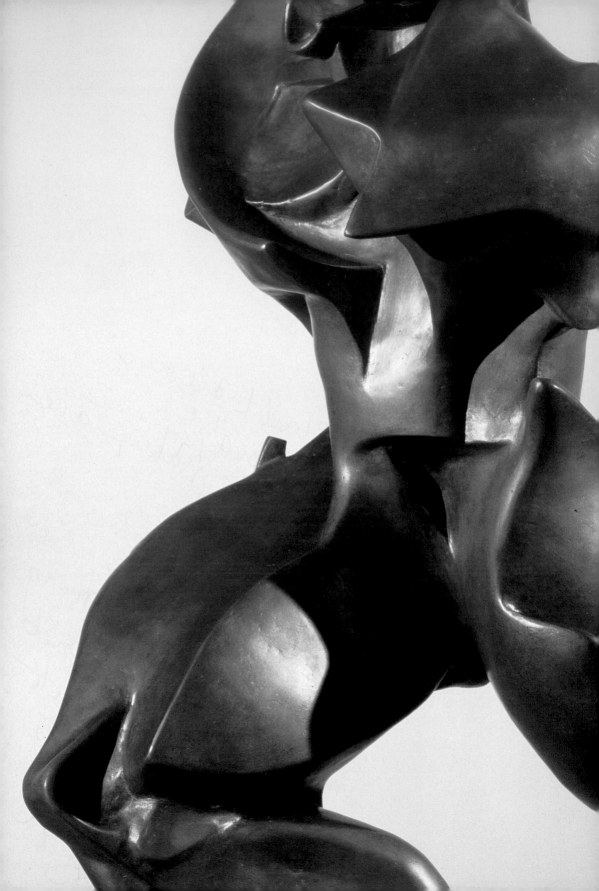

The Body in Three Dimensions

Tom Flynn

PERSPECTIVES

HARRY N. ABRAMS, INC., PUBLISHERS

Acknowledgments

Warm thanks are due to Tim Barringer, Steven Adams and Eve Sinaiko for their conscientious and perceptive reading of the manuscript and many constructive suggestions for improvement. Scott Reyburn not only read and commented on an earlier draft but has provided many hours of fruitful discussion on matters sculptural. I am also indebted to my wife Lucy Glazebrook for her advice and encouragement and to Kara Hattersley-Smith, Sue Bolsom Morris and Katherine Ridler at Calmann & King for their helpful comments and patience and support throughout. Grateful thanks are also due to the numerous galleries, museums and artists who have supplied information and images relating to works mentioned in the text.

Frontispiece UMBERTO BOCCIONI *Unique Forms of Continuity in Space,* page 97 (detail)

Series Consultant Tim Barringer (University of Birmingham)
Series Manager, Harry N. Abrams, Inc. Eve Sinaiko
Senior Editor Kara Hattersley-Smith
Designer Karen Stafford
Cover Designer Judith Hudson
Picture Editor Susan Bolsom-Morris

Library of Congress Cataloging-in-Publication Data

Flynn, Tom. 1956–
 The body in three dimensions / Tom Flynn.
 p. cm. — (Perspectives)
 Includes bibliographical references and index.
 ISBN 0-8109-2716-0 (pbk.)
 1. Human figure in art. I. Title. II. Series: Perspectives
(Harry N. Abrams, Inc.)
NB1930.F59 1998
731′.82 — dc21 97-34767

This book was produced by Calmann & King Ltd, London
Printed in Hong Kong

Harry N. Abrams, Inc.

100 Fifth Avenue

New York, N.Y. 10011

www.abramsbooks.com

Contents

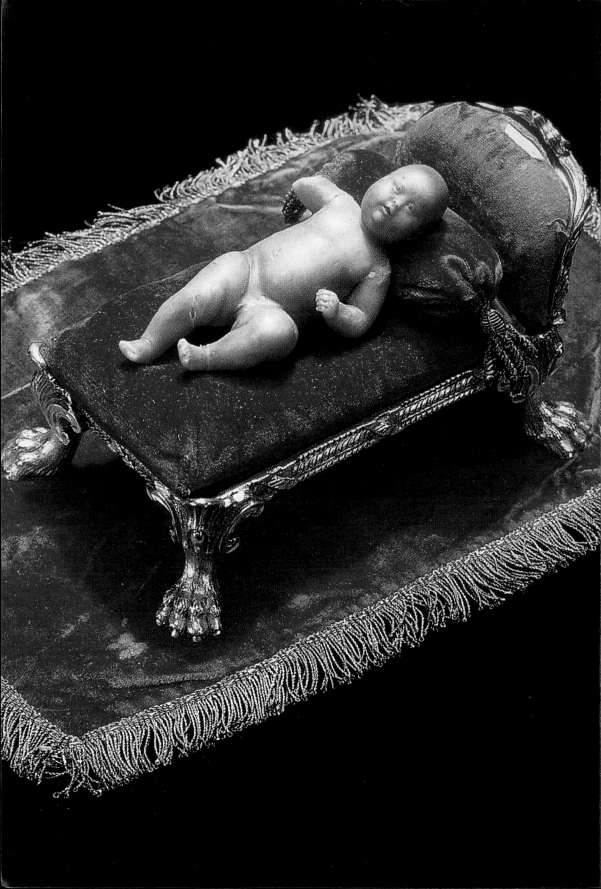

Waxworks, Dolls, and Doppelgängers

1. JOACHIM SMITH (attributed)
The Infant George IV, on a George III silver bed, 1762. Wax model, length 6" (15.2 cm).

George IV's biographer Robert Huish reported that Queen Charlotte kept the wax model of her infant son constantly on her dressing-table at Buckingham House. After her death "it was exhibited to us; the likeness was still palpable, though the original had outlived the date of the fairy model more than half a century."

T he history of sculpture is also a history of the body. However, while most histories of sculpture take as their subject the body in all its sculptural forms and include reliefs, medals, plaques and architectural decoration, the present book concerns itself only with the human body in its three-dimensional, freestanding form. This may seem a somewhat arbitrary limitation to impose on sculpture's history but, as the following pages will make clear, the three-dimensional body justifies separate and particular attention for a number of reasons. The founding myth of sculpture in the West – the story of Pygmalion, the legendary king of Cyprus, who fell in love with his own ivory sculpture of a woman, whom Venus then brought to life – narrates the process by which the seemingly magical properties of the three-dimensional sculpted body, its accurate representation of the human form, are eventually sufficient to bring about its elevation to the status of a living, breathing entity.

This propensity of sculpture to mimic the physical characteristics of the human body, the degree to which it can, if taken to certain lengths, achieve a counterfeit appearance of reality, has been a constant issue throughout the history of sculpture. Furthermore, those objects which directly mimic the body – dolls, waxworks, automata, robots – have been present as sculpture's *doppelgänger*, or double, since time immemorial, serving at different points in history as either a virtuous aspiration or as a dark warning of the consequences of hubris and human folly.

The American abstract painter Ad Reinhardt once flippantly defined sculpture as "something you bump into when you back up to look at a painting," poking fun at sculpture's apparently subservient status within the modern gallery space, little more than an encumbrance to a comfortable viewing of the "real" event – painting. On first reading, this seems to offer a contrasting view of the nature of the sculpted object with that expressed around a hundred years before by the French poet and critic Charles Baudelaire, who maintained that "sculpture is much closer to nature and that is why our very peasants, who are delighted at the sight of a piece of stone or wood industriously worked, stand unmoved in front of the finest painting." In fact, both comments refer, albeit indirectly, to an inescapable fact of the sculpted object, namely that it occupies the same physical space as the viewing subject and thereby invites a different sort of visual and psychological engagement to that which governs the viewing of pictures. We may only bump into sculpture but we cannot ignore it. It is for this reason that sculpture has invariably been the favoured medium of political and public art, of monuments and memorials.

Baudelaire's bewilderment at the tendency of the peasant classes to display a dumb fascination with the "thingness" of the sculpted form provides partial justification for the present book. It is specifically those characteristics which the three-dimensional sculpted body shares with the natural body that invest it with the immediacy to which Baudelaire obliquely refers and which ultimately mark it out as distinct from other forms of sculpture such as the bas-relief or decorative architectural component. The bust, and even the fragmented body part, occasionally partake of this uncanny magnetism and thus will also appear in the pages which follow.

The brief history offered here will no doubt be more notable to some readers for what it excludes than for what it includes. Some periods of history have been granted only cursory treatment while many prominent objects from those periods have been omitted altogether. In justification I would offer that the present book does not set out to provide an exhaustive history of sculpture, nor a complete history of the body, both of which have been granted exemplary treatment elsewhere. Rather, the intention has been to take advantage of the compact format by limiting the discussion to a range of objects which seem to speak with particular eloquence of the cultures from which they emerge and which in doing so illuminate in some way the historical development of the idea of the three-dimensional body.

Where the histories of painting and photography have seen the successful introduction of new and often radical theories and methodologies which open up questions of race, gender, and the economic realities of lived social relations, the history of sculpture has been slower to invite such approaches and as a result has been understood as an essentially conservative art form. This is all the more surprising when one considers that sculpture's central concern has always been the representation of the human body – the site upon which issues of religion, race, gender, and class have been inscribed and enacted throughout history.

Recently, however, thanks largely to renewed investigations in art history and the social sciences, the body has moved into sharper focus as a theoretical tool for questioning structures of power, ideology, and identity across a range of visual material.

The text which follows takes a parallel approach, tracking the body not as an unchanging, biological fact, but as a historical and cultural category changing with prevailing social, political, and economic forces. The history of three-dimensional representations of the body thereby becomes part of a broader history of changing attitudes towards corporeality, or the bodily dimension of human existence.

The broad historical narrative has become an unfashionable way to proceed in contemporary art history, but I have consciously adopted it here in order to facilitate discussion of a more comprehensive range of objects than would normally be embraced by a historical survey of this size. While it is to be expected that the more marginal approaches encountered in some chapters may occasionally sit uneasily with the more conventional method encountered elsewhere, I hope it will illuminate the fact that there are benefits to be derived from both approaches. It remains true that recent art historical methodologies have turned with gusto on the modern period but have been slower to embrace the art of earlier epochs; that imbalance is, however, continually under review.

While the body might emerge from a history of sculpture as representing a continuum – inasmuch as it remains as important to art practice today as it was in antiquity – what follows should nevertheless evoke something of the represented body as subject to historical change. Hence the demands for harmony and order required of the three-dimensional body in antiquity gave way in the early Middle Ages to a body born of religious preoccupations with corruption and decay. In our own period the body has emerged variously as an agent of political control and as an instrument of protest against social and sexual orthodoxies (FIG.

2. KIKI SMITH
Pee Body, 1992. Wax and
glass beads, 27 x 28 x 28"
(68.6 x 71.1 x 71.1 cm).
Fogg Art Museum,
Cambridge, MA.

The work of the American
artist Kiki Smith subjects the
body to relentless
examination, focusing on its
unacknowledged realities, its
fluids, and emissions, in an
attempt to subvert
traditionally "safe" readings
of the female body and to
draw attention to how we
have become estranged from
our bodies.

2), and as a means of confronting and responding to the realities of illness and disease. We will return to all these issues in greater depth in later chapters.

Adopting the three-dimensional body as the primary point of departure also enables us to broaden our analysis to embrace a diverse range of objects hitherto excluded from standard histories of sculpture. Waxwork figures, anatomical models, automata, robots, and dolls are all three-dimensional representations of the body, but in what ways do they relate to a broader history of sculpture and how, historically, have such representations impinged upon the development of more traditional sculptural practise?

The human impulse to create an animate body has a long history. From Ovid's myth of Pygmalion (FIG. 3) and Descartes's automaton Francine, reputedly destroyed on the grounds that it was the work of a sorcerer, to the many fictional creations – Olympia

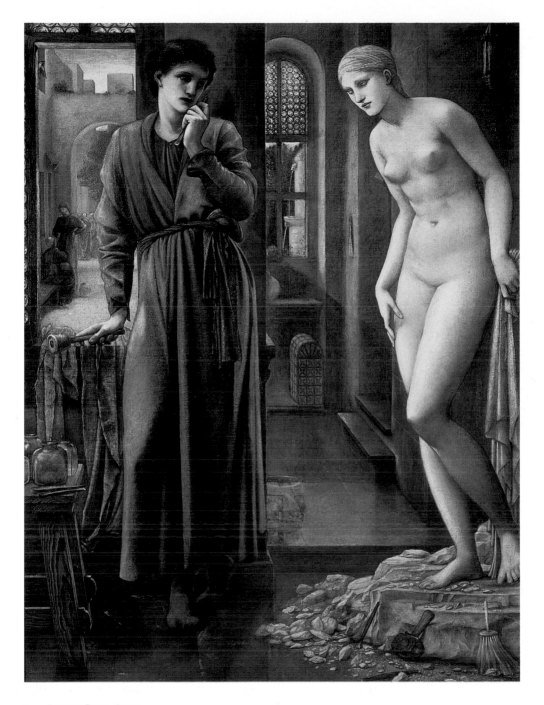

3. EDWARD BURNE-JONES
The Hand Refrains, 1875–8. Oil on canvas, 38¾ x 30″ (98.7 x 76.3 cm). Birmingham City Museum and Art Gallery.

The ancient story of Pygmalion, the sculptor who fell in love with his own statue of a woman which Venus then brought to life, provides the central metaphor for sculpting the human body and proved particularly popular with artists during the eighteenth and nineteenth centuries.

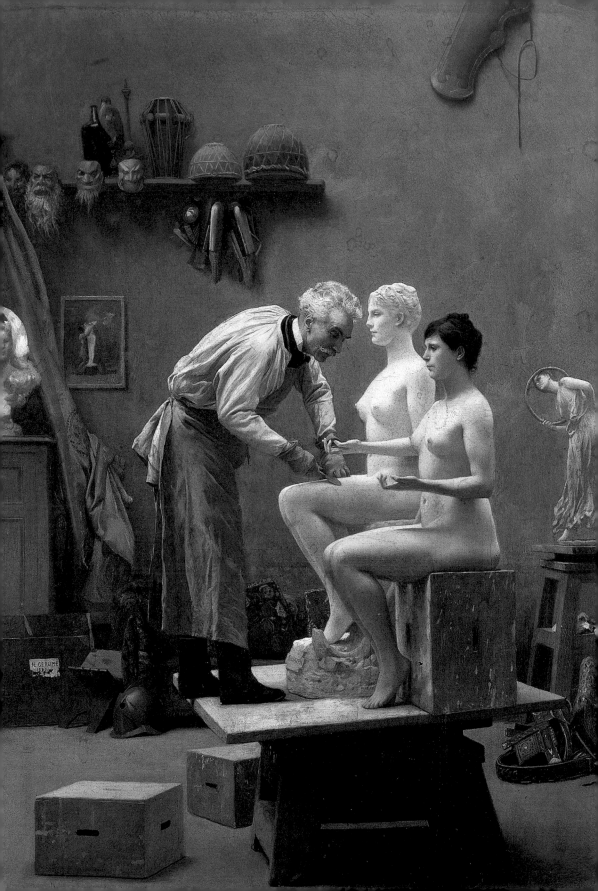

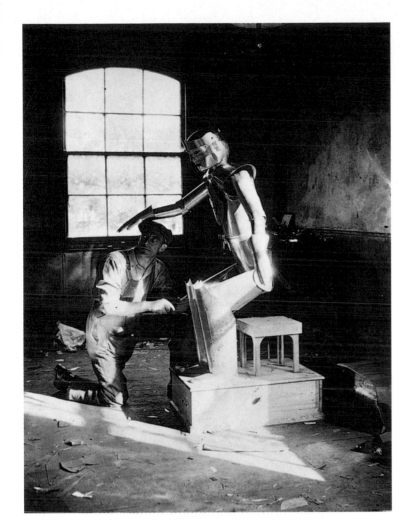

in Hoffmann's tale *The Sandman* (1816), Mary Shelley's *Franken-stein* (1818), Hadaly in Villiers de l'Isle Adam's *L'Eve Future* (1886) – the simulated, animated body has figured both as an allegory of the creative act and as a signifier of the undeclared aspirations and potentialities of science and technology.

One dimension which is central to a proper understanding of the significance of all such myths and objects (with the exception, perhaps, of the waxwork figure) is the private circumstances of their production, in which the studio becomes synonymous with the laboratory, both spaces charged with significance as the sites of interaction between sculptor/inventor and passive, tractable, soulless body (FIGS 4 and 5).

Like the *simulatum corpus*, or man-made body, of the Pygmalion myth, the automaton is animated by the erotic fascination

6. Crucifix with moveable arms from Grancia, Tessin, Germany, early sixteenth century. 4'10¼" x 4'8½" (1.48 x 1.44 m). Schweizerisches Museum, Zurich.

Although the early Christian church had largely prohibited the use of three-dimensional sculpture to depict the body of Christ, between the fourteenth and sixteenth centuries the realistically painted and articulated crucifix provided a means by which the body of Christ could even be moved and manipulated as a seemingly active participant in the liturgical dramas.

of the creator or viewer and functions as a modern metaphor for the rules and aims of representation. During the eighteenth and nineteenth centuries it served as a reminder of the dangers inherent in promoting naturalism in sculpture which, since antiquity, had occasioned such aberrant sexual practices as "profane statue-love" and "pygmalionism," in which a blurring of the boundaries between the natural and artificial body became the source of erotic delight.

The artificially animated body is not, however, an exclusively modern phenomenon, or a legacy of the Industrial Revolution, for the history of automata stretches back into antiquity. Neither has the need to articulate the body been a purely secular affair. From the Middle Ages onwards figures of Christ with articulated limbs (FIG. 6) served particular purposes within the rituals of Christian devotion, the moveable arms allowing the body to be lowered from the cross and manipulated into different poses, thereby creating the illusion of its active participation in the liturgical tableaux of Easter devotion.

While techniques of articulation are among the most ancient means by which to intensify the illusion of bodily presence, scale has proved perhaps the most powerful component in the use of the body as a carrier of political messages. Monumental figure sculpture has been the favoured medium of those in possession of political or military power since antiquity, the sheer size of the colossal human form often reflecting the scale of the ambition which sponsored it. The forty-foot (13 m) cult statue of *Athena Parthenos* in gold and ivory made by Pheidias in fifth-century BC Athens functioned not merely as a majestic votive offering to the city's most important deity, but as a grandiose rhetorical statement of Athenian military might under Pericles. The surviving fragments of the colossal seated statue of the emperor Constantine, originally erected in the Roman forum, offer further dramatic illustration of the importance of scale in the manufacture of visual propaganda in the ancient world. The numerous statues erected across Europe by totalitarian regimes in the twentieth century testify to the enduring potency of the colossal three-dimensional body as a symbol of the will to power. However, as the fall of the Communist regimes in Eastern Europe demonstrated, the bigger the body, the harder it falls: there is arguably no

more eloquent signifier of the consequences of overweening ambi-
tion than the toppled political monument.

The colossal statue of the American pop-star Michael Jackson
erected in Prague in 1996 (FIG. 7) offered a reminder that monu-
mental self-aggrandizement is not the sole preserve of politicians,
although the iconography of his statue does seem to derive from
a totalitarian aesthetic, thus imbuing the image with more sinister
associations than were perhaps intended.

Historically, the political arena has also contributed significantly
to the craft of wax modelling, particularly in the production of

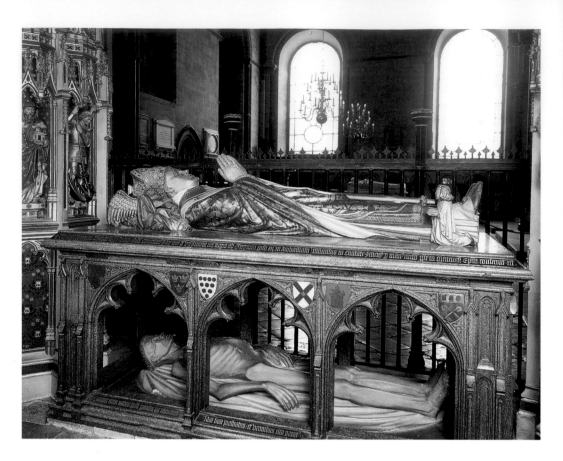

8. Tomb of Archbishop Henry Chichele (d. 1443), 1451. Polychromed marble and other materials. Canterbury Cathedral.

The use of polychrome materials in this double tomb accentuates the contrast between the vigour of the reposing "social" body and its double, the emaciated corpse below. The contrast is echoed in the tomb inscription which warns onlookers: "Whoever you may be who will pass by, I ask for your remembrance, you who will be like me after you die: horrible in all things, dust, worms, vile flesh."

effigies of deceased public figures. During the eighteenth and nineteenth centuries such practices excited fierce debates about the boundaries separating "high" art, or sculpture proper, from more popular forms of image-making.

The belief that painted sculpture had generally been employed for "perverted purposes," to "enforce superstition, or preserve an exact similitude to the deceased," as the British sculptor and Royal Academician John Flaxman put it in 1829, derived from the traditional use of polychrome or mixed media techniques in commemorative tomb sculpture. For example, in the so-called "transi" tombs (Gothic two-storey tombs evoking the body in transition to decay), which first appeared around 1400 (FIG. 8), varying degrees of realism were employed to evoke not merely the "social body" – the body as remembered intact by the living – but also its double, the body in its liminal, decaying state, which functioned as a *memento mori* for the onlooker, a reminder of the transience of human existence.

It was the propensity of waxwork models and painted plaster effigies to re-create closely the lost appearance of the deceased

which gave such techniques a prominent role within royal funeral ceremonies and other rituals in which the natural body was, for one reason or another, absent. The unsettlingly lifelike plaster head of the English Puritan statesman and Lord Protector, Oliver Cromwell (1599–1658; FIG. 9), made around 1658 probably by Thomas and Abraham Simon, is typical of the kind of object which came to occupy that zone between reality and representation which so troubled later academicians like John Flaxman.

Flaxman would have known that during moments of political instability such objects had often been seized by the mob which, deprived of the real body, enacted symbolic vengeance on its surrogate. Although Cromwell's body was buried privately in Westminster Abbey in September 1658, his effigy – from which this plaster head may have been modelled – lay in state in Somerset House until moved in November as part of the (mock) funeral procession to the Abbey. It was to be a brief repose. Upon the Restoration of the monarchy in 1660, Cromwell's wax effigy was hanged by the neck from Whitehall, while another was burned. Similar fates befell the wax masks made by Dr Curtius, Madame Tussaud's uncle and mentor, when, in July 1789 in Paris, an angry rabble surrounded his house shouting "Give us the Duke of Orléans! Give us Necker!" Curtius wisely responded by surrendering their wax effigies, which were duly paraded by a jeering mob through the streets. As the art historian David Freedburg has noted, in his study of *The Power of Images*, the "execution" of effigies – the destruction of images of individuals by their opponents – proceeds from the assumption that if one is worthy of being honoured in an image one is equally liable to be dishonoured in it. It can also be taken as an expression of how the actual body would be treated were it present.

Death and political revenge have not been the only prerequisite conditions for the production of counterfeit representations of the body. The wax model of the infant George IV (1762; FIG. 1) is an instance in which the realistically rendered three-dimensional body functions as a substitute for the real body. George IV's biographer, Robert Huish (1777–1850), tells us that the model became symbolic of Queen Charlotte's devotion to her son. The realistic nature of the representation and the materials employed in the tableau are important elements in the psychology of overvaluation – that which ascribes to the model the properties

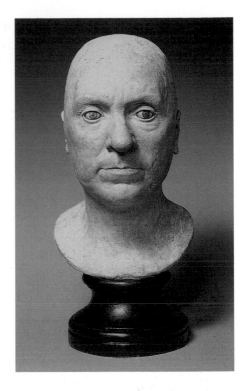

9. THOMAS AND ABRAHAM SIMON (attributed), Plaster funeral effigy head with glass eyes, *Oliver Cromwell*, c. 1598. Height 18" (46 cm) on later wood stand.

The ancient tradition of funeral effigies, images which stood in for the deceased at their funeral ceremony, continued in England until the early nineteenth century. Although Oliver Cromwell was buried in September 1658, his effigy provided a surrogate presence at his official funeral two months later.

10. Oskar Kokoschka
Doll, 1919. Fabric and hair,
life-size.

normally associated with the real, living body. While such objects properly belong in the realm of what has become known as *virtù* – precious, finely crafted artefacts, often of intimate personal significance – they nevertheless constitute a form of sculpture and thus demand that we broaden the historical profile of the three-dimensional body.

In the twentieth century, the boundaries continue to shift and expand. Where, for example, should we locate the curious doll which the Viennese artist Oskar Kokoschka had made for him in 1919 as a passive companion (FIG. 10)? Before dismissing Kokoschka's bachelor mannequin as a sexual peccadillo beyond the scope of serious inquiry, we should remember that it claims a rightful, if marginal place in the genealogy of the Surrealist object and thus within the realm of art. Far from being purely personal in its significance, Kokoschka's mannequin is documented as having had a significant influence on the perversely articulated dolls, or "bachelor machines" as they were known, made by the German artist Hans Bellmer in the 1930s.

The contemporary three-dimensional body remains in flux, its pivotal function in the 1960s within the diverse practices of performance art having endowed it with a powerful new immediacy, providing that "magical" animation which confounded orthodox modes of representation. The British artists Gilbert and George's

early performances, which involved transforming themselves into "living sculptures," spawned a range of imitations that continue to cut across the boundaries of art and popular culture (FIG. 11). The body's enduring qualities of "otherness" – that is, its ability to articulate a sense of the unknown and the unknowable – are still being seized upon by contemporary artists as a means of exploring fears and anxieties about a range of social, political, and sexual issues. Today, no less than at any other stage in its historical evolution, the body emerges in a multiplicity of adorned, elevated, and degraded forms to challenge taboos and subvert structures of power. As cybernetic technology continues to explore the frontiers of the "virtual" body in a "virtual" reality, so the parameters of representation have altered accordingly, artists now speaking of their bodies as forms of "software," as infinitely manipulable accumulations of data. The history of the body manipulated into three dimensions is the subject of this book.

11. Parisian Sunday street performance, 1996.

Many of today's street performers and other popular entertainers continue to exploit our fascination with the "bodily" nature of sculpture. These Parisian art students adopt the poses of classical statuary, thereby occupying a temporary place in that uncanny zone between the animated and the inert. Miming statues, or *poses plastiques*, has been a popular form of public and private entertainment since the nineteenth century.

ONE

Idols, Myths, and Magic: The Body in Antiquity

Nothing to get scared about, old man;
Daedalos' works all seem to move about
And his statues to speak; clever chap that one!

EURIPIDES (C. 480–406 BC),
EURYSTHEUS SATYRIKOS, TRANS.

12. Polykleitos of Argos, *Doryphoros*, a Roman copy after the original of c. 440 BC. Marble, height 6'11½" (2.12 m). Museo Nazionale Archeologico, Naples.

A sense of equilibrium was communicated through the *Doryphoros* by means of mathematical proportion – "perfection comes about little by little through many numbers" was how Polykleitos himself phrased it in one of the few surviving fragments from his treatise – and by a crisscrossing arrangement of limbs.

S ince earliest antiquity the sculpted body has emerged through myth and legend as an ambiguous entity, seemingly situated in an indeterminate zone between the living and the dead. Often occupying the same volume as the real body it purports to represent, the sculpted body is thereby endowed with an uncanny presence for the spectator. This has contributed to an independent tradition of myth and superstition, centring on the manufactured human form as the repository of a series of dark, magical powers or as the focus of various forms of witchcraft. Thus, statues by the legendary Greek artist and maker Daedalos were said to have been endowed with the power of movement, requiring them to be tied down to prevent them running away, while more recent historiography includes stories of statues that have been seen to bleed, others to lactate, and even in the twentieth century statues of the Hindu gods Ganesh, Shiva, and Parvati witnessed as miraculously drinking milk.

To dismiss such myths, legends, and illusions is to miss their true cultural significance and what they can tell us about the history of changing attitudes to three-dimensional representation.

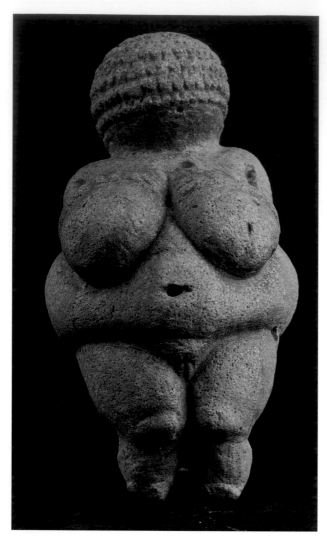

Similarly, what of the other side of the human-statue relationship, in which the living human assumes the guise of the inanimate sculpted body, as in the habit of Roman emperors of taking on a statue-like demeanour when entering a city in triumph, or the popular nineteenth-century pastime at social gatherings of adopting and holding the poses of classical sculpture? All these activities represent historically specific responses to the sculpted body, to sculpture as a body-related idea. But where should a history of the sculpted body properly begin?

The Mother Goddess

We have only to turn to one of the earliest surviving representations of the human form to discover that the body was a source of fascination even to Palaeolithic, prehistoric cultures. The tiny limestone carving known as the Willendorf Woman (FIG. 13) discovered in Willendorf, Austria, is thought to be between 25,000 and 30,000 years old. Anthropologists and art historians have drawn attention to the tactile nature of its bulbous contours, the pendulous breasts and swollen belly, leading them to speculate on the figure's possible talismanic function as a hand-held fertility symbol. More recently, the theory has been put forward that such Palaeolithic carvings might be the first attempts by women to represent themselves while pregnant. Thus the exaggerated breasts and midriff might have served some gynaecological function, plotting the changing forms of the female body in pregnancy.

Although such theories can only be treated as conjecture, they do effectively challenge a broad historical tendency to explain even the earliest representations of the unclothed female body as products of male erotic fantasy. We should exercise caution before ascribing ritual, social, or even artistic significance to such pre-

13. The Willendorf Woman, 30,000–25,000 BC. Limestone, height 4½" (11.5 cm). Naturhistorisches Museum, Vienna.

Recent theories put forward by anthropologists have suggested that Palaeolithic carvings such as this one may be the earliest attempts by women artists to represent their own bodies. Traces of pigment suggest they may originally have been painted.

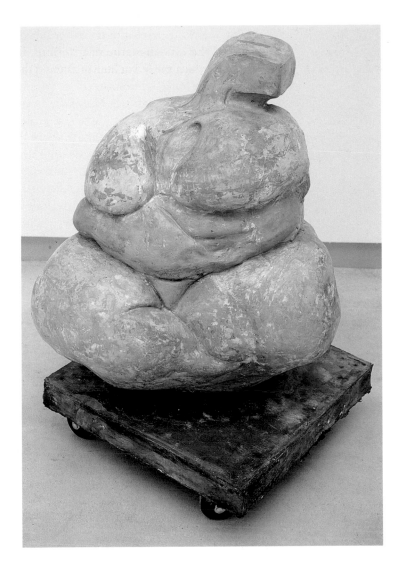

14. JEANNE SILVERTHORNE
Untitled, 1989. Hydrocal, rubber, and wheels, 35½ x 25 x 21¾" (90 x 64 x 55 cm). Collection of Thaddaeus Ropac, Salzburg.

Silverthorne's figure borrows the swollen anatomy of the Willendorf Woman to produce a poignant contemporary equivalent, whose corpulence threatens to engulf the recognizable body. The trolley wheels offer a witty take on the "hand-held" mobility of the ancient Palaeolithic carving.

historic objects, but we can properly treat them as early evidence of the human body as an important subject of representation among even the most archaic of cultures.

Today, the Willendorf Woman has assumed a fresh significance as an inspiration to contemporary artists. Jeanne Silverthorne's untitled sculpture (FIG. 14), for example, draws on the fleshly attributes of the little limestone carving and expands them, physically and conceptually, to produce a figure whose material plenitude is at once both majestically voluptuous and yet troubling in its vulnerability, the trolley wheels upon which the inert figure is mounted acting as an ironic echo of the effortless, hand-held, mobility of her diminutive forebear.

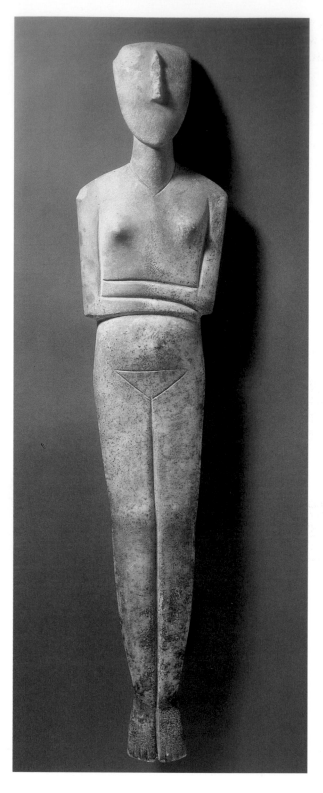

As the original function of Palae-olithic statues such as the Willendorf Woman is by no means certain, it would be wise to pause before assuming them to have acted as fertility symbols. Yet such figures (numerous examples of which have survived) invariably and unequivocally represent the female form, often with emphasized attributes of pregnancy. It may be possible to conclude, therefore, that during this period "woman" was invested with a singular significance among early European Stone Age peoples as the source of life. Hence it has been suggested that such figures are perhaps the first sacred representations of a Mother goddess, the earliest expression of belief in a great, overarching, maternal order in which the mysteries of birth and regeneration are found to reside in the female form.

Simplicity and Silence: Cycladic Sculpture

The first thing that strikes us about the delicate marble figures (FIG. 15) first discovered during the nineteenth century in the Greek Aegean islands of the Cyclades, and which date from the eight hundred years 3200–2000 BC, is their gently attenuated lines, mere ghostly silhouettes compared to their robust Palaeolithic predecessors. However, it is not merely the physical emphases which have changed in the millennia since the Palaeolithic figures were made, for not only are Cycladic figures occasionally represented as male, they also display a consistency of physical deportment and demeanour which prompt alternative readings to those connected to fertility and fecundity.

The majority of existing examples were discovered in graves and they are carved in a recumbent pose with arms folded as though dead or sleeping. This suggests a possible funerary function such as that fulfilled by the small ancient Egyptian earthenware *shabti* figures, which were intended to accompany the deceased into the tomb in order to attend to their needs in the afterlife. Some archaeologists have speculated that the absence of mouths (traces of painted eyes have been discovered) may be a consequence of their funerary associations, as though they were intended to evoke the speechless state of death. Not all Cycladic figures were found in graves, however, for some were discovered in settlement sites, further confounding attempts definitively to establish their original purpose and significance.

The painted surface decoration of Cycladic marble sculpture may have disappeared, but the figures have survived chiefly thanks to the durability of marble, a popular material among the Cycladic artists, who also occasionally worked in more perishable media such as wood. The relatively large number of surviving ancient sculptures made from limestone, marble, and other lasting materials compared to those in clay, wood, ivory, and similar soft substances led, during the ensuing centuries, to a distorted view of the development of ancient sculptural practice. Only in the early nineteenth century did this pattern change as the developing discipline of archaeology began to reveal the diversity of materials and surface treatments used by ancient sculptors.

Xoana – *Aniconic Idols*

Today, when we think of Greek sculpture we tend to think of figures of the human body in marble or bronze, but the earliest Greek statues, known in ancient times as *xoana* (singular, *xoanon*) to denote their invariably wooden composition, were aniconic representations. The term "aniconic" refers to objects which aimed to symbolize the gods without purporting to resemble them. Ancient Greek *xoana* – fashioned from ebony, olive, cypress, cedar, oak, or yew – were occasionally adorned with other more precious materials. These crude cult objects were the focus of primitive altar rituals in temples or shrines dedicated to the gods; they constitute the earliest stage in the development of what we might loosely term Greek "sculpture" in the centuries before stone became the principal material for statuary. So widespread was the use of wood in prehistoric Greek sculpture that even the earliest substantial stone statues, which appeared around the middle of the seventh century BC, bear traces of woodworking techniques.

Opposite
15. Cycladic figure of a woman, c. 3000 BC. Naxian or Parian marble, 30″ (76.2 cm). Ashmolean Museum, Oxford.

Now that almost all their original painted decoration has disappeared, their carved noses are often their only surviving facial feature. We can only speculate on their original significance.

Our awareness of the extreme antiquity of primitive wooden *xoana* – all of which have now perished – and the infrequency with which they are mentioned by ancient authors, makes it difficult to speculate on their likely appearance. Although it is not until around the eighth century BC that anthropomorphism (the representation of the gods through human form) begins to appear in Greek temple statues, archaeology has nevertheless furnished us with certain startling exceptions from an even earlier period, thus increasing our knowledge of the richness and diversity of prehistoric Greek sculpture, and of the *techne*, or knowledge and skill, of the sculptors who produced them.

The extraordinary flowering of Minoan civilization on the island of Crete between 2000 and 1400 BC has bequeathed us a statuette of a man dating from around 1500. Recently discovered at Palaikastro on the eastern tip of the island, the statuette provides evidence of a surprisingly sophisticated and intricate mode of manufacture quite at odds with the notion of a rough-hewn wooden idol conjured by the term *xoanon*. The figure is delicately constructed from hippopotamus ivory joined by wooden dowels and has a head of serpentine (a green metamorphic rock), and also retains traces of its original rock crystal and gold ornament, used for articulating details such as eyes and sandals. This figure might therefore be one of the earliest surviving examples of that type of Greek sculpture known as "chryselephantine" – combining gold and ivory – which later became the principal technique for constructing colossal cult figures of the gods, a type of statuary to which we will have cause to return in more depth later in this chapter.

If the sophisticated civilization that flourished in ancient Crete found its expression in a celebration of the human figure, that same anthropomorphism all but disappeared during the so-called Dark Ages following the decline of the Mycenaean palace civilizations after 1200 BC, only to reappear in what is often termed the "Renaissance" of the eighth century. By around 700, a new urban organization had begun to replace the largely pastoral, nomadic existence which characterized the Dark Ages, bringing with it greater social cohesion and internal security. The emergence of the *polis*, or independent city-state, marks a significant moment in the development of Greek society in which a unit of people, distinguished by their social and political autonomy and protected by their own internally recruited military force – the hoplites – established for themselves a new collective identity. The internal social organization of these new communities of citizens – "it is men who make a polis," said the Greek historian

Thucydides (c. 460–400 BC) – depended to a large extent upon the maintenance of religious rituals which served to promote and sustain a fruitful relationship with the gods. Since nature was, for the Greeks, the source of divinity, it followed that the human form would become the vehicle through which that divinity could best be expressed. Hence, the anthropomorphism of the Greek gods should not be taken as indicating that they were conceived in the image of human beings, but rather the contrary, that the human body itself could be seen to reflect the splendour of divinity.

It is around this period, in the early seventh century, that there began to appear one of the most radically new styles of sculpture to appear in Greece in the pre-Classical period, that style now conventionally known under the generic term "Daedalic."

The Daedalic style broadly coincides with the introduction of stone into Greek sculpture, largely as a consequence of increased contact with the East where coloured hardstones had long been a favoured medium. The Egyptian conquest of Assyria (broadly, part of today's Syria and Iraq) in 672 BC facilitated improved trading links with the Aegean and allowed Greeks for the first time to settle on the banks of the Nile, in turn enabling Aegean sculptors to assimilate certain characteristics of the Egyptian figural tradition. The extent of Greek absorption of Eastern modes of representation at this period is revealed in one of the most celebrated examples of early Daedalic limestone sculpture, the so-called "Auxerre" *kore* (FIG. 16), or free-standing female type, probably originally from Crete and dating from c. 650–625 BC. The most consistent characteristics of this kind of figure are the austere frontality of the pose, the arms held firmly at the sides or bent at the elbow, and the lingering sense of the rectangular block from which it was carved. While such figures clearly owe much to Egyptian sculpture, they continue to hint at the probable plank form of earlier Greek *xoana*.

It was only during the early nineteenth century that reliable archaeological evidence began to appear which indicated the extent to which the Greeks decorated their sculpture and architecture. While today it remains impossible accurately to reconstruct the original appearance of early Greek figure

16. Painted cast of the "Auxerre Goddess," the original c. 650–625 BC in limestone, height 25" (65 cm). Museum of Classical Archaeology, Cambridge.

The garish painting on this cast reminds us of our culturally embedded expectations of the uncoloured nature of ancient Greek sculpture.

sculpture, and however much we might still be conditioned to recoil from the notion of a garishly painted statue, we can be sure that applied polychrome decoration was an important part of the process of making objects such as the Auxerre *kore*.

Kalos thanatos: *The Beautiful Death*

The physical characteristics of the *kore* figures – their benign facial expressions, their sense of corporeal discipline and restraint – were intended to signify something more profound to a Greek polytheistic mentality than the bodily wellbeing which they ostensibly convey to modern eyes. As the historian of ancient religion, Jean-Pierre Vernant has indicated, what we might today call physical properties appeared to the Greek religious sensibility as powers of divine origin, beyond the realm of humanity. Most *kore*

Right

17. *Kleobis and Biton,* two *kouroi*, c. 600–575 BC, marble. Restored height 6′5½″ (1.97 m). Delphi Museum.

According to the Greek historian Herodotus (c. 484–c. 420 BC), when the oxen required to pull their mother's wagon to a festival in honour of the goddess Hera failed to return from the fields in time, the brothers volunteered themselves for the task and drew the laden wagon in fierce heat along six miles of inhospitable roads to the sanctuary in time for the festival. So moved was their mother at this act of pious loyalty that she prayed to Hera for a "beautiful death" for her sons. Her wish was granted, for while resting in the sanctuary a short time later, Kleobis and Biton died in their sleep.

Opposite

18. *Nenkhefta,* Old Kingdom tomb figure, c. 2400 BC. Limestone, 4′4″ (1.34 m). British Museum, London.

Egyptian sculpture, particularly the figures of striding males wearing the traditional pleated kilt, provided the model for Greek sculpture from about 650 BC, influencing the development of the kouros type.

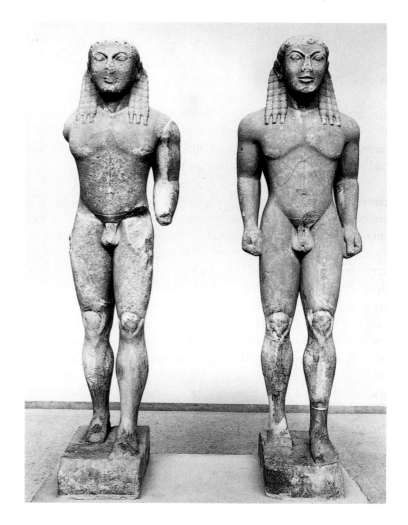

figures and their male equivalent, the *kouroi*, seem, for example, to have fulfilled a funerary or votive function commemorating those who died young while still in the bloom of bodily vitality. Their *kalos thanatos*, or beautiful death, was deemed to have spared them the decrepitude of old age and to have endowed them with a heroic stature in which the qualities of divinity, expressed through the body, are made radiantly and eternally apparent.

One of the most charming examples of the heroic *kouros* votive type – and one of the most articulate expressions of the Archaic style which replaced the Daedalic – is the pair of large marble figures from Delphi dating from c. 600–575 BC which commemorate the Argive brothers Kleobis and Biton (FIG. 17).

The brothers' muscular bodies, looking as robust as the oxen they replaced in pulling a wagon, are shown in the traditional *kouros* posture with one leg extending forward as though walking, their faces displaying an expression of happy tranquillity as though fully cognizant of their destiny. While the female *korai* were usually draped, male *kouroi* were invariably represented nude, and if we look at the Egyptian limestone tomb figure of Nenkhefta, dating from about 2400 BC (FIG. 18), we can see the likely origin of the V-shaped torso. The striding posture and the clenched fist were later adopted by Greek sculptors such as Polymedes of Argos (c. 600 BC) for his *kouroi* of Kleobis and Biton.

Although such heroic *kouroi* are still firmly stylized and conventional – that is, rigid and unspecific in the their physical characteristics – it is possible to detect at this point the first stirrings towards naturalism in Greek sculpture, towards imitating the appearance of the everyday world. The even distribution of weight across both legs, for example, imbues the figures with a greater degree of corporeal presence than had hitherto been the case. As the quote from Euripides at the head of this chapter indicates, subtle but momentous advances in formal vocabulary such as the striding posture were sufficient to generate a series of later statue myths. Such innovations were often wrongly attributed by the Greeks to the legendary Daedalos, who was said to have made statues that walked of their own accord. "The truth is this," said one ancient Greek writer, "in those days the sculptors of gods and men made the feet joined together and the arms hanging by the sides. Daedalos first made one foot striding forward, which is why men said, 'Daedalos has made this statue walk.' "

It is not difficult to see how such misunderstandings eventually grew into a body of legend and lore in which Daedalos, the archetypal craftworker and ingenious fabricator – who has no grounding in historical reality – becomes endowed with almost shamanic powers and, by extension, the ability to breathe life into inanimate material.

Egyptian and other Eastern influences provided the inspiration not merely for stylistic changes in Greek figure sculpture. The Egyptian use of calcite "alabaster" (sometimes called "onyx marble") for small objects, and dense limestone for monumental sculpture may well have prompted Greek sculptors to adopt marble as their medium, there being abundant supplies on both the mainland and on Cycladic islands such as Naxos, the first quarry to be extensively mined. Furthermore, advances in metallurgy, which allowed the manufacture of tools in hardened iron – chisels and punches for working marble – facilitated greater articulation in the modelling of bodily members and the more precise rendering of hair and folds of drapery.

It is difficult for the modern imagination to conjure a viable mental image of how the numerous examples of votive *kouroi*, *kourai*, and other sculptural decoration might have looked within the built environment of sixth-century BC Greece, their brilliantly painted drapery, ornamental detailing, jewellery, and other accoutrements providing a dazzling spectacle for the citizenry, stimulating their sense of civic pride and reminding them of the awesomeness of divinity.

Artemis, "Lady of the Beasts"

Just as the temple operated as one of the main pivotal points of social organization within the *polis*, so the cult statue which it housed functioned as the focus of religious ritual and altar sacrifice. In many instances the cult statue was an object of venerable age, occasionally an aniconic column or plank-form *xoanon*, but later statues were properly anthropomorphic representations bearing the specific attributes of the god, or goddess, to which they were dedicated.

The immense cult statue of the goddess Artemis in the temple at Ephesus in Asia Minor, now western Turkey (FIG. 19), was attributed in antiquity to Endoios, who was said to have been a pupil of Daedalos, and is one of the more enduring images of the classical world. Her widespread popularity spawned numerous later Hellenistic and Roman versions in marble and other materials. The original figure, which dated from around 500 BC or even

Opposite

19. *Artemis of Ephesus*, Roman copy from Baiae of the c. 500 BC original. Alabaster with bronze face, hands, and feet, 6'7¾" (2.03 m). Museo Nazionale, Naples.

Research into the Artemis of Ephesus has offered the likelihood that the breast-like appendages which adorn the goddess may have been intended to represent the scrota of sacrificed bulls draped over the idol during the course of sacred rituals. This would be entirely in keeping with Artemis's obscure genealogy: Homeric legend, for example, associates her with the Asiatic or Cretan goddess known as "Goddess of Wild Animals" or "Lady of the Beasts."

earlier, was probably constructed from either wood or ivory or perhaps a combination of materials, like the copy here in alabaster and bronze, which has survived from Roman times. The curious appendages which sprout from the goddess's torso have been the cause of lively speculation for centuries, but their significance in the temple rites continues to elude us.

In the melding of diverse traditions which formed the Greek pantheon, the sky and sun gods worshipped as patriarchal deities by invading Indo-European tribes from as early as 2500 BC became fused with the agrarian, lunar goddesses who had formed the basis of a still earlier, pre-Hellenic culture. Thus, over time the Great Mother Goddess of Minoan and Mycenaean culture bequeathed her various attributes to a variety of minor goddesses, Athena becoming associated with snakes and birds, Hecate with the dog, Demeter with corn, Artemis the huntress with the lion and other untamed beasts of the wild, and so on. Artemis thereby typifies the composite nature of Greek mythology as it emerged from a concatenation of different and distant sources over centuries, her attributes occasionally seeming contradictory or ambiguous. Hence her significance as both a mother and as a slayer of all beasts; as a virgin goddess who rejects erotic engagement while functioning as mistress of nurturing and childbirth through which woman briefly resumes her animal identity.

The ancient significance of Artemis can be understood as being poised on the threshold between the opposing forces of the tamed and the wild, between the civilized and the primitive, one of the goddess's functions being to foster the necessary reconciliation of these conflicting values. The archaic cult statue of Artemis of Ephesus, as it has been handed down to us in its Roman version, echoes these tensions. The head, hands, and feet display some of the vocabulary of a developed classicism while the trunk form of the body retains the flavour of an earlier, more

20. LOUISE BOURGEOIS
Nature Study 5, 1995. Pink
marble and steel, 20 x 36½ x
23" (50.8 x 92.7 x 58.4 m).

The bodies and body parts
produced by Bourgeois
trigger contradictory feelings
of attraction and repulsion,
confounding our normal
processes of cognition.

primitive *xoanon*. Today the statue's meaning remains as elusive
as ever, its indeterminate components interrupting our ability
to read the body as a continuous coherent entity. We struggle
to reconcile its columnar lower section – a compartmentalized bes-
tiary of lions, leopards, and stags, referring to Artemis in her aspect
as huntress – with the barely articulated suggestion of legs beneath.
Similarly, the bizarre efflorescence of breasts or bovine scrota denies
immediate visual comprehension, ensuring that any attempt at
a satisfactory reading will remain incomplete.

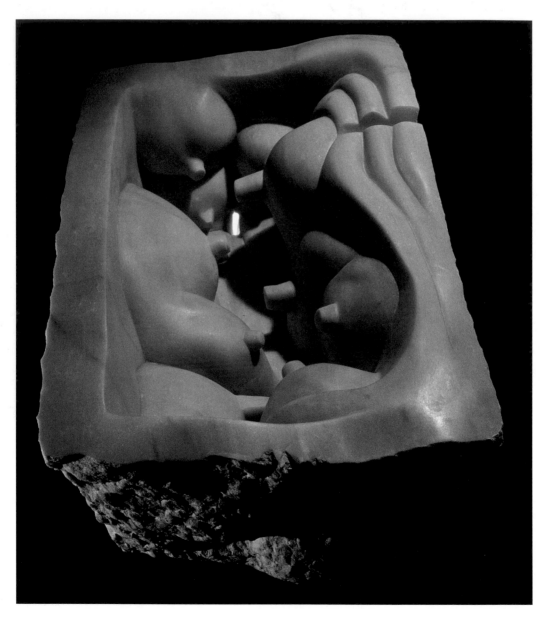

Perhaps it is the indeterminate, fugitive significance of the figure, its baffling, yet compelling effect on the spectator, which has made the Artemis of Ephesus so inspirational to contemporary artists. It has occasionally been suggested, for example, that the work of the French-born American sculptor Louise Bourgeois (b. 1911) draws upon a similar sense of troubling ambiguity, defying immediate categorization. Objects such as *Nature Study 5* in pink marble and steel (FIG. 20), continue to develop the themes explored in Bourgeois' work of the 1960s for which the American art critic Lucy Lippard coined the term "Eccentric Abstraction."

In its radical sense of distance from what we tend to think of as Greek sculpture, the Artemis of Ephesus signals both her archaic ancestry and her likely origins from outside an indigenous Greek tradition. Certainly by the turn of the fifth century BC advances had been made in the representation of the human figure which ensured that the Greeks themselves would have viewed the Artemis as distinctly different.

Sophrosyne *and Self-knowledge*

We need only turn to an example of the kind of sculpture which began to appear in Athens around 480 BC to realize how momentous were the changes brought to bear on representations of the body at the turn of the century. The *Kritios Boy* (FIG. 21), a marble *kouros* just under lifesize, was dedicated on the Athenian Acropolis around 480 BC and embodies as well as any figure might what has become known as the "Greek Revolution," in which a new naturalism signals both the demise of archaic stylization and the arrival of the Early Classical period (c. 480–450 BC).

Historians have long struggled to explain this stylistic change in Greek sculpture as an expression of Greek political liberty. This developmental model is one of the principal legacies of the eighteenth-century Enlightenment, and specifically of the work of the German archaeologist and art historian Johann Joachim Winckelmann (1717–68), whose *Geschichte der Kunst des Altertums* (The History of the Art of Antiquity), published in 1764, laid the foundations for the modern discipline of art history. For Winckelmann, the great flowering of Greek art was intimately related to the Greeks' sense of their own civic liberty, both as a social

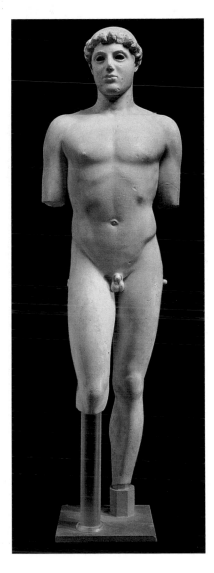

21. *Kritios Boy*, c. 480 BC. Marble, height 33¾" (86 cm). Acropolis Museum, Athens.

This statue shows a new animation and apparent vulnerablility to external stimuli which seems to bespeak a change in Greek self-perception as though a new national self-confidence were finding its expression in the representation of the human form.

group free from external interference and internal tyranny and in terms of a particular consciousness engendered by their autonomous political system. Hence, just as "through freedom the thinking of the entire people rose up like a noble branch from a healthy trunk," as Winckelmann put it, so the arts, the animated expression of that thinking, rose with them.

This kind of simple determinant relationship between civic liberty and the individual artist can never offer a complete and satisfactory explanation for the marked rise in what one might term the "idealised naturalism" which characterizes the sculpture of the Early Classical period, but it is not without its persuasive elements. Scholars are agreed that the emergence of a new humanism in sculpture around 480 BC does coincide with a new Greek self-confidence following the Athenian victory over the Persians at Marathon in 490 BC and the subsequent repulsion at Salamis in 480 BC of a further Persian invasion under Xerxes which had resulted in the sacking of Athens.

The *Kritios Boy*, found on the Acropolis at Athens during the nineteenth century, probably dates from the period of freedom immediately following the Persian invasion. As such it has been made to bear much of the burden of historical explanation, being viewed as a symbol of the artistic and social transformation that characterized this period of Greek history. Although the schematic frontality of earlier models to some extent remains, its severity is now tempered by a responsive turn of the head, as though the attention has been momentarily engaged, while the shift of weight away from an even distribution onto the left leg offers an eloquent evocation of internal bodily control, belying any external artistic expediency.

More than any other figure of its time, the *Kritios Boy* encapsulates that peculiarly Greek virtue of *sophrosyne*, or self-knowledge, espoused by late sixth-century dramatists and philosophers and characterized by a belief in inner restraint and a denial of excess. Only *sophrosyne*, it was believed, could provide a path to enlightenment and so prevent the forces of chaos and disorder from upsetting the balance of human happiness. It was arguably the impact of this maxim within contemporary Greek culture which helped nurture the new naturalism heralded by statues such as the *Kritios Boy*.

From now on the body serves not only as an expression of human potentiality in general but also as a vehicle for articulating greater psychological presence. Enhanced levels of naturalism facilitated by the increasing use of bronze helped to achieve these ends by enabling sculptors to render bodily detail with greater

Opposite

22. *Warrior "A"* (detail), found in the sea off Riace Marina, Italy, in 1972, c. 460–440 BC. Bronze with naturalistic decoration, height of whole statue 6'6⅘" (2m).Museo Nazionale, Reggio Calabria.

The lost-wax process of bronze casting allowed ancient sculptors to achieve extraordinary levels of realism, the body's presence intensified by the addition of copper lips and nipples, silvered teeth, and inlaid eyes. The finely-modelled features and crisp tendrils of hair and beard lend the face a suppleness which contradicts the brittle nature of the medium, while the inset teeth and eyes intensify the illusion of abiding intelligence.

precision and specificity. This is particularly noticeable in the two monumental bronze figures of warriors dating from 460–450 BC which were recovered from the sea off Riace Marina in southern Italy in 1972 (FIG. 22). Thought to belong originally to one

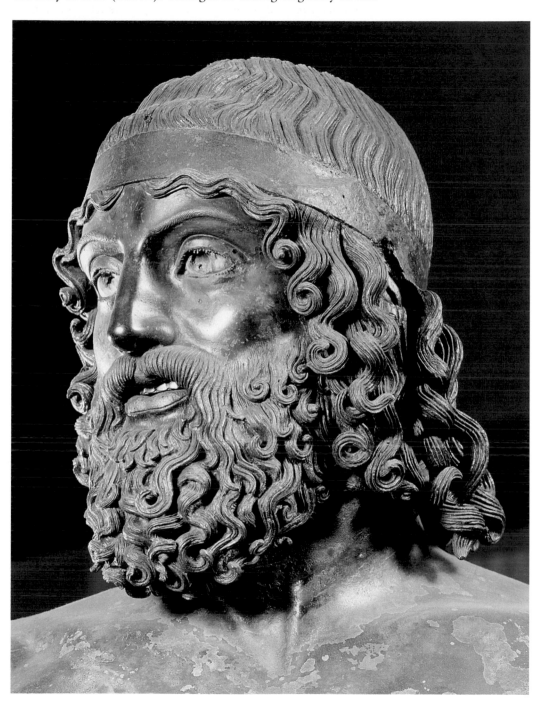

of the large-scale bronze groups at Olympia by Onatas of Aegina – and occasionally even attributed to Pheidias, the greatest sculptor of Periclean Athens – the figures were made using the indirect method of bronze casting which facilitates a close correspondence to the sculptor's original.

Perfection Through Numbers

What distinguishes the Riace warriors as paradigmatic instances of classical Greek sculpture is the success with which they blend the attributes of the divine and the human, the universal and the specific. Although one can detect subtle differences of character and bodily ambience between the two figures, each somehow stands alone as an exemplar of the ideal, a model of transcendent physicality formed in the mind of the sculptor and transposed into his chosen medium. The two sculptors regarded as having brought these principles to fruition, and thereby endowing us with the central works of what we now know as the High Classical period (c. 450–430 BC), were Polykleitos of Argos and Pheidias of Athens.

It is to Polykleitos that we attribute the first theoretical treatise on bodily proportion – the original Canon, or law. The written version of the Canon is now lost, but its two central principles of *rhythmos* (composition), and *symmetria* (commensurability of parts), grounded in mathematical proportion, were embodied in an accompanying statue – the *Doryphoros*, or "*Spear Bearer*" (FIG. 12), later ancient versions of which survive. So close is the *Doryphoros* in general demeanour and bodily disposition to the Riace *Warrior "A"* that there has been much speculation as to the possible direction of influences between the two figures. Certainly it would come as no surprise to us if *Warrior "A"* were found to have been modelled on the *Doryphoros*, for the impact of Polykleitos' instructive model was widespread and was to endure for centuries. For example, the great physician and anatomist Galen (AD 129–99), writing some six hundred years later, testified that:

> Modellers and painters and sculptors, indeed image-makers in general, paint or model the most beautiful figures, such as the comely man, horse, ox, or lion, by observing in each case what is the mean within each genus. And one might commend a certain statue, the one called the "Canon" of Polykleitos, which got its name because it had a precise commensurability [*symmetria*] of all the parts to one another.

The "mean" to which Galen refers, and which the statue embodied, had a deep resonance for the Greek mind, which saw harmonious balance and equilibrium as the most elevated expression of human life. In the *Doryphoros*, a harmonious bodily "mean" is achieved through the relationships between movement and stasis, action and contemplation, between left and right, straight limbs and flexed limbs; all these opposing but mutually justifying dynamics imbue the figure with an internal balance that is emblematic of a much broader philosophical and cultural bias.

We have only to call to mind two of the most familiar images from the Italian Renaissance – the graphic reconstruction of the Polykleitan Canon by Leonardo and Michelangelo's *David*, which clearly refers back to the *Doryphoros* – to comprehend the lasting influence which Polykleitos' canonical system came to exert on Western aesthetics. One theory has even gone so far as to suggest that the general preference for such ancient systems of bodily proportion became so deeply ingrained within Western culture that it may have had an impact upon sexual selection. This idea goes back at least as far as the German Enlightenment thinker Gotthold Lessing (1729–81), who suggested of the ancient Greeks that "Beautiful statues fashioned after beautiful men reacted upon their creators, and the state was indebted for its beautiful men to beautiful statues."

"An inescapable delight for the vision"

The reputation of Pheidias (c. 490–415 BC), arguably the most celebrated sculptor of the High Classical period, rests principally upon his achievements as overseer of the great Athenian building programme instituted by his friend Pericles, the Athenian general and ruler of Athens, between about 447 and 430 BC. The principal achievement of the Periclean initiative was the erection of a new temple – the Parthenon – dedicated to the city's deity, Athena Parthenos whose statue resided within.

A painting by the Dutch-born British artist Sir Lawrence Alma-Tadema (1836–1912; FIG. 23) imagines Pheidias directing a group of his fellow Athenians around the frieze of the Parthenon, the marbles shown freshly painted in many colours. The idea that the ancients had painted their sculpture was something which early nineteenth-century academics and critics had been unable to accept, particularly as the surviving fragments of the Parthenon pediment, frieze and metopes – the "Elgin Marbles," acquired by the British Museum in 1816 – had long since lost any of the colour they originally possessed.

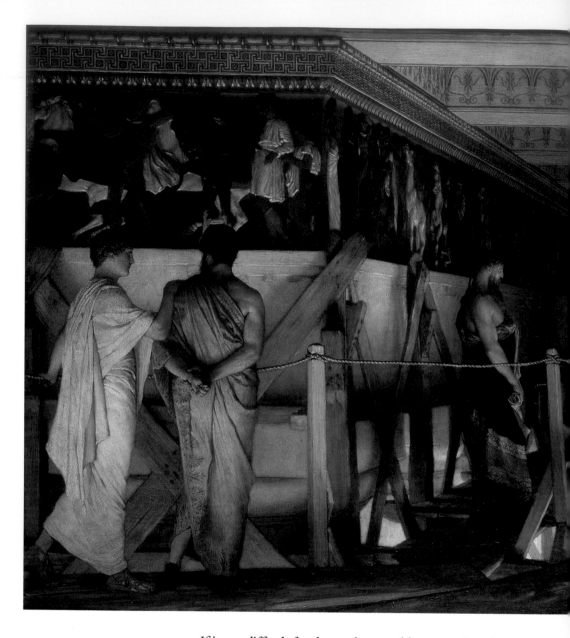

If it was difficult for the modern world to appreciate the extent to which ancient marble sculpture had been painted, it was even more difficult to imagine the impact of the central focus of the new Parthenon temple complex – the great colossal chryselephantine cult statue of *Athena Parthenos* by Pheidias, known to the modern world only through ancient texts, coins, and later copies (FIG. 24). Standing (with her base) nearly 38 feet (11.5 m) high, the statue was constructed from a central wooden core onto which were attached plates of gold for the figure's drapery and veneers of ivory

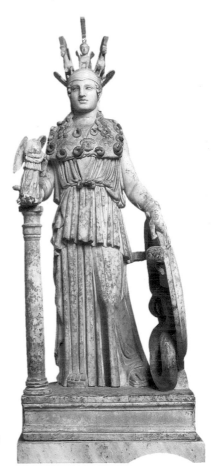

24. After Pheidias, *Varvakeion Athena*, a second-century AD Roman copy of the fifth-century BC *Athena Parthenos*. Pentelic marble, height 3'5" (1.05 m). National Museum, Athens.

The classical chryselephantine *Athena Parthenos* is known only through ancient literary sources and later "souvenir" models such as this example, thought to date from the Hadrianic period, discovered in Athens in 1880 in a Roman house beside the Varvakeion Gymnasium. The head of the Nike is missing, but otherwise it is in a remarkable state of preservation with numerous remains of colour.

23. SIR LAWRENCE ALMA-TADEMA
Pheidias and the Parthenon Frieze, 1868. Oil on canvas, 29½ x 42¼" (75.3 x 107.5 cm). Birmingham City Museum and Art Gallery.

Painted at the height of the controversy over coloured sculpture, Alma-Tadema's canvas imagines Pheidias showing a gaudily-painted Parthenon frieze to Athenian citizens. The colour scheme Alma-Tadema adopts for the sculptures seems to suggest that he was aware of current research into the subject of ancient polychromy.

25. Antoine Chrysostôme Quatremère de Quincy, reconstruction of the ivory veneers of the *Athena Parthenos*, 1815.

Quatremère de Quincy's graphic reconstruction of the *Athena Parthenos* was the first serious attempt to investigate the ancient technique of gold and ivory sculpture.

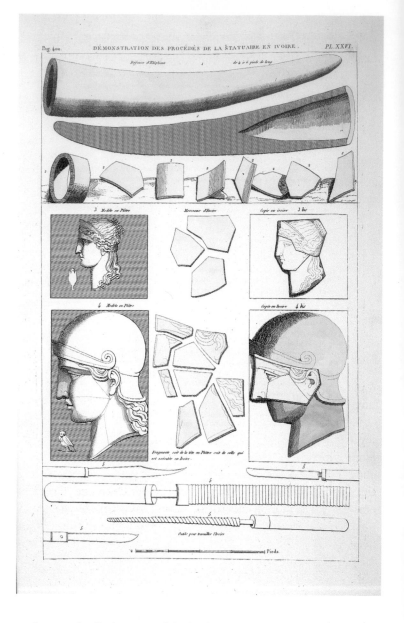

to denote the flesh parts of the body (FIG. 25). A pool of oil at the foot of the statue helped to lubricate the ivory components. According to ancient testimony, the ivory and gold technique employed in the statue's construction produced a dazzling body of awesome proportions (FIG. 26), "an inescapable delight for the vision," said the orator and philosopher Dio Chrysostom (AD 40–112): "it would even overwhelm those beings in creation that have an irrational nature – the animals – if they could once see this work."

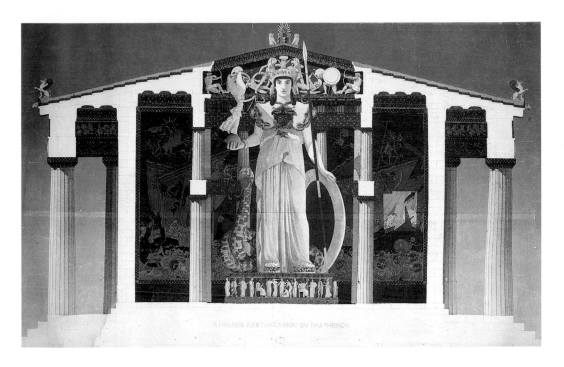

The decoration of the shield, pedestal, and other attributes of the statue combined a series of related themes signifying the triumph of civilization over barbarism, echoing Athenian civic pride at having repulsed the threat of Persian domination and reasserting Greek national identity. Furthermore, the valuable materials from which the *Athena Parthenos* was constructed tell us much about how art, politics, and religion were tightly interwoven practices within the social formation of the Periclean age. Greek literature is rich in allusions to the power attaching to the golden object, a material mythically associated with divine authority and heroic power; the golden fleece, the shower of gold, the shield of Achilles, to name but a few, all attest to the potential of the material to evoke a sense of power divinely endowed. Hence to dress the *Parthenos* in such a material was to invoke something of deep consequence within the culture of Periclean Athens, for wealth was at this time inextricably connected to a notion of religious awe, thereby intensifying the significance of such an act into a potent mix of lived political action and shared historical identity. Pericles was quick to remind his fellow citizens that the gold component of the statue could be removed and melted down for redeployment should the necessity arise. In her significance both as a symbol of a will to power and an emblem of civic identity, the gold-plated *Parthenos* embodies that peculiarly Periclean alloy of the political, the social, and the religious.

26. BENOIT LOVIOT
A Cross-Section of the Parthenon showing the Athena Parthenos, Reconstruction drawing, 1879–81. 4′¼″ x 6′4″ (1.255 x 1.93 m). Ecole des Beaux-Arts, Paris.

The ancient lost chryselephantine statue of Athena exerted a particular fascination over nineteenth-century artists and archaeologists who treated the written accounts of the colossal statue as evidence of the coloured nature of the ancient world.

Although the term "colossal" now denotes an object of extraordinary size, the original, ancient Greek use of the term conveyed nothing about an object's dimensions but referred to something erected, set up, and therefore, unlike the portable *xoanon*, immovable. However, as contemporary readings of the *Athena Parthenos* make clear, expanding the dimensions of the human form also served to symbolize a sacred power not of this world, a body of divine significance. It was not long before the rhetoric of increased bodily dimensions became appropriated as an agent of political propaganda, in which temporal power was communicated through the tension which exists within a body which is recognizably human in form but superhuman, and therefore intimidatingly inaccessible, in scale.

The colossal seated statue of the Roman emperor Constantine (r. AD 306–37) from the Basilica of Constantine in the Roman forum (FIG. 27), originally measuring over 30 feet (9 m) in height, is the true progeny of the great colossal pagan statues erected during the High Classical period such as the *Athena Parthenos* and the *Zeus* at Olympia, and testifies to how later secular leaders availed themselves of such traditional visual strategies to evoke divine power. The last recorded sighting of the Olympian *Zeus* was at Constantinople in AD 476, where it took its place among the many other Greek statues looted by Constantine's armies. Although the emperor himself was converted to Christianity in 312, the fragments of his own colossal statue reveal the extent to which he was prepared to appropriate some of the visual characteristics of the ancient pagan colossi for his own political purposes.

The impact of the colossal scale of Constantine's statue, the head of which alone measures 8½ feet (2.59 m) in height, was not, however, confined to its own historical era, for as the drawing by the eighteenth-century artist Henry Fuseli illustrates (see FIG.

27. Head and hand fragments of the colossal statue of Constantine from the Basilica of Constantine, Rome, AD 313. Marble, height of head 8'6" (2.6 m). Palazzo dei Conservatori, Rome.

65), the surviving fragments continued to fascinate artists for centuries. Unlike the *Athena Parthenos*, whose assembled composition largely contributed to her complete disappearance, and whose original appearance can only be reconstructed from ancient texts, the figure of Constantine resonates even today through the power of fragments.

This chapter has attempted to illustrate the centrality of the body in the ancient world as an expression of the power of divinity, as an icon of nationhood, and as a symbol of political power. While it would be an oversimplification to treat the objects discussed as a direct reflection of the culture from which they emerged, we can nevertheless view the gradual development of the body from crude symbolic forms to more accurate imitations of the nude within the context of a growing self-confidence in the Greek world and its self-fashioning through the writing of myth-history. In summary, a constructive contrast can be observed by glancing back and comparing *Kleobis and Biton* (see FIG. 17) with the *Kritios Boy* (see FIG. 21) or the Riace *Warrior A* (see FIG. 22). The bodies of the two archaic brothers dating from around 575 BC are fashioned according to simple rules or conventions concerning the arrangement of limbs and disposition of body weight, while the *Kritios Boy* and *Warrior A*, both made around a century later, reveal the growing ability on the part of sculptors to achieve a more life-like treatment of the body through greater realism and a more diverse range of attitudes, whether in action or repose. That change in the representation of the body remains one of the most profound developments in Western art.

This movement towards a more accurate imitation of nature was to continue into the Roman period when enthusiastic emulation of Greek culture ensured the continuing centrality of the three-dimensional body. The difficulties encountered by later generations, including our own, in sorting original Greek sculptures from their Roman copies testifies to the body's enduring significance through late antiquity. As we enter the medieval period we witness the body undergoing further radical change and it is these changes which form the subject of the next chapter.

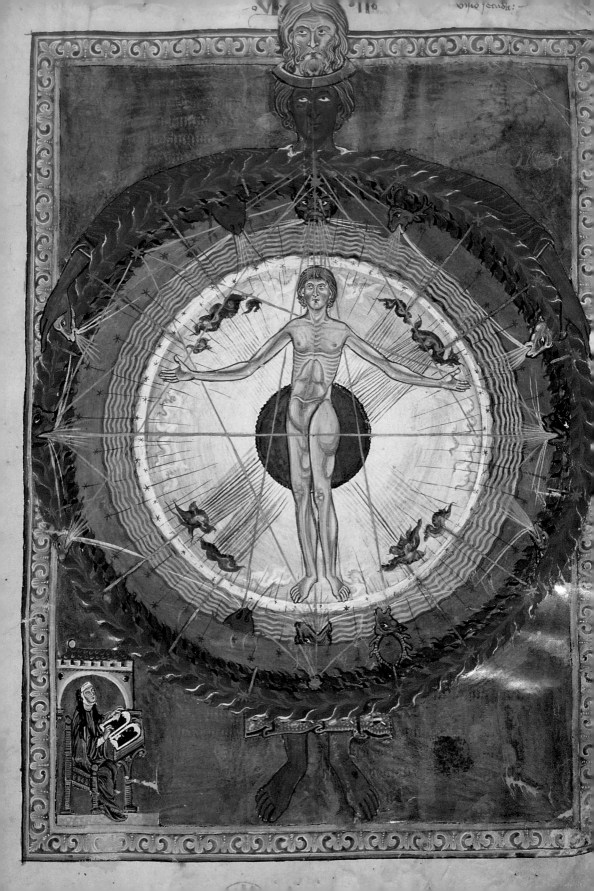

TWO

The Body Re-born: The Middle Ages

28. Man as a microcosmos of the macrocosmos, frontispiece miniature in a manuscript of the writings of St. Hildegard of Bingen. State Library, Lucca.

The Benedictine abbess, Hildegard of Bingen (d. 1179), was a medical practitioner, theologian, dramatist and visionary who placed the human body at the centre of her contemplations about God's governance of the universe. This miniature, which includes Hildegard herself at lower left, reveals something of her holistic approach, positioning humankind at the centre of the great cosmic design.

W e began this book by suggesting that the history of the body is also a history of ideas about the body, a history of the body as an expression of a diverse range of cultural forces. We need only turn our attention to the Middle Ages (c. 1150–1450) to discover how the three-dimensional body is anything but a fixed and unchanging category.

Although the arrival of Christianity had a cataclysmic effect on the Greco-Roman pagan world, the body remained of central importance throughout the medieval period. Mind and body were conceived at this time as inextricably linked; knowledge gained through the senses did not require mental processing to acquire significance and was therefore essentially carnal in nature and the church exploited this to profound effect.

While religious art was not the only context within which the body gained prominence during the Middle Ages, for the early Christian church, the body assumed a pivotal function in the formulation and dissemination of Christian doctrine. In both its human and sculpted form the body was the central arena for contesting the controversial issues of incarnation, transubstantiation, and resurrection so fundamental to Christian doctrine. Hence the body became a mediating mechanism between humankind and God. For example, between the second and the fourteenth centuries, the notion of resurrection remained a specifically bodily affair; only thereafter did it become possible to conceive of resurrection in non-corporeal terms, that is, as a survival of the self as disembodied soul.

A sense of the centrality of the body to the Christian church can be seen in a miniature from the manuscript of writings by the Benedictine Abbess St Hildegard of Bingen (1098–1179; FIG. 28).

This map of the sacred hierarchy positions the human being – represented by the male body – as the centre of a microcosm (a little model of the universe), in turn enveloped as part of a broader macrocosm (the great universe), itself anthropomorphized and presided over by an omnipotent God the creator. At first sight it might be tempting to draw a parallel between this popular medieval view of the body as a microcosm and the Polykleitan Canon. However, while both depend upon the body as the point of harmony between the human and the divine, as organizing systems for thinking about humanity's place in the universe, they emerge from quite distinct frameworks of belief, with quite different implications for the bodies at their centre.

If the classical world promoted a rationale of dynamic bodily perfection as the principal expression of the divine, so medieval eschatology – the doctrine of final judgement at the end of time – looked to the agonized, suffering body for the prospect of ultimate salvation. As the historian, Caroline Walker Bynum, has observed, "Medieval images of the body have less to do with sexuality than with fertility and decay. Control, discipline, even torture of the flesh is, in medieval devotion, not so much the rejection of physicality as the elevation of it – a horrible yet delicious elevation – into a means of access to the divine."

Medieval religion viewed the body as shameful, fallen flesh which required disciplining against sin in order to gain redemption, but we should not assume that all medieval representations of the body were suffering bodies, or that the suffering body is peculiar to the medieval period. The centrality of the body within medieval culture is expressed across a range of treatises, studies, and representations, each carrying its own particular nuance of meaning and significance. For example, the melting down and reforging of a statue became a common metaphor for resurrection among medieval Christian theologians, evoking the notion of bodily continuity after death; the body was also adopted as the ordering template upon which the groundplan, interior organization, and liturgical ceremonies of the cathedrals were based. As the medieval liturgist Durand de Mende expressed it: "The disposition of the built church corresponds to the human body; for the choir, or the place where the altar is situated, represents the head, the north and south transepts correspond to the arms and hands, and the nave, extending to the west, corresponds to the rest of the body." Thus in the Middle Ages the body is once again enshrined within systems of belief, finding its concrete expression in the great cathedrals erected in the centuries between 1050 and 1350.

The Body Emerges

One of the most significant legacies of the so-called "twelfth-century renaissance" – which saw the flowering of scholastic and artistic culture issuing from the monasteries and universities – was to instil a greater humanism into men and women's perception of their relationship to God. This fundamental change – essentially representing a move away from an earlier view based on a fear of death and final judgement to one emphasizing understanding and forgiveness – is manifested most vividly within the context of cathedral decoration.

As the hub of the town's economic, religious, and social life, the cathedral offered the means by which church teaching could be articulated to the people, both through liturgical devotion and in material form through the fabric of the building itself. Once again, the human body became the communicating device through which this new spirit of Christian humanism and scientific enquiry was disseminated. The body of the church, itself symbolizing the human form, became then the repository of other bodies, both in literal, fragmentary form as holy relics, and in sculpted, mimetic form as representations of Christ, the saints, the Virgin and Child, and donors, dispersed around the various altars, chapels, and church furniture.

To suggest that the three-dimensional body "emerges" as a consequence of the cathedral building programme in the twelfth and thirteenth centuries is to draw attention to three distinct but related issues regarding the development of monumental sculpture in the Middle Ages. In the first instance, the period from the twelfth century onwards marks the emergence of monumental sculpture from the long period of decline following the collapse of the Roman empire in the West in the fifth century. Sculpture had not entirely disappeared in this period, but it was predominantly small-scale. Secondly, the rise of the cathedrals also marks an early moment in the gradual re-emergence of the sculptor, or *ymagier tailleur*, as a distinct profession, for the first time since antiquity, evolving from among the diverse allied trades of masons, stonecutters, and architects – the mechanical arts – eventually to attain a status of relative autonomy among the liberal arts of the Italian Renaissance. And thirdly, this period marks the moment at which the sculpted body itself begins to emerge from its structural role as an architectural element, integrated into the fabric of the building, to achieve independent status as a three-dimensional entity occupying its own space, again for the first time since antiquity.

29. *Life of St. Cheron,*
c. 1225 (detail). Stained
glass window. Bay 42,
north apse, Chartres
Cathedral.

The window appears to
show the interior of a
mason's lodge with work
proceeding on the statue of
a crowned king, the left-
hand panel depicting an
ymagier tailleur, or
stonecutter, at work with a
chisel, watched by a
companion or apprentice,
while the right-hand panel
reveals perhaps an earlier
stage in the process in
which a hammer and chisel
are being used at right
angles to the sculpture to
rough out the basic form.
The back of the figure
would then have been
hollowed to lighten its
weight for hoisting into
place.

The term "sculptor" as it is traditionally understood as a carver
or maker of images in three dimensions, did not exist in the
Middle Ages, when the various tasks which combined to produce
ornamental sculpture were subsumed under the general duties
of stonemasons and stonecutters, in turn presided over by the mas-
ter mason or architect. The stained glass window from the north
apse at Chartres Cathedral (FIG. 29) is one of the many articu-
late representations of medieval sculpture in progress to survive
from the period and seems to offer substance to the theory that
monumental jamb (doorway) figures were carved *avant la pose,*
that is, on the ground before being hoisted into place, rather than
positioned on the building as blocks and finished *in situ.* To
document this artisanal activity in relative detail in the form of
a pictorial window and to memorialize it within the fabric of
the building is surely to acknowledge its significance within the
building process. Certainly, it offers an illuminating commen-
tary on how the jamb figures might have been made, revealing
them as the products of honest human labour, narrated here almost
as a devotional exercise in itself.

Another key to the individual conditions of manufacture of
the statuary of medieval cathedral architecture is the slight but
noticeable disparity in height between certain figures, a conse-
quence of having been hewn prior to positioning on the build-
ing's façade and perhaps of a medieval disregard for Classical rules
of symmetry and proportion. The elongated jamb figures around
the central doorway of the Royal Portal of Chartres Cathedral
(FIG. 30) represent an instructive early moment in the transition
between a Romanesque idiom – the previously dominant style
of the Middle Ages characterized by the surviving traces of Roman

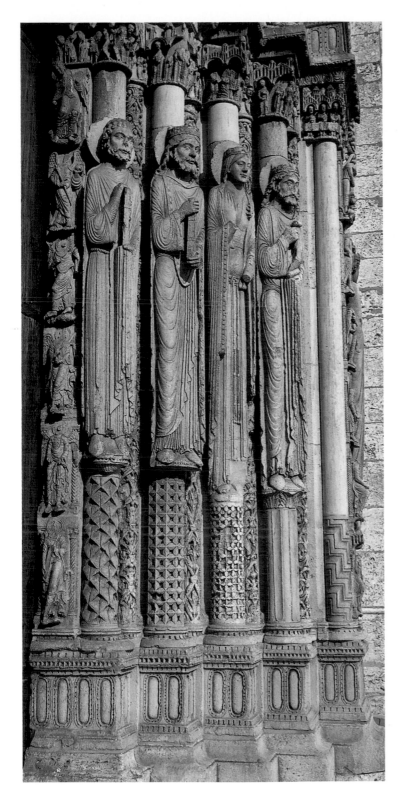

30. Jamb figures, central
doorway of the west portal
of Chartres Cathedral,
c. 1145–50.

classicism – and the first intimations of an emergent Gothic. Although retaining the illusion of structural responsibility – early jamb sculpture had been principally architectural and had consequently attained a high degree of stylized abstraction – the figures on the Royal Portal are already beginning to work themselves free of their columnar supports. This sense of an emerging bodily autonomy and individuality is echoed in the figures' facial characteristics, for while these are still essentially the unseeing, introspectively focused expressions of an archaic sensibility, their gently flickering smiles and benign bodily demeanours offer an indication of an evolving humanism.

Mary the Mediator

The decisive shift from the austere, meditative expressions of earlier medieval sculpture to the growing naturalism of the Gothic is nowhere better expressed than in the *Visitation* and *Annunciation* figures to the right of the central doorway on the west front of Rheims Cathedral (FIG. 31). In the intervening century since the jamb figures produced by the head master of Chartres, the body has stepped still further from the constraints of architectural relief decoration, its new three-dimensional liberty establishing a connection both with human spectators, and with its surrounding companions. Unlike the figures of the ancestors of Christ at Chartres, who are isolated in their seeming indifference both to each other and to the world of human affairs, the Rheims figures interact in a mutual narrative engagement which brings from the angel of the Annunciation an animated turn of the head, a subtle diversity of bodily movement – articulated by vigorous folds of drapery – and a benevolent smile that looks forward to the humanism of the Italian Renaissance. This subtle transformation of bodily type between 1145 and 1245 – stated in simplistic terms as a transition from stiffness to naturalism – is of a similar order and implication to that witnessed in the previous chapter between Kleobis and Biton and the *Kritios Boy*.

By the time the figures on the west portal at Rheims had been completed in the mid-thirteenth century the cult of the Virgin Mary was fully installed within the liturgical practices and iconog-

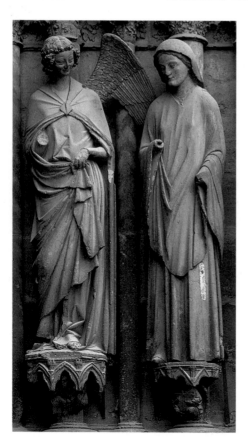

31. *Annunciation,* west portal of Rheims Cathedral, c. 1255-65.

raphy of the Christian church, chiefly thanks to the earlier twelfth-century devotional programmes conducted by St Anselm, Archbishop of Canterbury, Abbot Suger at Saint-Denis, St Bernard of Clairvaux, and others. Hence the essentially affirmative sculptural language of the Rheims portal locates Mary as a welcoming mediator between the human and the divine in a relationship now grounded in qualities of understanding and compassion rather than in fear and intimidation.

Naturally, as Marian devotion gathered its adherents so cult images proliferated. Heightened levels of naturalism seem gradually to have emerged as a means by which Mary could be more effectively promoted as an intercessor between God and humankind, and painted decoration was employed to this end (FIG. 32). Such figures would originally have been lavishly decorated, exploding the notion of "truth to materials" which nineteenth-century champions of the Gothic liked to promote.

While a more lifelike means of representation seems to have both contributed to, and been a consequence of, the spread of Marian devotion, we should beware of assuming that increased naturalism was a prerequisite for intense devotional identification. Earlier medieval cults ascribed bodily movement, bodily emissions (weeping, lactating), and other miraculous occurrences, to statues which we would today regard as anything but lifelike representations; specific statues were occasionally ascribed specific healing powers, thus engendering local loyalties. It follows that the process of devotional empathy could be enhanced by a certain particularity of representation, as in the use of real materials (cloth for draperies, jewels, crowns of real thorns) in statues of Christ which helped invoke the drama of the Passion and thereby intensified pious engagement with Christ's suffering. The fourteenth-century polychromed wooden statue of the crucified Christ at Burgos Cathedral (FIG. 33) in Spain, has real hair, a real crown of thorns, and real fabric garments. These elements, combined with other realistically rendered details, help reinforce the effect of bodily suffering, producing a three-dimensional equivalent to the often harrowing meditational tracts of the late Middle Ages. One such tract, written by Pseudo-Bede in the mid- to late thirteenth century, exhorted the faithful to concentrate on Christ's torment "as if you were actually present at the very time when he suffered. And in grieving you should regard yourself as if you had our Lord suffering before your very eyes, and that he was present to receive your prayers."

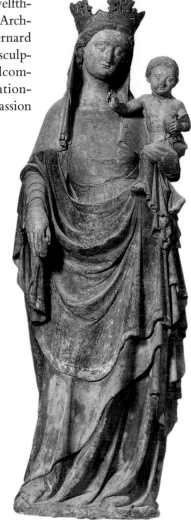

32. *Virgin and Child*, fourteenth century
Polychromed limestone, height 5'8" (1.73 m). Victoria and Albert Museum, London.

The statue displays a pronounced naturalism in the carving – lending the body a torsion and suppleness quite at odds with its stylized Romanesque predecessors – which is intensified by the delicate polychrome decoration.

33. *Crucifixion*, fourteenth
century. Polychromed
wood and mixed media,
over life-size. Burgos
Cathedral, Spain.

What this kind of devotional engagement amounted to was a reciprocal three-dimensional relationship in which the represented body of Christ was delivered with all its pathos into the real world of the worshippers, who were in turn transported, through the affective devices of narrative realism in which they were themselves momentarily implicated, into the imagined realm of Christ's suffering. The vivid representation of acute bodily torment was not, however, the sole means by which the faithful could be brought closer to God. Such modes of realism, which emphasize the agony of the flesh as a route to pious devotion, have come to be seen as the quintessential expression of a Gothic sensibility, but it is perhaps our awareness of the contrasting means of portraying the human body that we associate with the Italian Renaissance which has led to these conclusions.

One particular sculptural project which might help us understand the transition between the predominantly northern European Gothic sculpture discussed so far, and the emergent humanism which was to characterize the Italian Renaissance of the fourteenth and fifteenth centuries, is the series of works executed by the Netherlandish sculptor Claus Sluter (fl. 1379–1404) for Philip the Bold, Duke of Burgundy, for the Carthusian monastery the duke had founded at Champmol near his capital city of Dijon in central France.

The dukes of Burgundy were among the most powerful ruling families in northern Europe in 1390, when Sluter succeeded the late Jean de Marville as master in charge of the decoration of the Charterhouse at Champmol. In the following decade Sluter oversaw the design and execution of most of the sculpture, including the portal of the Church of the Chartreuse and a Crucifixion group of which only fragments survive but whose base – the so-called "Moses Fountain" – remains intact.

In fact, one of the most dramatic historical events of the medieval period provides a more vivid context in which to understand Sluter's work. The bubonic plague, or Black Death, which had swept across Europe between 1347 and 1351, had bequeathed a legacy of anxiety and uncertainty, responses to which ranged from various forms of religious fanaticism, such as that practised by the Flagellants, to more rational contemplations on the nature of humanity's relationship with God such as that undertaken by the meditative Order of Carthusian monks.

Sluter's work on the portal of the Church of the Chartreuse de Champmol (FIG. 34) can be read within this context, as the Chartreuse, or Charterhouse, was the name given to the first monastery of the Carthusian order. What separates the five figures

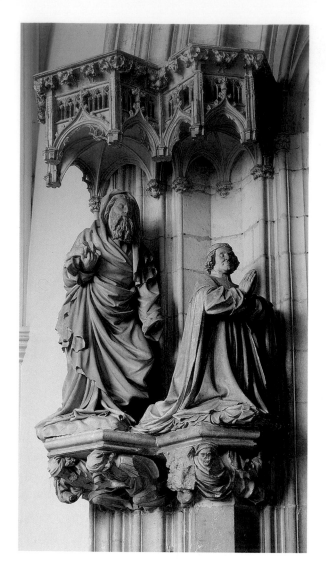

34. CLAUS SLÜTER
Portal figures of the Church of the Chartreuse
de Champmol, Dijon, completed 1400.

The arrangement comprises five figures –
the Virgin in the centre in her role as Queen
of Heaven, flanked by the Duke and Duchess
of Burgundy kneeling to her left and right
respectively, in turn presented by St. John the
Baptist and St. Catherine who intercede on
behalf of the ducal couple that their souls
might be embraced into the kingdom of
heaven.

on this portal from their predecessors at Chartres, and even at
Rheims, is their almost complete three-dimensional liberation from
the constraining harness of the architectural surround. The pointed
arch now functions as a kind of proscenium, or theatrical frame,
in which the figures, swivelled out of the strict frontality of
earlier Gothic types, assume their role as *dramatis personae*, free
to interact naturalistically with one another through an exchange
of glances. Even in purely formal terms, enlivened as they are
by dynamic swirls of drapery, one cannot fail to be moved by
the figures' extraordinary vitality. We can only wonder how they
must have appeared to contemporary viewers in the full splendour
of their realistic polychrome painted decoration.

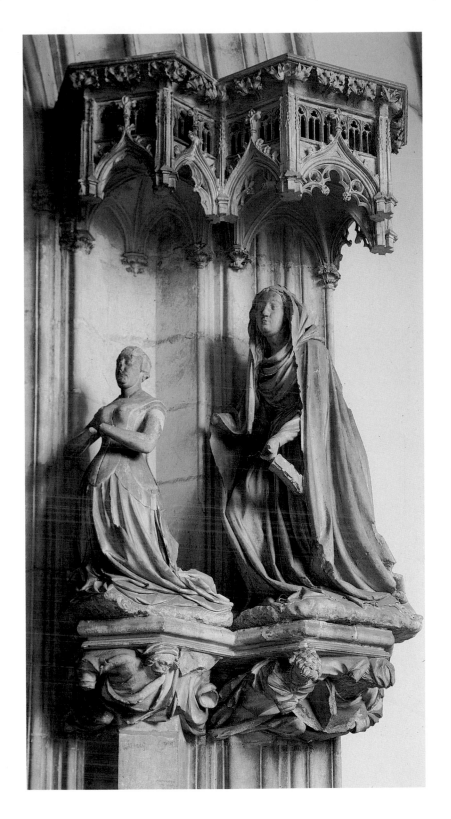

Sluter's radical departure from established sculptural conventions announces a break with the austere treatment of the body within the Gothic tradition. Equally importantly, the conditions of enlightened patronage which gave rise to the Champmol commission and the singularity of vision required to conceive and execute it prefigure the creative consequences issuing from the emancipation of the sculptor from the constraints of guild rules during the fifteenth century.

Opening the Body

Interest in antiquity was revived by the rediscovery in Western Europe of classical texts and is traditionally seen as the foundation of Italian Renaissance humanism. It was above all a revival of the human body as a central organizing principle for the expression of humanity's place in the universe. A renewed interest in the art and culture of Greece and Rome manifested itself most notably in the adaptation of ancient classical ideas of bodily proportion, movement, and gesture, all of which could be used, it was believed, to express the inner workings of the soul. However, for the surface of the body to articulate deeper structures of human motivation required a knowledge of the body's internal mechanisms and it was this imperative which drove many artists towards the study of human anatomy. The dissection of corpses belonged ostensibly to a realm of medical inquiry which reached its apogee in the work of the great Flemish physician Andreas Vesalius (1514–64). The publication in 1543 of Vesalius's *De Humani Corporis Fabrica* (On the Structure of the Human Body) marked a seminal moment in the development of a modern science of the body, but the general culture of enquiry within which it was conceived also provided the necessary preconditions for artists to perform their own excursions into the body's interior. As dissection provided a clearer understanding of the body's internal mysteries, so those researches allowed them to import a greater realism into three-dimensional representations of the human form.

For Leonardo da Vinci (1452–1519) dissection was no mere adjunct to artistic practice or an opportunity scientifically to expose the mechanics of bodily organization; rather, it became part of a broader project aimed at nothing less than

35. LEONARDO DA VINCI
Human Figure in a Circle and Square, illustrating Vitruvius on Proportion, c. 1485–90. Pen and ink, 13½ x 9⅝ " (34.5 x 24.5 cm). Accademia, Venice.

a comprehension of the relationship between the spiritual and material components of human nature itself. Leonardo's diagrammatic representation of the proportions of the body, known as the Vitruvian–Polykleitan Canon (FIG. 35) and dating from around 1485–90, amounts to a graphic manifesto of fifteenth-century ideas of the body, illustrating the notion of *homo bene figuratus,* or "the well-shaped man," adapted from the Roman architect Vitruvius (first century BC) who in turn drew on Polykleitos' original Canon.

One of the earliest indications of the impact of ancient, classical ideas of the body on an emergent Renaissance sensibility can be found in the figures produced by the sculptor Nicola Pisano (active c. 1258–78) for the pulpit in the Baptistry at Pisa, which date from 1260, long before Sluter. Of particular note is the almost freestanding statuette emblematic of the cardinal virtue of Fortitude (FIG. 36), positioned at one of the angles beneath the main relief panels. One of Pisano's sources for this may well have been the figure of Hercules on a classical sarcophagus now in the Terme Museum in Rome. Like that earlier figure, the *Fortitude* is most notable for its disposition of bodily weight, known as *contrapposto* (one leg flexed and weight-bearing, the other trailing), which ultimately derives from Polykleitos and which was to become a leitmotif of later fifteenth-century sculpture. Here, furthermore, is one of the earliest instances in which the body is rendered heroically nude and thereby endowed with a dignity more in keeping with an evolving Renaissance humanism than with the bodily shame associated with medieval piety.

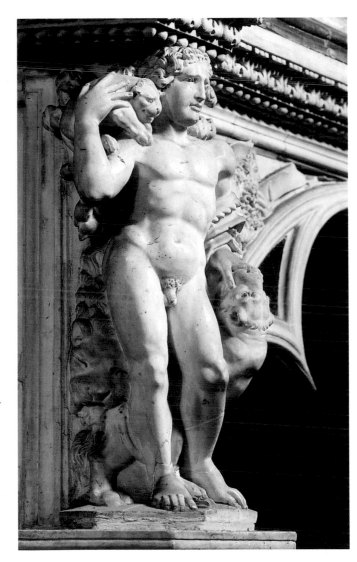

36. NICOLA PISANO
Fortitude, 1260, from the Pisa Baptistry pulpit. Marble, height 22″ (56 cm).

Fortitude, one of the four cardinal virtues deriving from Plato's Republic, was traditionally represented as a female warrior with club and lion skin. Nicola seems to have departed from this tradition by casting his Fortitude as a classical Hercules.

The Body in Perspective

The Sluter and Pisano figures serve to remind us of the co-existence of Gothic and classicizing elements within much of the sculpture produced in the century or so before the Renaissance and those elements continued side by side into the early decades of the fifteenth century. Although not quite freestanding, Pisano's *Fortitude* offers an early intimation of later developments in which the human figure came to assume a new presence as a volumetric entity, often positioned in the medium of relief sculpture within a rationally organized, fictive space. Just as the science of anatomy served to articulate the volume of the body through the revelation of its interior geography, so the body's volume could be expressed in three-dimensional representations through the use of that other great Renaissance achievement – single-point perspective, perfected by the Florentine architect Brunelleschi in the 1420s. Together these new ways of looking at and thinking about the world – an interest in the classical heritage in all its forms, a passionate curiosity about human anatomy, and innovations in the science of perspective – combined to deliver an approach to free-standing sculpture in which the central criterion for success was truth to nature.

During the early fifteenth century in Italy, the commissioning of art in major cultural centres was largely controlled by the seven major guilds, and the main guild hall in Florence, Or San Michele, itself became the site of a number of important works during the first quarter of the century. The decision in 1406 to decorate the niches on the exterior of the building with freestanding figures stimulated the competitive spirit of sculptors such as Donatello, Ghiberti, and Nanni di Banco, each of whom executed at least one commission. The position of the niches some way above head height necessitated the use of perspectival foreshortening – the elongation of the torso to compensate for the low viewing position – and the resulting works executed between 1411 and 1417 represent a survey in microcosm of prevailing attitudes towards the legacy of Greece and Rome.

One of the most striking examples of how contemporary sculptors quoted the formal grammar of their classical forebears can be seen in the *Quattro Santi Coronati* (the Four Crowned Saints; FIG. 37), executed some time around 1413 by Nanni di Banco (c. 1384–1421). Commissioned by his own guild, the Arte dei Maestri di Pietra e Legname (the Guild of Stone and Woodcutters), the work commemorates the four Christian martyr sculptors. One of only two instances on Or San Michele when more than one figure

occupies the niche, the four life-size saints, foreshortened to enhance their visibility, use a similar means of mutual exchange to that employed by Sluter on the Champmol portal. Here, the saints' gestures and facial expressions set up a narrative relay which moves from figure to figure, their volumetric substance conveyed through swathes of tumbling drapery. Above all, this is ancient Rome

transposed into a modern Florentine setting, a consciously "Romanized" vocabulary distilled through a thoroughly contemporary sensibility, and it was to prove enormously influential.

The classicizing innovations of the Renaissance did not, however, bring about the demise of the Gothic, for aspects of the two traditions coalesced into a new and rapidly evolving means of expression. The freestanding figure marked a momentous break with the Gothic past, bestowing on the body an autonomy and independence which directly mirrored that new sense of humanity's place in the world promulgated by the humanists. One increasingly visible by-product of this was the proliferation of beautiful nude bodies in public places.

Some sense of how the vestiges of the Romanesque and Northern Gothic traditions could be deployed upon the autonomous freestanding form can be seen in the polychrome wood figure of *Archangel Gabriel* (FIG. 38) made around 1421–26 by the Sienese sculptor Jacopo della Quercia (c. 1374–1438). All too often painted wood sculpture is marginalized within the historical record, largely on account of its tendency to approach extreme levels of naturalism, particularly when combined with real garments and accessories. However, such naturalism was for Renaissance artists a noble aim in itself, particularly when it served to quicken the narrative charge of a subject such as the Annunciation.

Donatello: Ancient into Modern

For another, still more innovative example of the use of polychromed wood in a freestanding figure we can turn to the work of the most celebrated sculptor of the fifteenth century, Donatello (1386–1466). Donatello's figure of St. John the Baptist (FIG. 39) was commissioned by the Florentine community in Venice for their church of Santa Maria Gloriosa. It has been suggested that the *St. John* was executed in wood to allow easy transport from Florence, but the choice of medium may also have facilitated the heightened

Opposite

38. JACOPO DELLA QUERCIA
Archangel Gabriel from the
Annunciation, 1421–6. Polychromed
wood, height 5′8¾ ″ (1.75 m).
Collegiata, San Gimignano.

The realism of Jacopo's figure,
which requires that it be viewed from
a frontal position in which gestures
and expressions can be easily
comprehended, heightens the sense of
bodily presence and intensifies the
emotional engagement between viewer
and object so important to the
devotional ritual.

Right

39. DONATELLO
St. John the Baptist, 1438. Painted and
gilded wood, height 4′7½ ″ (1.41 m).
Santa Maria Gloriosa dei Frari, Venice.

Commissioned by the Florentine
community in Venice, Donatello's *St.
John* seems to have absorbed something
of the Byzantine influence so central to
Venetian culture but which was also
being felt in Florence where the figure
was made. Naturalistic details such as
the irregularly fashioned eyes, one with
a heavy lid, impart a sense of
individuality to the haggard features.

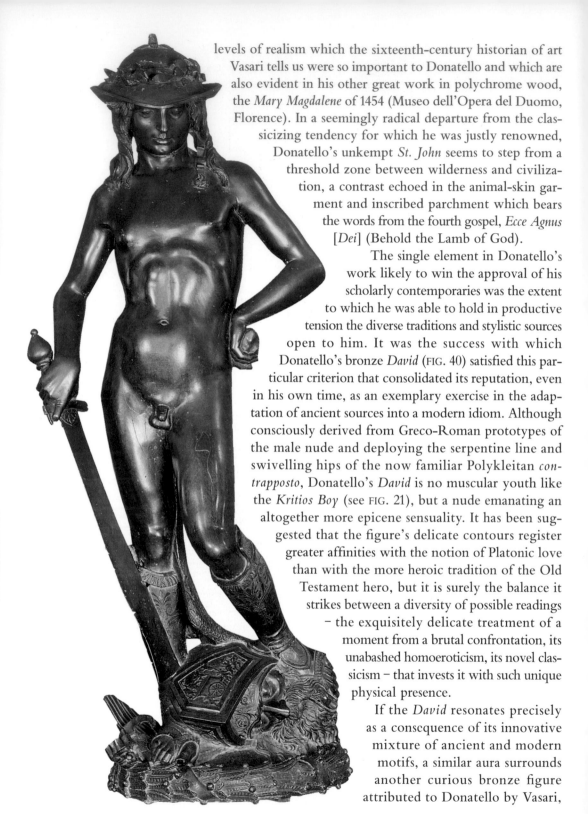

levels of realism which the sixteenth-century historian of art Vasari tells us were so important to Donatello and which are also evident in his other great work in polychrome wood, the *Mary Magdalene* of 1454 (Museo dell'Opera del Duomo, Florence). In a seemingly radical departure from the classicizing tendency for which he was justly renowned, Donatello's unkempt *St. John* seems to step from a threshold zone between wilderness and civilization, a contrast echoed in the animal-skin garment and inscribed parchment which bears the words from the fourth gospel, *Ecce Agnus [Dei]* (Behold the Lamb of God).

The single element in Donatello's work likely to win the approval of his scholarly contemporaries was the extent to which he was able to hold in productive tension the diverse traditions and stylistic sources open to him. It was the success with which Donatello's bronze *David* (FIG. 40) satisfied this particular criterion that consolidated its reputation, even in his own time, as an exemplary exercise in the adaptation of ancient sources into a modern idiom. Although consciously derived from Greco-Roman prototypes of the male nude and deploying the serpentine line and swivelling hips of the now familiar Polykleitan *contrapposto*, Donatello's *David* is no muscular youth like the *Kritios Boy* (see FIG. 21), but a nude emanating an altogether more epicene sensuality. It has been suggested that the figure's delicate contours register greater affinities with the notion of Platonic love than with the more heroic tradition of the Old Testament hero, but it is surely the balance it strikes between a diversity of possible readings – the exquisitely delicate treatment of a moment from a brutal confrontation, its unabashed homoeroticism, its novel classicism – that invests it with such unique physical presence.

If the *David* resonates precisely as a consequence of its innovative mixture of ancient and modern motifs, a similar aura surrounds another curious bronze figure attributed to Donatello by Vasari,

Opposite
40. DONATELLO
David, 1430s–50s. Bronze,
height 5′2¼″ (1.58 m).
Museo Nazionale del
Bargello, Florence.

Originally a private
commission from the
Florentine politician and
banker Cosimo de' Medici,
Donatello's *David* was later
displayed in the Palazzo
Vecchio courtyard where it
no doubt resonated as a
powerful republican
symbol, an emblem of
Florentine resistance to
external political control.
The figure may also subtly
allude to ideas outlined in
Plato's *Symposium* in which
tolerance of homosexual
love was seen as a liberal
virtue of republican states.

Left
41. DONATELLO
Amor-Atys, 1440s–50s.
Bronze, height 40¾″ (104
cm). Museo Nazionale del
Bargello, Florence.

known as the *Amor-Atys* (FIG. 41). Garbed in the costume of a
Roman peasant, the dancing youth sports a range of attributes asso-
ciated with the antique, albeit codified beyond our comprehen-
sion. The topless trousers, facilitating generous genital display,
are of an established type worn by Roman peasants, while the other
devices – the snake being crushed underfoot signalling the young
Hercules, the winged sandals, the Cupid's wings, the satyr's tail,
the liberal scattering of poppy-heads – together combine to

42. NICCOLÒ DELL'ARCA
Lamentation over the Dead Christ, 1463–85. Painted terracotta. Santa Maria della Vitas, Bologna.

Commissioned for the hospital of Santa Maria della Vita, dell'Arca's group dramatizes the moment when Christ's body was removed from the cross, soliciting extreme bodily expressions of grief from the onlookers. Such terracotta groups probably derive from the real-life theatrical tableaux practised by the faithful during Easter ceremonies and could be rearranged into complex groupings. Niccolò dell'Arca's *Lamentation* proved particularly influential on painting and sculpture in northern Italy.

confound any straightforward reading. The figure remains as baffling to modern scholars as it had been to earlier writers.

What the work of Donatello has bequeathed to us above all is a sense of the individuality so important to the Renaissance artist and intellectual. It is not simply that these works defy our immediate and complete understanding that makes them so compelling but also that they represent a singular vision of the world. Contemporary viewers versed in Neo-Platonic philosophy would have had no difficulty in comprehending the finer nuances of meaning communicated in the attributes of such figures, for legibility of symbols – whether of gesture, facial expression, or religious iconography – was of paramount importance to a Renaissance audience and nowhere was this principle more important than in the treatment of religious themes.

Occasionally, the mechanics of gesture and expression could be stretched to an astonishing degree as in the extraordinary life-size freestanding Lamentation groups produced by Guido Mazzoni, Nicolò dell'Arca, and others in northern Italy in the second half of the fifteenth century. The painted terracotta group of the *Lamentation over the Dead Christ* (FIG. 42) by the Apulian sculptor Niccolò dell'Arca in the hospital church of Santa Maria della Vita in Bologna is virtually a *tableau vivant*, the emotional intensity of the figures increasing from left to right as the relative calm of the kneeling Nicodemus on the left gives way to the hysterical, almost airborne figure of Mary on the extreme right, whose turbulent drapery seems metaphorically to reinforce the depth of her grief. Above all, it is the inert figure of the dead Christ which provides the central foil for the exaggerated energy of

the surrounding ensemble, for in the tradition of contemporary religious drama, the group was designed to elicit the maximum emotional empathy from the pious beholder.

It is not the only time we will encounter an almost theatrical treatment of an elevated religious theme in freestanding three-dimensional format, for in some respects Niccolò dell'Arca's group prefigures certain aspects of the Baroque sensibility, a subject which we shall ponder in the following pages.

This chapter has been concerned with the ways in which the body was seized upon by the Christian church both as a means of ordering knowledge about the world and as a model through which to express humanity's relationship with God. From the outset Christian doctrine was centred around a powerfully emotive image of corporeality – the Crucifixion – and from this symbol sprang a series of deeply rooted, body-centred preoccupations. We have seen how the body came to provide a model upon which the cathedral groundplan was based and we have considered how the idea of resurrection was until the early fourteenth century a specifically body-related concept. The corporeal nature of Christian doctrine was further reinforced by the mystery of the eucharist at the centre of the Catholic mass, in which bread and water were thought to be transubstantiated into the body and blood of Christ.

Just as the medieval body could reveal signs of fear and instability fostered by superstition and by the Church's emphasis on the corporeality of religious experience, so the bodies of the Renaissance came to display a sense of the renewed confidence which arose from a return to rationalism, humanism, and classical scholarship. Occasionally that confidence entailed an excursion beyond the body's external boundaries.

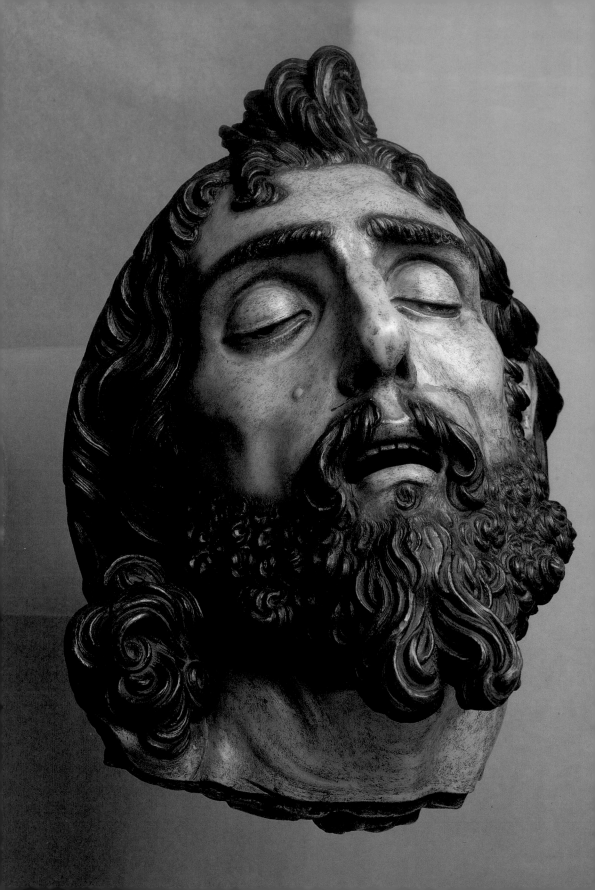

THREE

The Apotheosis of the Body: Mannerism and Baroque

43. GASPAR NÚÑEZ
DELGADO
The Head of St. John the Baptist, 1591. Painted terracotta, life-size. Museum of Fine Arts, Seville.

Delgado's head belongs to a tradition of heads of St. John the Baptist in which verisimilitude, achieved through realistic painting, played an important role in conjuring up St. Mark's account of St. John's Passion.

W hen the Italian painter and architect Giorgio Vasari (1511–74) published his pioneering work of art history, the *Lives of the Painters, Sculptors, and Architects,* in 1550, he sought to present Florence as the crucible of artistic perfection in which the achievements of antiquity had been rescued from the barbaric Gothicism into which they had declined during the Middle Ages. In doing so, he plotted a path from the Florentine painters Cimabue and Giotto through Masaccio, Donatello, and Brunelleschi, a route which culminated in the supreme accomplishments of Michelangelo. The rationale upon which his biographical method was based held the faithful representation of nature to be the aim of all artistic endeavour and the benchmark by which art should be judged.

In the ninety years in which Michelangelo rose to almost god-like status among his contemporaries – "something supernatural and beyond human experience" was how he was perceived in his own time – Italy itself had undergone radical social, political, and religious transformation. While republican city-states in the peninsula engaged in almost continuous internecine warfare, the military powers of Spain and France moved to capitalize on the instability which resulted, culminating in the defeat of the French king Francis I in 1525, the beginning of Spanish rule in much of Europe, and the formation of modern nation-states and empires.

Against this landscape of political turmoil the Church too underwent fundamental change and upheaval as two centuries of growing European-wide dissent against Rome found its final expression in the Reformation of the early sixteenth century. The resulting schism effectively signalled the demise of Catholic hegemony in Europe and the establishment of Protestantism, later to become the dominant religion of many northern European countries. The Counter-Reformation constituted a revival and reform of Catholicism (only in part a reponse to the rise of Protestantism), from around the 1540s to the early seventeenth century.

It is a commonplace of the criticism of Vasari's *Lives* that for all its illuminating biographical detail and richly rewarding anecdote, it conspicuously failed to establish any meaningful connection between art and the conditions of its production. But we should not criticize Vasari for failing to accomplish what he never set out to achieve in the first place. The model of artistic decline and rebirth that he adopted was a historical commonplace among humanists and commentators, and it is always more difficult to recognize the impact of political and social forces when one is living under their influence. Vasari's *Lives* did, however, bequeath an enduring methodology which concentrated on aesthetic discernment and the recognition of individual genius, at the expense of social context. Only in the last twenty years has connoisseurship – the faculty of aesthetic discrimination – been recognized as failing to account for a range of more urgent considerations.

If one were to monitor the three-dimensional body in purely formal terms from the beginning of the fifteenth century to the time of Michelangelo, one might concur with Vasari in discerning a steady movement towards the accurate representation of nature. But what were the circumstances which effected this drive towards naturalism?

Surface and Structure: The Body Flayed

Our own appreciation of the impressive sense of bodily presence achieved by High Renaissance sculptors, when compared to their Gothic and even earlier Renaissance forebears, was shared by the sixteenth-century beholder. For a clue to what constituted Michelangelo's early *modus operandi* we can return to Vasari's own comments on one of the sculptor's earliest works, the life-size *Pietà* in St. Peter's, Rome (FIG. 44). "It would be impossible," Vasari suggests, "to find a body showing greater mastery of art and possessing more beautiful members, or a nude with more detail in the muscles, veins and nerves stretched over their framework

Opposite

44. MICHELANGELO
Pietà, 1497–1500. Marble, 5'8 1/2" x 6'4¾" (1.74 x 1.95 m). St. Peter's, Rome.

Michelangelo's first masterpiece of sculpture, executed when he was just twenty-four, is a tour de force of marble carving. Such virtuosity might have contributed to the charges of blasphemy levelled at the work by the strict Counter-Reformation authorities. In fact it echoes a popular contemporary theme: the Virgin Mary lamenting Christ's death by dreaming of her son as a sleeping infant in her arms.

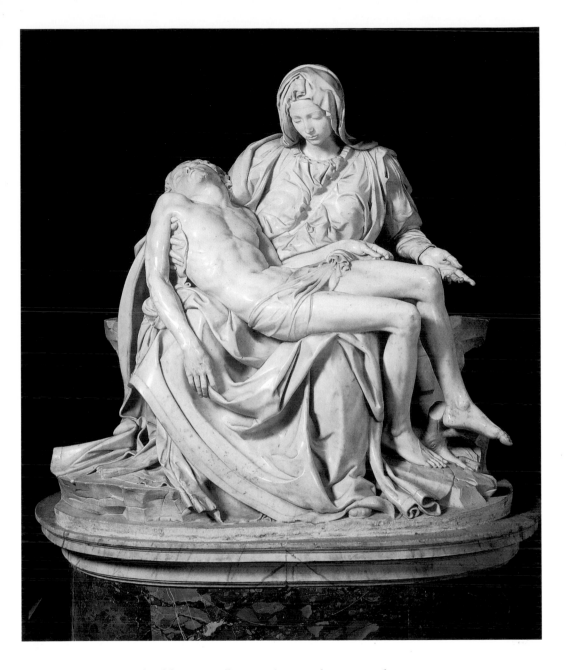

of bones, or a more deathly corpse." It requires no deep textual
analysis to detect Vasari's fixation with the internal workings of
the body in his appraisal of Michelangelo's marble group, and
it was a fixation engendered by a culture in which scientific and
medical inquiry coincided with the aims of artistic endeavour.
Renaissance artists understood that as the exterior of the body sug-
gests something of its interior structure, a familiarity with the

body's internal composition was required in order to render the surface of the body convincingly. The practice of dissection was therefore intimately connected with the accurate representations of the human body achieved by Michelangelo which so impressed Vasari.

While Michelangelo's group continues an established northern European tradition of *Pietàs*, it marks a novel break with this format, deriving much of its power from an implied reference to the conventional iconography of the Madonna and Child. This is reinforced by the abrupt contrast between the still youthful Madonna and the broken corpse of her now fully mature son. Recent scholarship suggests that this disparity in ages may represent Michelangelo's own genuflection towards Dante's *Paradiso* at the end of which St. Bernard refers to the Virgin as the daughter of her son – "figlia del tuo figlio." However, it is above all upon the convincing visualization of the relationship between the body's surface membrane and internal armature that the success of such a contrast ultimately depends and which marks Michelangelo's *Pietà* as a turning point between the close of the fifteenth century and the dawn of the High Renaissance.

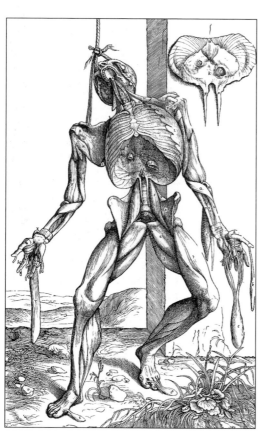

Like his contemporary Leonardo, Michelangelo was not averse to hunkering down in the viscera of human remains in order to acquire the necessary anatomical knowledge to further his artistic aims: such was the young Michelangelo's enthusiasm for dissection that Niccolò Bichiellini, the prior at the Florentine Hospital of Santo Spirito, provided him with corpses for this purpose. The contribution of artists to the scientific study of human anatomy is an acknowledged fact in the history of medicine, most eloquently testified to in Vesalius's *De Humani Corporis Fabrica* and commonly regarded as marking the beginning of modern science.

The series of woodblock plates which illustrated the *Fabrica* indicate the productive exchange between the artistic and scientific communities during the sixteenth century. The so-called "musclemen" plates (FIG. 45), in which the peeled body stands isolated and apparently alive in a landscape, refer to the ancient myth of the satyr Marsyas flayed by Apollo, a subject as popular with Renaissance

audiences as it had been in antiquity. One or two of the muscle-men seem even to hint at the source of the corpses, for Vesalius himself described scavenging the bodies of executed malefactors from the roadside gibbets outside Paris in order to conduct his research; hence such images may even have functioned as a kind of *memento mori*, or moral caution, reminding beholders of the brevity of human existence.

The concept of *memento mori* is worth pondering for a moment as it is intimately related to the body. Originating in the medieval period and derived from the Latin "remember you must die," it gains its power and significance by playing on anxieties related to the fragility or instability of the bodily state. These ideas incited real fears during the Middle Ages when the ecstasy which was thought to accompany final resurrection or the eternal torture issuing from damnation were perceived as ends to be experienced by the body. Although by the time Vesalius's text appeared a new rationalism had replaced the worms and maggots which medieval superstition assumed to be resident within the body, the mus-clemen nevertheless occupy a place within the *memento mori* tradition, reminding the viewer that *et in Arcadia ego* – "Even in Arcadia am I [Death] to be found."

The importance of the assimilation of human anatomy to the student of art inevitably led to the appearance of the three-dimensional equivalent of the Vesalian muscleman, the *écorché* or flayed model which, from the sixteenth century onwards, became part of the standard impedimenta of the artist's studio and of the academy. The presence of such figures in the numer-ous representations of academy life-rooms of the eighteenth and nineteenth centuries (FIG. 46) reveals the centrality of Vesal-ius's contribution to anatomical study in the subsequent development of art edu-cation, and underscores the symbiotic rela-tionship between the anatomical investi-gations undertaken by artists and the scientific research conducted by the uni-versity medical faculties.

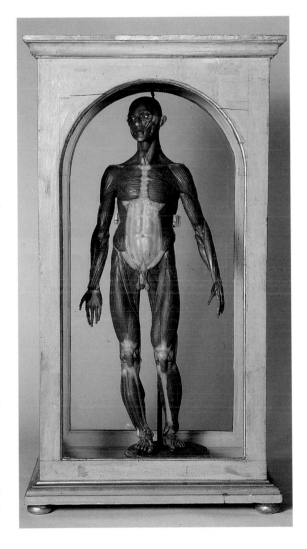

46. An *écorché* (flayed) figure, eighteenth century. Wax, height of case 39¾" (101 cm). Science Museum, London.

This figure was probably made by the artists Susini and Calenzuoli in Florence between 1776 and 1780, and is one of a set of seven small-scale versions of life-size models provided by the Grand Duke of Tuscany for medical students at the University of Florence.

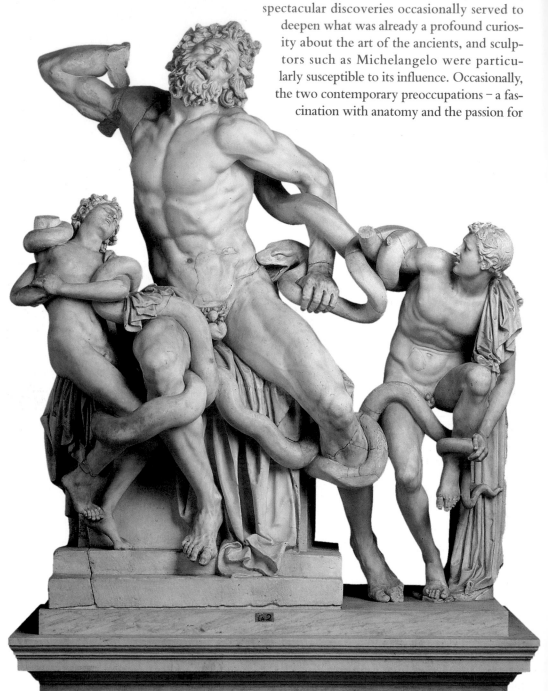

47. *Laocoön*, c. AD 50.
Marble, height 6' (1.84 m).
Vatican Museums, Rome.

Laocoön: the Body Unearthed

Interest in antiquity was as great in the first half of the sixteenth century as it had been during the fifteenth century. Indeed, spectacular discoveries occasionally served to deepen what was already a profound curiosity about the art of the ancients, and sculptors such as Michelangelo were particularly susceptible to its influence. Occasionally, the two contemporary preoccupations – a fascination with anatomy and the passion for

antiquity – coincided, as in the discovery in January 1506 of the marble *Laocoön* (FIG. 47), a first-century AD Roman reconstruction of a Greek theme. It was described in the immortal words of Pliny the Elder as "of all paintings and sculptures, the most worthy of admiration."

One can only speculate on the excitement felt by Michelangelo on viewing the newly discovered ancient marble group shortly after it was unearthed among the ruins near Santa Maria Maggiore in Rome. Having already completed an ambitious, monumental life-size group – the *Pietà* for old St Peter's (see FIG. 44) – Michelangelo must have been transfixed at the anatomical realism, physiognomic range, and intensity of human emotion which the statue displayed. Here was a three-dimensional group of three bodies locked together in intense suffering, but unlike Niccolò dell'Arca's *Lamentation* group (see FIG. 42), the combined force of which can be fractured by the separation and re-arrangement of its component parts, the *Laocoön* compresses the figures into a tighter space, thereby intensifying the sense of shared bodily duress under which they struggle.

What made the *Laocoön* particularly impressive was that it was reported by Pliny to have been carved from a single piece of marble. That such a complex and technically demanding group might have been executed in this way inevitably served to elevate the reputation of the ancients in the eyes of Renaissance artists, while acting as a challenge to their own ambitions. However, shortly after its discovery it was established that this was not in fact the case, the visible joins and different types of marble eventually confirming its composite construction. Nevertheless, the possibility of carving such a contorted human form from a single block may well have been present in Michelangelo's mind when he returned to Florence in 1506 to continue the interrupted work on the figure of *St. Matthew* (FIG. 48), the start of an ambitious project commissioned by the Florentine Wool Guild to carve, over a period of twelve years, the twelve Apostles. As it transpired, the *St. Matthew*, itself never completed, was the only figure in the series undertaken by the sculptor.

48. MICHELANGELO
St. Matthew, 1504–08. Marble, height 8'10¾" (2.71 m). Accademia, Florence.

The *St. Matthew* offers an ideal illustration of Michelangelo's method, which involved working from the front of the block backwards, gradually liberating the body from its marble casing, the saint seemingly straining and twisting as if to assist the sculptor in his labours.

The Apotheosis of the Body: Mannerism and Baroque 73

Cellini: Eight Views of the Body

It is predominantly upon Vasari's biographical profile of 1550 and
that compiled by Ascanio Condivi in 1553 that our knowledge
of the life and work of Michelangelo depends. Unfortunately, with
one or two particularly notable exceptions, we have no equiva-
lent source of contemporary data for the artists who came to dom-
inate the second half of the sixteenth century and whose work has
come to be seen as representative of that style known by the vague
term of Mannerist. The main exception is the now notoriously
untrustworthy autobiography by the Florentine goldsmith and
sculptor Benvenuto Cellini (1500–71), written between 1558 and

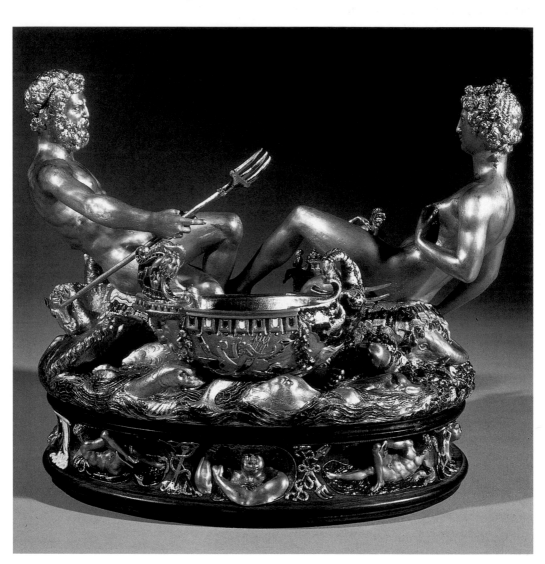

1562. Although offering a wealth of commentary on his contemporaries, Cellini's literary self-portrait is far from reliable and is most notable for converting the individualism so characteristic of the Renaissance mentality into a flamboyant exercise in unashamed braggadocio and self-aggrandizement.

Cellini's most influential sculptural achievement, apart from his two technical treatises on goldsmithing and bronze casting published in 1568, is his bronze *Perseus* (1545–54; placed in the public, outdoor Loggia dei Lanzi, Florence), which was above all an overt attempt to outshine earlier adjacent Florentine masterpieces such as Donatello's *Judith and Holofernes* and Michelangelo's *David*. Apart from having been designed as a fully three-dimensional work offering multiple viewpoints, the elaborate pedestal and generally exotic tenor of the *Perseus* mark it out as a quintessential example of mid-century Florentine Mannerism.

Cellini will be best remembered, however, for the gold and enamelled salt cellar completed in Rome in the 1540s for the French king Francis I (FIG. 49), an object of extraordinary preciosity long recognized as a virtuoso example of the goldsmith's craft and one of the most significant small-scale *objets de luxe* to survive from the Renaissance. Although designed to fulfill a utilitarian function, the salt cellar was also intended as a demonstration of Cellini's superiority over his contemporaries, and over the ancients, at modelling the body in miniature. His autobiography relates the success by which he achieved his aim, the French king exclaiming on seeing the model: "This is a hundred times more divine a thing than I had ever dreamed of. What a miracle of a man!" It is chiefly these three works, the *Perseus*, the salt cellar, and the supremely egotistical *Autobiography*, which established Cellini as arguably the most significant figure in sixteenth-century sculpture between Michelangelo and Giambologna.

If Cellini's autobiography achieved anything it was to provide multiple viewpoints of the one subject and in this respect it functions as an apt literary analogue of Cellini's aim in sculpture. "The greatest art among the arts based on design is sculpture," he once pronounced; "it is seven times greater than painting because a statue must have eight views which should all be of equal quality." This somewhat opaque pronouncement (which essentially recommends aiming at visual coherence from *all* possible viewpoints) was an opinion echoed in the work of a number of Cellini's contemporaries and never more so than in that of the Flemish-born sculptor Giovanni da Bologna (1519–1608), or Giambologna as he has become known, who spent most of his career in Italy.

The Unfolding Narrative

Giambologna is rightly celebrated as one of the finest exponents of the monumental public fountain and the small-scale bronze statuette, which helped to disseminate his work across Europe. He is of particular interest here for his facility in achieving complex arrangements of the human form.

After arriving in Italy in 1550, he fully assimilated the lessons of antique statuary and grafted this appreciation onto a contemporary aesthetic born of the legacy of Michelangelo and his fifteenth-century predecessors to produce a wholly fresh approach to the three-dimensional body. Giambologna's technical preoccupations and dynamic approach to the treatment of the body in motion are immediately identifiable in the monumental marble *Samson Slaying a Philistine* (FIG. 50) for Grand Duke Francesco de' Medici. Such groups represented a technical challenge to Giambologna, offering an irresistible opportunity to rival the supreme achievements of Michelangelo and indeed the *Laocoön*. They were worked out in advance with the use of small sketch models, or *bozzetti*, in wax, some of which have survived to provide an insight into the unfolding of the imaginative process. As one circles the work, the *intrecciamento*, or interweaving, of bodies and the coherence of the multiple viewpoints lend the illusion of a dramatic physical encounter unfolding. The technical achievement – in liberating the two bodies from the single block in order to leave only five supporting points of contact with the base – in itself would have been received by contemporary spectators as evidence of Giambologna's *virtù*, or virtuosity, in triumphing over technical difficulty.

We might legitimately ask how Giambologna's earlier and abiding preoccupation with predominantly pagan subject matter was reconciled with the stringent requirements of the Catholic Counter-Reformation regarding the production of religious imagery. That question can be answered by reference to one particular aspect of his achievement. The extent of Giambologna's contribution to the development of a narrative tradition within sculpture has only recently become subject to serious reappraisal, but it can help us to understand the deeper engagement with religious themes with which he was later concerned. One of the means by which the Catholic Counter-Reformation church authorities aimed to draw the faithful into more direct involvement with the liturgy was by calling for coherent and legible visual representations – lucid story-telling which would elicit devout responses from the spectator. Giambologna's development of the technically

Opposite

50. GIAMBOLOGNA (GIOVANNI DA BOLOGNA) *Samson Slaying a Philistine*, 1561–2. Marble, 6'10" (2.1 m). Victoria and Albert Museum, London.

Giambologna's group became the most famous work of Italian sculpture in England following its presentation to the Prince of Wales, later King Charles I, in 1623. It offers one of the best demonstrations of the multiple view, a work designed to be appreciated from a variety of angles.

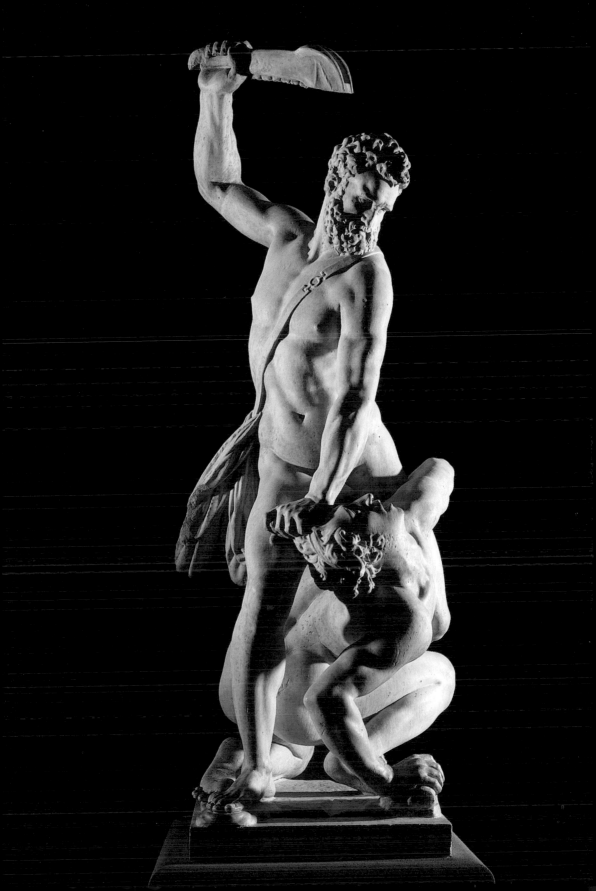

Opposite
51. TORRIGIANO (PIETRO
TORRIGIANO D'ANTONIO)
St. Jerome in Penitence,
sixteenth century.
Painted terracotta, life-size.
Museum of Fine Arts,
Seville.

The statue was regarded as
a landmark in the
iconography of St. Jerome
in Spanish art, in which the
saint was traditionally
represented as a Father of
the Church in his cardinal's
robes. Torrigiano's figure
combines the longer,
thinner body of Italian
Mannerism with the striking
realism of the Spanish
polychrome tradition.

advanced narrative group, of which the *Samson* is an exemplary instance, proved particularly appropriate to those ends: it could draw the viewer in to a gradually unfolding event, thereby fostering a deeper emotional and psychological connection with the underlying message. This was one realm in which the three-dimensional body proved particularly resonant since it occupied the same space as the beholder and so triggered a more direct empathetic response. During the last thirty years of his life Giambologna went on to adapt these narrative techniques to the production of religious relief sculpture.

Polychromy: The Painter's Hand

The promotion of narrative was not the sole means through which the liturgy could be effectively communicated. Thus far our attention has been concentrated largely on monochrome works in marble and bronze, but one area of sculptural production which gained particular prominence during the Counter-Reformation was polychrome sculpture in wood and terracotta. As we have seen, some Italian sculptors of the fifteenth century such as Donatello and Jacopo della Quercia, inspired by Gothic example, explored the possibilities of colouring sculpture, but it was principally in Catholic Spain during the late fifteenth and throughout the sixteenth century that polychromy emerged as an important part of sculptural practice. Once again, its progress was assisted by the spread of Counter-Reformation edicts concerning the proper means of representing religious subjects, but it was above all the collaborative efforts of painters and sculptors which helped to foster the levels of realism which served to promote pious contemplation of the liturgy. No longer were formal characteristics alone deemed an adequate means of achieving these ends, for, as the Spanish painter and theorist Francisco Pacheco (1564–1654) insisted in 1622, "the figure of marble and wood requires the painter's hand to come to life."

Such was the importance with which the subject of polychromy was treated by Spanish artists that the painting of sculpture was institutionalized as a separate realm of expertise from that of the sculptor, the polychromers' guild comprising not only the respected *pintor de imagíneria* (the painter of sculpture) but also a range of experts qualified in other specific areas such as the gilding of drapery.

As Pacheco's pronouncement partly reveals, the co-operation between painters and sculptors resulted in a range of naturalistic effects by which the sculpted body seemed indeed about to

"come to life." An early example of the powerful bodily
presence that could be achieved through polychrome
painting is the life-size terracotta sculpture of *St. Jerome
in Penitence* (FIG. 51), dating from the first quarter
of the sixteenth century, not by a Spanish sculptor
but by a Florentine resident in Spain, Pietro Torrigiano
(1472–1528). Torrigiano has gained somewhat dubious
renown mainly through being responsible for break-
ing Michelangelo's nose in a student squabble in
the Brancacci Chapel of Santa Maria del
Carmine, an act which, according to Vasari,
forced him to flee Florence. After a period in
Rome in the service of Pope Alexander VI,
he travelled to England in 1511 where he
was responsible for the tomb and funerary
effigy of Henry VII, eventually settling in
Seville in the 1520s. Grafting the crisp real-
ism of the Spanish vernacular onto the
slightly attenuated body and subtle *con-
trapposto* associated with Florentine Man-
nerism, the *St. Jerome* established an
important prototype for later Spanish
religious sculpture.

Often, the combination of real-
istic modelling in terracotta or wood
with naturalistic painting allowed
Spanish sculptors to deliver some of
the more extreme aspects of Christian iconogra-
phy: the Seville sculptor Gaspar Núñez Delgado
(d. 1617) used a close study of anatomy to bring
startling veracity to his severed *Head of St. John the
Baptist* in painted terracotta (FIG. 43). The
work refers to the account in St. Mark's
gospel (6: 21-28), in which Herod, bewitched
by the dancing of his step-daughter Salome,
grants her demand for the head of the Baptist
on a dish. In obedience to the text, Del-
gado's work was intended for display
on a silver plate! The uncanny verisimil-
itude of the decapitated head, which
aims to concentrate the minds of the
faithful on the horror and pathos of the
Gospel, finds an ironic echo in a provo-
cative work by the twentieth-century

The Apotheosis of the Body: Mannerism and Baroque 79

English sculptors Jake and Dinos Chapman, entitled *Bring Me the Head of Franco Toselli!* (FIG. 52) which uses the iconography of St. John to produce a sardonic visual pun.

It is instructive when addressing the question of realism in Spanish sculpture of the late sixteenth and early seventeenth centuries to bear in mind that religious painting also strove towards illusionistic ends, or towards what has been called a "poetic of the holy *trompe-l'oeil*." If painters aimed at the illusion of three-dimensionality in their work, it is perhaps not surprising that the sculpted body arrived at an even more counterfeit mode of representation when subject to similar techniques of realistic painting, and it may have been this which served to promote sculpture above painting in some ecclesiastical circles. One of the most celebrated examples of early seventeenth-century Spanish painted wooden sculpture, the life-size carved wooden crucifix known as the *Cristo de la Clemencia* (FIG. 53) by the Seville sculptor Juan Martínez Montañés (1568–1649), was intended from the outset to promote a direct – one might almost say "person-to-person" – transaction between the body and its beholder. Montañés's contract stipulated that the crucified Christ must be represented in such a way as "to look at anyone who might be praying at His feet as though He were speaking to that person, lamenting the fact that He was suffering for the one praying to Him."

The physical presence and sheer sensuality achieved by the three-dimensional body over its painted equivalent is arguably nowhere more evident than in the carved wooden figure of Christ known as the *Imagen del Salvador* (FIG. 54), occasionally attributed to El Greco (1541–1614) and seemingly a direct transposition of the figure of Christ from the artist's *Resurrection* of 1603–07. Recently art historians have begun to investigate the controversial question of Christ's sexuality in order to account for the numerous instances of genital display and "genital manipulation" in religious representations. The addition of a loin cloth does not always serve to divert attention from such considerations, however: in the case of El Greco's *Christ* it was removable, which merely reveals the absence of genitalia, prompting us to recall the long tradition of "vacant loins" in representations of Christ. What

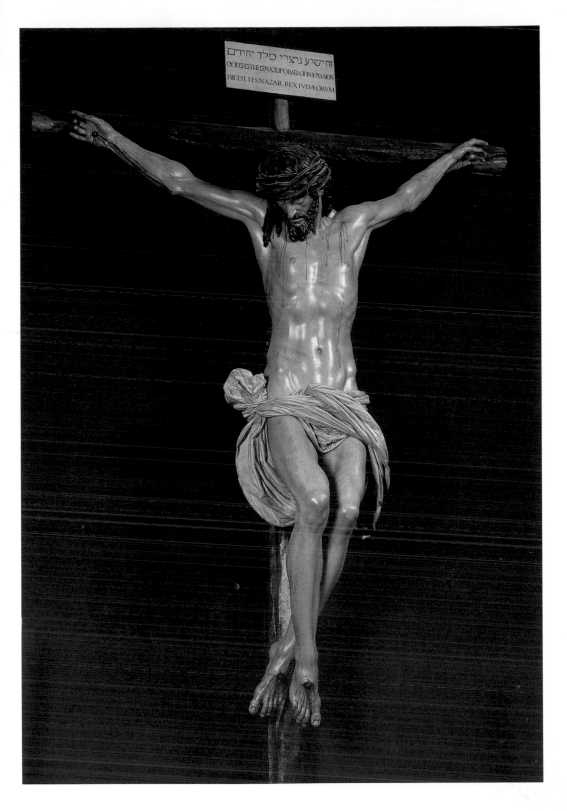

the removable loin cloth reveals is that Christ has nothing to hide.

The impact of Spanish polychrome sculpture was not always dependent upon the representation of the entire body, as the severed head of St. John demonstrates; the fragment or bust could occasionally exert equal power, the central message somehow intensified by being concentrated into the salient details of physiognomy. The painted pinewood *Mater Dolorosa* or *Virgin of Sorrows* (FIG. 55), by the Andalusian sculptor Pedro de Mena (1628–88), is of a type originating from the mid-sixteenth century in which busts or half-length figures of the Virgin were often paired with busts of Christ as *Ecce Homo* (Behold the Man). Pedro de Mena's *Virgin* exemplifies the variety of technical means available to seventeenth-century Spanish sculptors in their attempts to

54. EL GRECO (attributed?)
Imagen del Salvador (Figure of Christ), early seventeenth century. Polychromed wood. Hospital de Tavera, Toledo.

This polychromed sculpted version of the figure of Christ from the artist's *Resurrection* painting (1603–07, Prado Museum, Madrid) draws attention to the sensuality which three-dimensional representation can impart. A removable loin cloth originally formed part of the statue. While Michelangelo had succeeded in rendering Christ nude and without a loin cloth in white marble, such a treatment would have been unacceptable in polychrome wooden sculpture which drew attention to bodily specifics.

55. PEDRO DE MENA
Mater Dolorosa (The Virgin
of Sorrows), 1670s.
Polychromed wood.
Museum of Fine Arts, Seville.

Often reaching astonishing
levels of realism, such
polychrome works may
derive from the tradition of
reliquary busts containing
relics of the saint which
were common in Andalusia
in the seventeenth century.
They occasionally formed
pendants to busts of Christ as
Ecce Homo.

communicate the psychological dimension of religious teaching.
In such works the delicate curls of hair were occasionally rendered
from spirals of wafer-thin wood shavings, the teeth, sometimes
formed from real ivory, while the eyes – and in some versions even
tears applied to the cheeks – were often made of glass.

Mystical Visions: The Body in Ecstasy

The profession of sculptor in seventeenth-century Spain was almost
wholly dominated by men, making the achievements of the Seville-
born sculptor Luisa Roldán ("La Roldana"; 1652–1706) particu-
larly noteworthy. After marrying Luis Antonio de los Arcos, a
polychromist, Roldán established her own workshop before mov-
ing to Madrid in 1688, where she won the prestigious post of Court
Sculptor to Charles II. A work dating from the 1690s – *The Vir-
gin and Child with St. Diego of Alcalá* (FIG. 56) – is typical of the

small-scale terracotta groups made by Roldán for private patrons and fuses the naturalistic treatment of earlier seventeenth-century Spanish sculpture with more overtly Baroque motifs. One of the most interesting aspects of the group is the means by which Roldán has presented the subject as a mystical vision by positioning all the figures except the Franciscan saint on clouds.

The mystical vision, or theophany as it is correctly termed, was one of the most common subjects in Spanish art of the seventeenth century and presented specific problems to both painters and sculptors. In blurring the boundaries of the material and the spiritual, the earthbound and the celestial, and in privileging the spectacle, the mystical experience could almost be seen as a private manifestation of the Baroque sensibility. Although the Baroque style was subject to subtle variations across its diverse European manifestations, the general characteristics we have come to associate with Baroque art and architecture – the theatrical disposition of space, the equal importance attached to painting, sculpture, and architecture in the making of the work, the emotional experience of the beholder in completing the meaning of the ensemble – all required a reassessment of the traditional relationship between the arts and of the viewer's involvement in their reception. This made the Baroque idiom a particularly appropriate means by which to realize the dramatic and all-encompassing nature of the mystical experiences reported by saints such as Teresa of Avila (1515–82). However, sculptors wishing to render these mystical accounts into three-dimensional form were confronted by a central conundrum at the heart of the theophanic experience: how could the body be made to render, honestly and convincingly, a mystical "out-of-body" experience?

The artist who came closest to overcoming this seemingly intractable problem was the Italian architect, sculptor, painter, playwright, and theatre designer Gianlorenzo Bernini (1598–1680), the most versatile exponent of the Baroque in seventeenth-century Italy. Bernini's marble group of *Ecstasy of St. Teresa* (FIG. 57), in the Cornaro Chapel of Santa Maria della Vittoria in Rome, combines an acute theatrical awareness, virtuoso marble carving, and a dramatic *mise-en-scène* to represent the climactic moment in the spiritual ecstasy of the great Spanish Carmelite reformer.

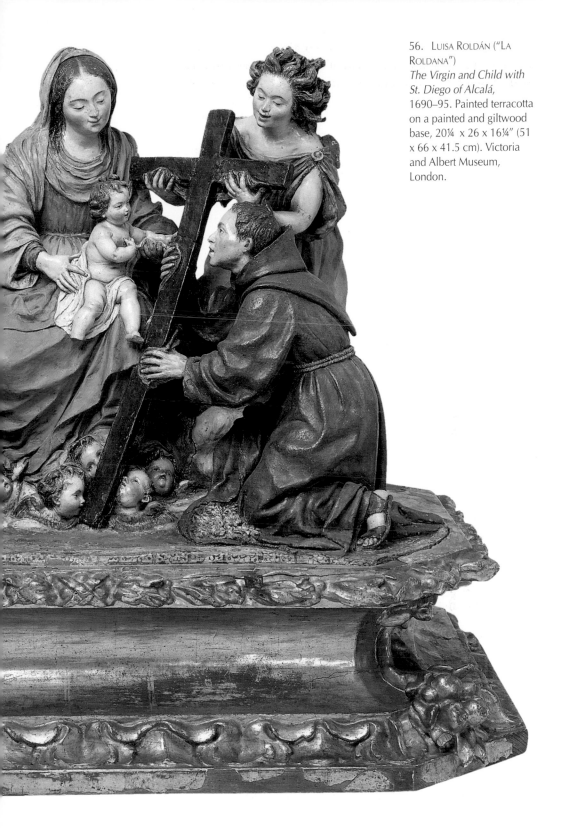

56. LUISA ROLDÁN ("LA ROLDANA")
The Virgin and Child with St. Diego of Alcalá, 1690–95. Painted terracotta on a painted and giltwood base, 20¼ x 26 x 16¼" (51 x 66 x 41.5 cm). Victoria and Albert Museum, London.

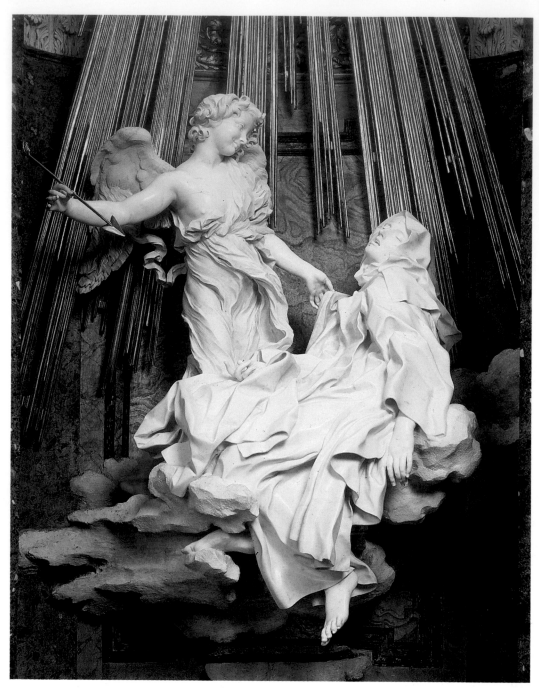

57. GIAN LORENZO BERNINI
Ecstasy of St. Teresa, 1646–52. Marble, height 11'6" (3.5 m). Cornaro Chapel, Santa Maria della Vittoria, Rome.

"This spiritual state … is so extreme, that the soul appears to swoon away and seems on the point of leaving the body," said St. Teresa (1515–82). The problem confronting artists such as Bernini was how the body could be used to represent a spiritual, non-body experience.

St. Teresa herself described the sensation of receiving the "fiery dart" of God's love, specifying that "the sufferer gives vent to loud cries, which she cannot stifle, however patient and accustomed to pain she may be, because this torture is not corporal, but attacks the innermost recesses of the soul."

Although Teresa stipulated that the painful ecstasies she was describing were not of the body but of the soul, in a later passage she reveals that the experience "leaves the limbs all disjointed and the pulse as feeble as if the body were at the point of death." It was by seizing upon the reference to these outward, physical signs that Bernini succeeded in evoking an interior, spiritual experience, his technical virtuosity allowing him to turn the saint's drooping left arm and foot into eloquent signifiers of bodily surrender. Furthermore, the specifics of this narrative clearly demanded that the marble be left in its uncoloured state, the better perhaps to communicate the saint's bloodless body on the point of expiry, any colour present instead deriving from the tonal contrasts between mass and void in the deeply cut folds of drapery.

Bernini's Baroque arrangements also pioneered the combination of sculpture, architecture, and painting in the one work, producing, in the words of his contemporaries, the *bel composto*, or beautiful whole. What this strategy draws attention to is how a composite construction of diverse elements can promote a more unified experience on the part of the spectator. This is not the only occasion in which we will encounter the work of art as an assemblage of separate elements brought together to form a whole, but Bernini's use of it is entirely novel. The gathering of components should be understood, however, within the context of specific devotional practices issuing from the Catholic Counter-Reformation, which saw human nature as a fusion of the two elements of body and soul. Bernini's positioning of the three-dimensional body within a theatrical ensemble composed of other elements was therefore underpinned by Catholic doctrine itself, which was at this time promoting the concept that unity emerges from diversity.

The theatricality pioneered by Bernini in his sculptural groups inevitably exerted an impact on later generations of sculptors. Although born and trained in Paris, the French sculptor Pierre Legros the Younger (1666–1719) is often considered within the context of Italian sculpture because most of his important commissions were undertaken during his long residence in Rome. His most celebrated work, and the one which reveals the greatest debt to Bernini, is the polychrome monument to the Polish Jesuit novice,

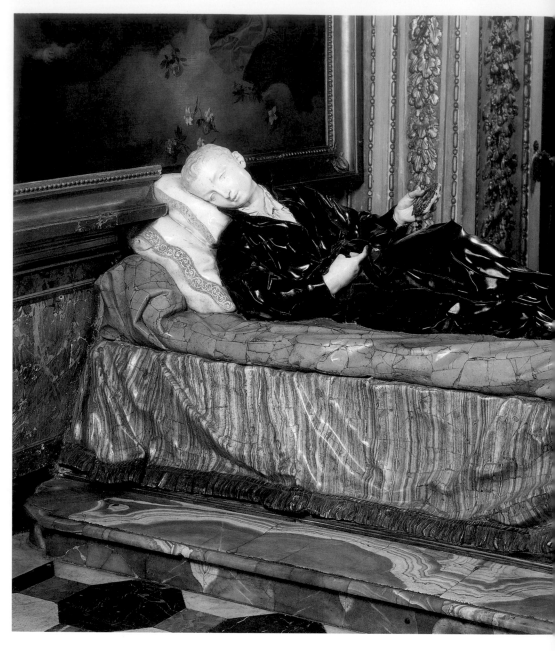

58. Pierre Legros the Younger
The Blessed Stanislas Kostka on his Deathbed, 1702–03. Marbles and
alabasters. Sant'Andrea al Quirinale, Rome.

Situated in the darkened room in which the young novice died, the work
derives much of its power from the suggestive use of coloured stones –
Carrara marble for the head, hands, and feet, black Belgian marble for
the drapery, and yellow marble and banded calcite alabasters for the
bed on which the body lies.

the blessed Stanislas Kostka, who died in 1568 at the age of 18 (FIG. 58). Commissioned by the Jesuits in 1702 for the novitiate beside Bernini's church of Sant'Andrea al Quirinale in Rome, the monument was intended to foster devout contemplation of the blessed Stanislas within the context of Jesuit teaching, specifically the *Spiritual Exercises* of St. Ignatius of Loyola. A sense of the contemporary impact of the work and the illusionistic effect of the polychrome marble comes from a document in the Jesuit archive which reveals that "among the shadows of the room, it appears to those who enter like a dead man on a bier and moves them greatly." Legros's statue exemplifies the technical options available, and indeed occasionally recommended, to sculptors working within the Catholic tradition, options which would have been deemed inappropriate elsewhere in Europe at that time. Later eighteenth-century sculptors went on to co-opt certain elements from these elaborate tableaux, however, distilling from them a new vocabulary better suited to secular needs.

As we have shown, monitoring the three-dimensional body from Michelangelo to Bernini is also to follow a series of changing religious attitudes towards bodily representation. Anatomical investigation facilitated greater accuracy in the representation of external appearances, which in turn fostered a process of pious contemplation. Attention to the composite nature of the body served to sustain its central role in acts of Christian devotion that placed an emphasis on stimulating the emotional empathy of the beholder. We have seen how the multi-figure terracotta groups produced by Niccolò dell'Arca (see FIG. 42) gain their expressive power not merely through realistic representation of the body, but also by allowing the separate components to be arranged in a variety of configurations. Bernini's use of the *bel composto* extended this notion further still, prompting the contemporary observer imaginatively to combine the individual elements into a unified whole. In the chapter which follows we will consider how some of these "theatrical" strategies were employed to powerful effect in the service of funerary sculpture.

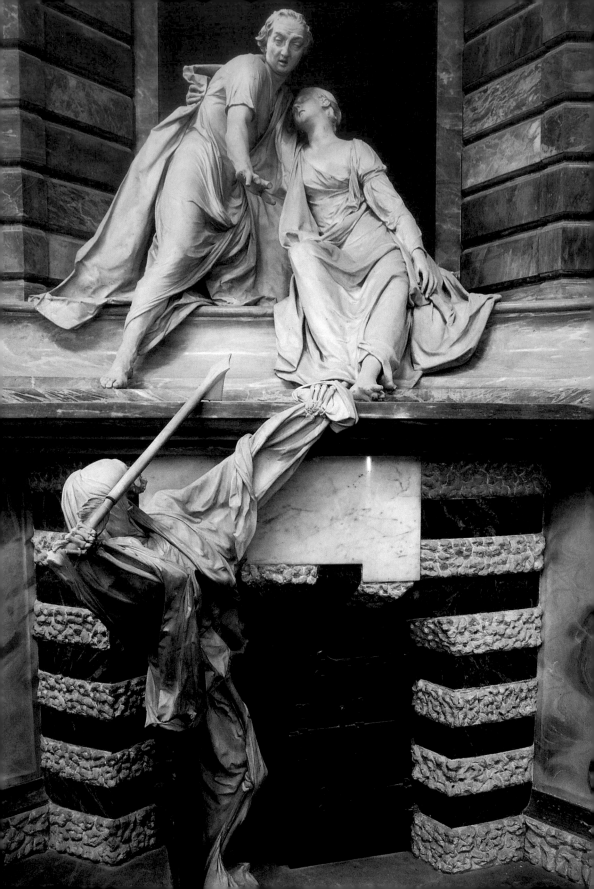

FOUR

The Sublime Body: The Eighteenth Century

The lingering influence of Bernini and the Roman Baroque of the seventeenth century gave rise to an increasing internationalism in sculpture during the first half of the eighteenth century. This can be detected in the genre of funerary monuments produced in France and England during the middle of the eighteenth century, most noticeably in the work of French sculptors such as Louis François Roubiliac (c. 1705–62), Michel-Ange Slodtz (1705–64), and Jean-Baptiste Pigalle (1714–85).

Roubiliac settled in England in 1730 where he soon gained a reputation for his lively portraiture. His first commission was a statue of the composer George Frederick Handel, erected in London's Vauxhall Pleasure Gardens in 1738, which broke new ground in its intimate, informal approach to portrait sculpture, but he also became one of the most able and innovative practitioners of funerary sculpture. Westminster Abbey was the most prestigious location in which a sculptor's commemorative work could be seen and Roubiliac's Abbey monuments are particularly worthy of note for their often dramatic intervention into the space of the beholder. The first thing that strikes us about the commemorative monuments of the immediate post-Reformation period is their often extraordinary size. The dimensions of the funerary monument gradually came to be regarded as an index of the social status of the person commemorated.

If Legros's debt to Bernini resided in the melancholic evocation of religious piety, Roubiliac's can be located in his attempts to venture beyond the traditional parameters within which the

Monument to Maréchal de
Saxe, 1753–6 (detail).
Marble. Saint-Thomas,
Strasbourg.

Maréchal de Saxe was a
brilliant soldier whose
death in 1750 was the
cause of national grief.
Much of the work's psycho-
logical impact stems from
the maréchal's fearless
confrontation with the
figure of Death emerging
at lower right.

three-dimensional body had been represented in funerary mon-
uments. By the time he visited Rome in 1752, Roubiliac had already
undertaken a number of tomb commissions for Westminster Abbey,
but encountering Bernini's works for the first time had a profound
effect on the Frenchman, who was reported to have enthused over
their "captivating and luxuriant splendour."

Although the funerary monuments executed by Roubiliac
after the European tour of 1752 betray a long-distance debt to
Bernini – and particularly to his monument to Alexander VII in
St. Peter's – they also reveal the more immediate influence of
contemporary French sculpture. Working plans and early versions
of the 1753 monument to Languet de Gergy by Michel-Ange Slodtz
in the church of Sainte-Sulpice in Paris and Jean-Baptiste Pigalle's
monument to Louis XV's general, Maréchal de Saxe, in Strasbourg
(FIG. 60) – one of the century's most influential monuments – may

have provided Roubiliac with the inspiration for his monuments to Major General William Hargrave and to Joseph Gascoigne and his wife Lady Elizabeth Nightingale (FIG. 59) in Westminster Abbey, both of which post-date his continental tour.

The Nightingale monument, commissioned in 1758 and erected in 1761, dramatizes an encounter between the couple, represented as living persons, and the ghastly skeleton of Death emerging from the sepulchre to claim its victims. Although Roubiliac might have drawn on Slodtz's monument to Languet de Gergy for the figure of Death, it may also have been inspired by a dream recalled by Lady Nightingale's brother-in-law in which, a friend related, he envisioned Death in the guise of a skeleton who "stood at the bed's foot, and, after standing a while, untucked the bedclothes … and lay between him and his Lady." Although viewed by nineteenth-century critics as excessively macabre, the Nightingale tomb nevertheless exerted a powerful emotional impact on eighteenth-century viewers who regarded it as "inimitable," "beyond praise," and "the finest piece of sculpture in the Abbey." The Nightingale tomb draws attention to sculpture's propensity to trigger an empathetic response by encroaching directly into the same floor space as that occupied by the viewer. This serves to break down the sense of distance which separates a work of art from the real world of the beholder and in so doing draws attention to the precarious status of sculpture as both artificial object and seemingly "real" body, "as brutal and positive as nature herself," as Baudelaire later described it.

Falconet: The Triumph of the Moderns

In funerary sculpture the drama which unfolds aims to concentrate the mind of the viewer on the plight of the deceased through attention to the body, but similar mechanisms of almost involuntary involvement were also deployed in mythological subjects. The marble *Milo of Croton* (FIG. 61) by Roubiliac's near contemporary, the French sculptor and theorist Etienne-Maurice Falconet (1716–91), demonstrates Falconet's unconventional approach to his art and reveals his deeply felt belief in the primacy of the moderns over the ancients. This prompted Falconet to take a number of liberties in his treatment of the subject.

61. ETIENNE-MAURICE FALCONET
Milo of Croton, 1754. Marble. Louvre, Paris.

Milo was a sixth-century BC athlete who, trapped by the fingers while attempting to split a tree with a wedge, was devoured by wild beasts.

In other hands the ungainly disposition of bodies and manically jutting limbs might have dissipated the impact of the narrative. However, Falconet's insistence on an uncompromisingly personal treatment of the theme (Milo's head is a self-portrait of the artist) enabled him to concentrate the dramatic energy in a triangle formed between the lion's jaws, Milo's desperate scream, and the pathetically harnessed hand at its apex. In their concern with naturalism, Falconet's most significant achievements – particularly the *Milo* and the 1782 bronze equestrian statue of Peter the Great in St. Petersburg for the Empress Catherine II of Russia – foreshadow the Romanticism of the early decades of the nineteenth century.

Falconet's commitment to the superior ability of the moderns over the ancients – articulated most forcefully in his theoretical *Réflexions sur la sculpture* of 1761 – should be seen in the context of increasing contemporary fascination with the art of antiquity. Artists, scientists, philosophers, and other protagonists in the European-wide cultural phenomenon known as the Enlightenment espoused the power of reason and the perfectibility of men and women as the keys to human progress. Henceforth, rigorous rationalism would be opposed to superstition, morality to frivolity, stoicism to hedonism. Within the framework of this philosophy, the ancient world was seen to offer an alternative to the dexterous, illusionistic mechanisms of the Baroque and the licentious excesses of the Rococo that had characterized the tastes and inclinations of the French *ancien régime*. If the Rococo encapsulated the dainty, epicurean, private world of perfumed frippery typified by the delicate porcelain figurines of the Sèvres and Meissen factories and the idyllic *fêtes champêtres* painted by Boucher and Fragonard, Neo-classicism embraced the grave, ascetic, public realm of Greco-Roman virtue captured in the dramatic etchings of ancient ruins by the Italian artist Giovanni Battista Piranesi (1720–78) and the didactic history paintings of Jacques-Louis David (1748–1825).

Noble Simplicity: Antiquity Revived

A series of major cultural developments in the mid-eighteenth century accelerated the spread of interest in antiquity and helped foster its adoption as a model of purity, simplicity, and virtue worthy of emulation by the modern world. The discovery of the ancient cities of Herculaneum in 1738 and Pompeii in 1748 was followed in 1762 by the publication of the first volume of *The Antiquities of Athens* by the British architects and travellers James

"Athenian" Stuart and Nicholas Revett, which helped disseminate knowledge of the architecture and monuments of antiquity. While this work was to have considerable importance in stimulating the Greek Revival which gathered particular impetus during the early nineteenth century, still more momentous was the publication in 1764 of *The History of the Art of the Ancients* by Winckelmann (FIG. 62). This publication, subsequently credited with having laid the foundations for the modern discipline of art history, was pivotal in the development of Neo-classical theory. It was in this work that Winckelmann expounded his doctrine of ancient sculpture, first outlined in an essay of 1755, in which he spoke of "noble simplicity" and "calm grandeur" as the guiding principles through which the Greeks had risen to the pinnacle of artistic supremacy.

62. ANTON VON MARON
Portrait of Winckelmann, 1768. Oil on canvas, 53½ x 39" (136 x 99 cm). Schlossmuseum, Weimar.

The eighteenth-century German antiquarian and archaeologist Johann Joachim Winckelmann (1717–68) is commonly regarded as the father of modern art history. His *History of Ancient Art* of 1764 conceived the sculpture of ancient Greece in terms of an underlying cycle of rise and decline. His belief that this cycle could be detected through an analysis of style remained a central tenet of art history into the twentieth century.

Throughout most of the eighteenth century the sculpture of antiquity represented a precarious body of knowledge, the objects of study constituting, for the most part, copies or casts of a limited number of works whose authenticity, age, and provenance were still a matter of serious antiquarian dispute. Today, in the light of knowledge distilled from subsequent archaeological discoveries, we can bring a more incisive critique to bear on Winckelmann's contribution to Enlightenment aesthetics than that available to his contemporaries. Because of its roots in his subjective appraisal of a limited range of sculptures, Winckelmann's *History* emerges as a severely circumscribed account of the sculpture of antiquity, often mistaking Roman copies for Greek originals and unable to confront the extent to which the ancients might have painted their statues. His often ecstatic rhetorical responses to the uncoloured white marbles to which he gained access in Italy (Winckelmann never visited Greece) seem to have been predominantly informed by a homoerotic longing for an imagined golden age of ideal male beauty and male same-sex desire, itself subject to strict prohibition within the culture in which he moved.

Something of the complexity of Winckelmann's aesthetic vision can be sensed with reference to the *Laocoön* (see FIG. 47), the object he elected as embodying the essence of "noble simplicity"

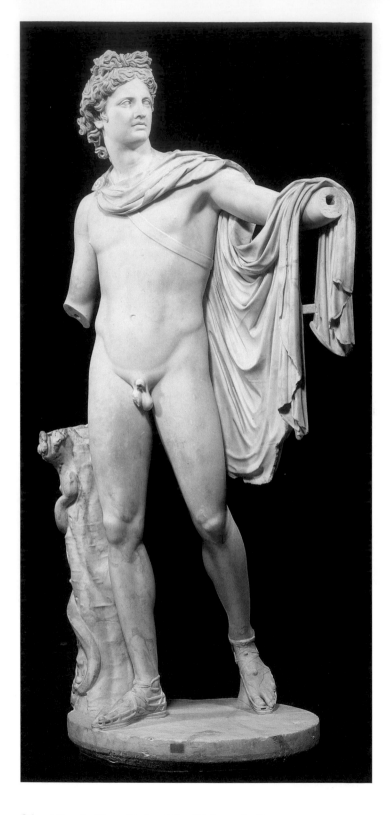

63. *Apollo Belvedere*, Roman copy of a late fourth-century BC Greek bronze. Marble, height 7′4″ (2.24 m). Vatican Museum, Rome.

The *Apollo Belvedere*, a roman marble copy of a classical or Hellenistic Greek bronze original, was discovered at the end of the fifteenth century. During the eighteenth century it came to be regarded by Winckelmann and others as the pinnacle of Greek art, subsequently influencing the development of Neo-classicism.

and "calm grandeur." A modern sensibility may rightly ask how such an idea could legitimately be applied to an image of such apparent physical turmoil but, as the art historian Alex Potts has suggested, the state of calm which we associate with the Greek ideal in Winckelmann's mature writing is also a state of suspended terror. Unlike Bernini's *Ecstasy of St. Teresa*, represented at the moment in which bodily pain transmutes into the ecstatic calm of spiritual enlightenment, the *Laocoön* in Winckelmann's analysis diplays a series of bodily signs expressive of the moment at which extreme pain and attempts to resist it reach a state of mutual cancellation.

Of all the classical statues inviting enthusiastic encomiums from eighteenth-century antiquarians and historians it is perhaps the *Apollo Belvedere* (FIG. 63) which best encapsulates the ambivalent presence of eroticism and heroic male beauty that assumed such a constant if subliminal presence in Neo-classical aesthetics in the late eighteenth century. "This celestial mixture of accessibility and severity, benevolence and gravity, majesty and mildness" was how the German poet and historian Schiller summed up its subtly conflicting attributes, while for Winckelmann, "an eternal springtime, as if in blissful Elysium, clothes the charming manliness of maturity with graceful youthfulness, and plays with soft tenderness on the proud build of his limbs." The apparent contradiction implicit in such language – accessibility and severity, benevolence and gravity, maturity and youthfulness – was to prove particularly useful as the abstract principles of Neo-classical aesthetics were gradually co-opted for political ends. The pure, uncorrupted body of antiquity could stand as a symbol of the unblemished body politic to which the modern citizen aspired.

Collecting the Past

While the surviving material culture of antiquity provided artists and theorists with the raw materials on which to draw in their promotion of a contemporary strain of classicism appropriate to modern artistic, social, and political needs, it also offered an opportunity for collectors and aesthetes to display their cultural sophistication. The collecting of marble statuary and ancient fragments was first established in Italy during the Renaissance but was adopted by English aristocrats such as Thomas Howard, Earl of Arundel, in the seventeenth century. It became particularly fashionable, however, during the eighteenth century as an important element of the Grand Tour, those obligatory peregrinations around Italy undertaken by enlightened aristocratic gentlemen and

64. JOHAN ZOFFANY
Charles Townley's Library, 1783–93. Oil on canvas, 50 x 39" (127 x 99 cm). Townley Hall Art Gallery and Museums, Burnley.

Zoffany's painting is a fictitious arrangement of the collection, for the objects, many painted out of scale, were never all present in one room. Townley is seated on the right, while at the desk in the centre is Pierre François Hugues, a notorious freeloader who published some of the collection on Townley's behalf. Behind him stand the Hon. Charles Greville (nephew of the collector and patron Sir William Hamilton) and the palaeographer Thomas Astle. The *Discus Thrower* in the foreground was only added to the picture when acquired ten years later.

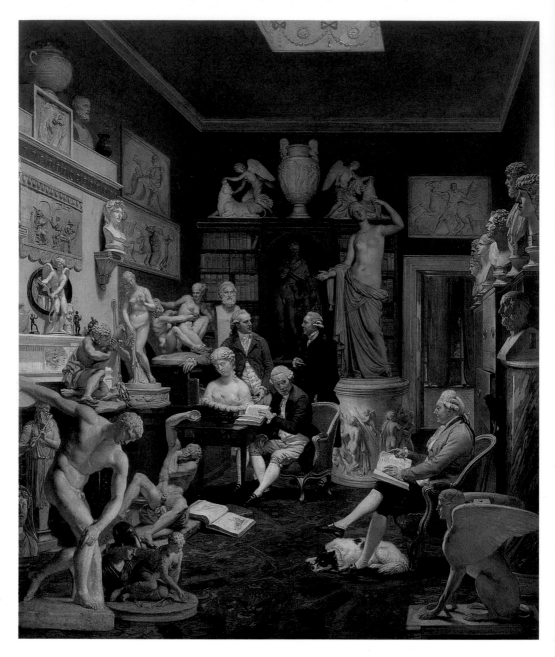

ladies concerned to further their education, refine their taste, and expand their social circle.

Some of the collections put together in the second half of the eighteenth century resulted from long and concerted projects of acquisition, such as that formed between 1768 and the early 1790s by Charles Townley (a descendant of the Earl of Arundel) at his house in London (FIG. 64). In assembling his collection, Townley drew on the advice of the English sculptor Joseph Banks who, according to fellow sculptor John Flaxman, had "formed his taste on the antique and introduced a purer style of art." Objects were acquired both through direct acquisition while on tour or by order through contact with agents in Rome, some of whom, such as Gavin Hamilton and Robert Fagan, were also excavators of ancient works of art.

This was a period in which antique statuary, and particularly the Roman fragment, came to exert an almost mystical power over artists and antiquarians. As a comment on the power of sheer scale to induce a sense of awe in the beholder, the small study by the anglicized Swiss painter Henry Fuseli (1741–1825), *The Artist Moved by the Grandeur of Antique Fragments* (FIG. 65), amounts to a visual manifesto of the Sublime, a branch of that influential aesthetic theory variously propounded by the British Whig politician Edmund Burke in 1756 and the German philosopher Immanuel Kant in 1764. The sublime grandeur, in Fuseli's treatment, derives not from the fragments themselves, but rather from what they suggest of that which is lacking – the surviving components of the Colossus of Constantine (see FIG. 27) – forcing an imaginative contemplation of the awesome plenitude of the now lost, complete body.

Occasionally, aspects of the true but "lost" nature of the ancient world remained subject to scholarly neglect or were marginalized within developing theories of the ancient world, either because there was insufficient evidence to supply a fuller understanding of their implications, or because those implications were deemed inappropriate for incorporation into modern usage.

65. HENRY FUSELI
The Artist Moved by the Grandeur of Ancient Fragments, 1778–79. Red chalk and sepia wash, 42 x 35.2 cm (16½ x 13¾"). Kunsthaus, Zurich.

Surviving fragments of antique sculpture exerted a powerful influence on the eighteenth-century imagination, offering a tantalising glimpse of the unassailable achievements of the ancients. Fuseli's artist sits, physically and spiritually overwhelmed, at the foot of the Colossus of Constantine.

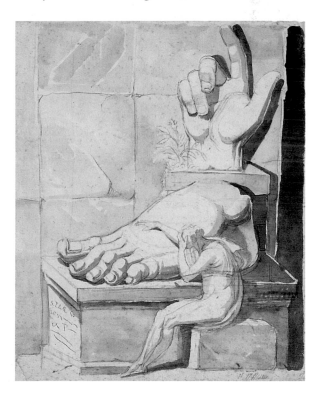

66. ANTONIO CANOVA
Pauline Borghese as Venus Victorious, 1808. Marble, length 6'7" (2 m). Borghese Gallery, Rome.

Pauline Bonaparte Borghese, the Emperor's sister, liked to show her statue to close friends and family by night under torchlight, the flickering flames no doubt adding a "Gothic" ambience and subtle animation to the otherwise inanimate marble. A contemporary figure portrayed in such a revealing pose would have been scandalous in public.

The inherently abstract nature of classical statuary offered the eighteenth century an ideal template through which to mobilize ideas of civic virtue and high moral purpose, particularly in France, where a nascent Republicanism required a heroic model of the ancient world in which notions of purity and restraint were the most important attributes. In this respect the Neo-classical body can be seen to operate as a mirror of the body politic, as a cipher for a deeper set of social concerns, its uninterrupted surface seeming to provide visual confirmation of its structural integrity. This symbolic function was if anything reinforced by the burgeoning popularity in the eighteenth and early nineteenth centuries of "low" forms of public entertainment such as dolls, fairground dummies, automata, and waxwork exhibitions whose counterfeit, carnivalesque treatments of the body aroused the suspicion of academic art theorists and other arbiters of elevated taste.

Illumination and Enlightenment

If the Neo-classical "ideal" body provided an abstract trigger to intellectual improvement, in which the absence of specificity could be completed by imaginative contemplation, it was not a process without its own occasional element of illusionistic "play." The pre-eminent practitioner of Neo-classical sculpture during the late eighteenth and early nineteenth centuries, the Venetian Antonio Canova (1757–1822), recommended viewing his sculptures at night when a procession through the darkened gallery by torchlight would subject the works to the animating flicker of a shifting flame. One can imagine the potential effect that this romantic illumination might have imparted to a work such as *Pauline Borghese as Venus Victorious* (FIG. 66), commissioned from Canova by the subject herself.

Such nocturnal *divertissements* may be read as a means by which the aesthetic rules governing the production and reception of the uncoloured white marble body could be stretched – invariably under strictly private circumstances – to enhance its affective potential. Despite the mounting evidence that the ancients had painted their statues and mixed their materials, the colouring of sculpture remained a taboo subject in academic circles until well into the nineteenth century. Evidence of its marginal status can be detected in a variety of contexts.

When Jacques-Louis David was executing his history painting *The Lictors Returning to Brutus the Bodies of his Sons* (FIG. 67), he inserted on the left side of the canvas a statue of a seated female, personifying Rome. As a compositional device, the statue

functions to reinforce a set of thematic contrasts activated through the metaphorical manipulation of light and dark, its location within the darkened left side of the canvas placing it in the same conceptual space as that occupied by Brutus, the contiguity of the two figures underlined by their seated positions. Hence Brutus is rendered half in shadow and half in light – drawn between a public, political imperative and the private realm of the family – while the statue, a symbol of the impassive authority of the state, adumbrates that higher principle to which all citizens must pay allegiance and which is the original cause of the drama that has unfolded. The demands of the Republic have, quite literally, come between Brutus and his sons.

67. JACQUES-LOUIS DAVID
The Lictors Returning to Brutus the Bodies of his Sons, 1789 (detail). Oil on canvas, 10′7″ x 13′10″ (3.23 x 4.22 m). Louvre, Paris.

One of the seminal images of the French Revolution, this painting relates the story of the Roman consul whose loyalty to the republic demanded that, on discovering his sons involvement in a conspiracy against Roman liberty, he condemn them to death. David's awareness of the ancient practice of colouring sculpture allowed him to insert a polychrome statue of Roma, the city's deity, into the shadows behind Brutus.

68. Antoine Chrysostôme Quatremère de Quincy
Reconstruction of the interior of the Temple of Zeus at Olympia, frontispiece to *Le Jupiter Olympien*, 1815.

Quatremère de Quincy's *Jupiter Olympien* helped consolidate the already established model of the seated chryselephantine Jupiter, or Zeus, during the early nineteenth century. It was a common theme in the paintings of Ingres, Delaroche, and others and became a stock pose in public statuary.

David's source for the statue of *Roma* was likely to have been Montfaucon's *L'Antiquité expliqué*, the most extensive compendium of antiquities assembled during the first half of the eighteenth century, appearing in two instalments between 1719 and 1724. Within the context of the Salon of 1789, where the *Brutus* was first exhibited, the iconographic significance of the statue would have underscored the painting's political charge, but one detail which is seldom mentioned in discussions of the image – perhaps partly on account of it being in deep shadow – is the fact that David has dimly, but definitely, rendered the statue as a work of polychrome or mixed media sculpture.

Quatremère de Quincy: Polychromy Reassessed

In 1789 the question of colouring sculpture was still largely undefined in theoretical terms and did not become subject to critical debate until the early decades of the nineteenth century, when sculptors began to embark upon tentative experiments and when critical discourses began to proliferate around the objects produced.

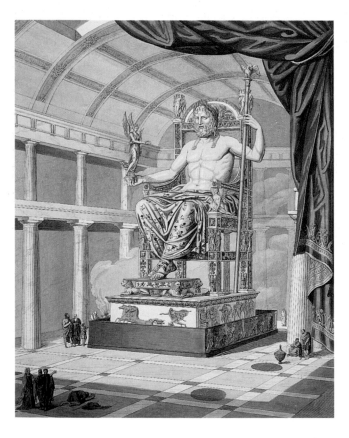

One of the first artists and theorists to begin a concerted programme into discovering the extent to which the ancients had engaged in polychrome or mixed media sculpture was David's friend, archaeologist, and later the perpetual secretary of the Académie des Beaux-Arts, Antoine Chrysostôme Quatremère de Quincy (1755–1843). Quatremère's scholarly inquiry into the nature of the chryselephantine, or gold and ivory, sculpture of antiquity, published in a magisterial folio volume in 1815 entitled *Le Jupiter Olympien* (FIG. 68), represented one of the most radical revisions of ancient sculpture yet undertaken. Not only did the *Jupiter* effectively establish the foundation for a series of far-reaching debates into the subject of polychromy which rumbled on through the ensuing decades of

the century, it also stimulated a range of practical excursions into coloured and mixed media sculpture that continued to generate controversy until well into the 1890s.

The figure of Jupiter enthroned, inspired by the chryselephantine statue of Zeus at Olympia by Phidias, whose putative appearance was disseminated through compendiums of antiquities throughout the eighteenth century, functioned as part of the common currency of Neo-classicism. During the early nineteenth century it provided artists with a prototype for communicating the majesty of imperial power – as in Ingres's *Napoleon on the Imperial Throne* of 1806 (Musée de l'Armée, Palais des Invalides, Paris) – but its political function was not confined to a European context. Recognized by American statesmen as an appropriate vehicle for the carriage of republican ideals, the grammar of Neo-classicism had been adopted as the official style of the new American republic from the early 1780s, when the Frenchman Jean-Antoine Houdon (1741–1828) executed portraits of heroes such as the French soldier and nobleman Lafayette, who had fought against Britain in the American War of Independence of 1775–83, and later of George Washington.

69. HORATIO GREENOUGH *George Washington*, 1832–41. Marble, height 10'6" (3.20 m). National Museum of American History, Washington, D.C.

Greenough's statue borrows antique and modern motifs to glorify America's first president, combining the seated posture of Pheidias's *Zeus* at Olympia with Washington's own contemporary hairstyle.

Neo-classicism in the United States

It was not until the early nineteenth century that there appeared an American sculptor capable of rivalling the major European exponents of the style. The Boston-born Horatio Greenough (1805–52) underwent the traditional baptism to which most European students of sculpture aspired by visiting Rome in 1825 – where he met the great Danish practitioner of Neo-classicism Bertel Thorwaldsen – before settling in Florence. Greenough's most memorable commission, the marble *George Washington* (FIG. 69), draws directly on the ancient Pheidian colossus as refracted through Quatremère, Ingres, and the many other contemporary reconstructions, casting the first

American president as a muscular Zeus with contemporary coiffure. Greenough's somewhat awkward conflation of antique and modern motifs contrasted unfavourably with Houdon's more approachable hero and points up the problems faced by sculptors in dressing contemporary public figures in the garb of antiquity.

This is not to suggest, however, that Neo-classicism did not find its successful exponents in the United States. The marble figure known as *The Greek Slave* (FIG. 70) by Greenough's contemporary countryman and fellow Florence resident, Hiram Powers (1805–73), ranks alongside Canova's *Three Graces* or John Gibson's *Tinted Venus* as one of the most familiar and influential Neo-classical statues of the nineteenth century. Its widespread success – it was one of the sensations of the 1851 Great Exhibition in London – can be attributed to its timely subject matter, managing on an abstract level to evoke a range of contemporary political and social issues from the reverberations of the Greek War of Independence (1821–29) to the abolition of slavery movement in America. It would be disingenuous, however, not to acknowledge the possible recognition by a nineteenth-century male audience of a certain erotic charge, for notwithstanding Powers's avowed Christian sentiments, *The Greek Slave* also anticipates some of the more salacious visions formulated by later nineteenth-century artists such as Jean-Léon Gérôme and others, which contributed to the generic construction of an imaginary, exotic "Orient." The success of Powers's statue can be said to derive from its managing to hold such contradictory values in fruitful tension.

70. HIRAM POWERS
The Greek Slave, after original plaster of 1843. Marble, height 5′5½″ (1.66 m). Yale University Art Gallery, New Haven.

This was one of the most popular sculptures of its time. Following its appearance at the London Great Exhibition of 1851 it was exhibited in America where male and female audiences were segregated.

An Unsuitable Job for a Woman

One of the most productive developments in art historical research in recent years has been the process of revision aimed at adjusting the apparently exclusively male-dominated profile of the profession of sculptor in the nineteenth century. The late American art historian Eleanor Tufts, for example, offered a significant corrective to this gender imbalance in 1992 by unearthing evidence of the resistance encountered by American women sculptors such as Anne Whitney (1821–1915) and Vinnie Ream Hoxie (1847–1914) during the 1870s and 1880s.

Hoxie's statue of *Abraham Lincoln* (FIG. 71) was the first government commission ever given to a woman sculptor but, despite

being the winning entry in the competition, was not granted without controversy, for prevailing attitudes deemed it unacceptable for a woman to sculpt male anatomy. "The woman question," as it became known, arose again five years later when Anne Whitney anonymously submitted an entry into a competition for a monument to the late Senator Charles Sumner of Massachusetts. On discovering that the winning design had been entered by a woman, the committee of twelve Boston men paid Whitney off with the prize money of $500 but passed her over for the work in favour of the sculptor Thomas Ball. However, twenty-five years after its rejection, Cambridge patrons sponsored an over-life-size bronze cast of Whitney's statue for Harvard Square, where it resides to this day.

American opposition to Whitney and Hoxie's interventions into a largely male-dominated sphere of artistic activity has its roots in attitudes to public sculpture incubated in France during the late eighteenth

71. VINNIE REAM HOXIE
Abraham Lincoln, 1870. Marble, height 6'11" (2.1 m). United States Capitol Art Collection, Washington, D.C.

Women sculptors faced obstructive opposition from the conservative establishment during the nineteenth century, despite sometimes winning anonymous competitions for projects. Hoxie's *Lincoln* met with just such chauvinism. "Think of a woman bringing her mind to bear on the legs of a man – even if those legs were inside a pair of stone trowsers!" said the New York *Evening Post* in 1879, poking fun at the critics.

72. Pierre-Jean David d'Angers
Le Grand Condé, 1827. Bronze.
Louvre, Paris.

The French military hero of the 1644
Battle of Freiberg is shown at the moment
when he hurls his baton into the trenches
of the Bavarian troops before leading his
men to victory.

and early nineteenth centuries – the original source of American Neo-classicism. Although presented as a disquiet over women representing male anatomy, the resistance should also be interpreted as expressing a more deep-seated objection to the entry of women into the higher affairs of state. As has been demonstrated, sculpture was understood in France during the early 1800s as "a sign of the beliefs, ambitions, and accomplishments of men," the sculpted male body thereby coming to signify a range of ideas above and beyond the specific attributes of the figure represented. The proliferation of public sculpture during the early nineteenth century – *statuomanie* as it has been called – reflects the self-image of the state in all its diversity and mutability, albeit invariably filtered through the authoritarian strictures and sanctions levied on individual projects by the government and by the Académie, the official institution for the formal teaching of fine art.

Monuments and Men: The Body in Public

Among the most conspicuous public sculpture projects executed in France during the first quarter of the nineteenth century, and one which exemplifies the role of public statuary in the construction and sustenance of national historical identity, was the proposed erection on Paris's Pont Louis XVI (today's Place de la Concorde) of a series of statues commemorating great heroes of the state. The original plan had emerged during the First Empire when it had been proposed to honour military figures who had perished in imperial campaigns, but in 1815 on the Restoration of the Bourbon monarchy under Louis XVIII, these proposals were replaced by a counter-revolutionary theme glorifying historical figures loyal to the Bourbon dynasty. Thus was established what was to become a recurrent trend in nineteenth-century French public sculpture – the manipulation of public monuments to serve political ends – a trend as erratic, contradictory, and transient as the political landscape itself.

Such prestigious public commissions could make or break the reputation of a young sculptor. Among the artists chosen to execute statues for the Pont Louis XVI was Pierre-Jean David d'Angers (1788–1856), whose republican sentiments were momentarily held in abeyance for the duration of the Restoration. David's contribution was a statue of the seventeenth-century general known as the *Grand Condé* (FIG. 72), a work surviving only through a half-size plaster version. The almost Baroque treatment of the pose and fastidious rendering of historical costume represented an innovative departure from prevailing tastes and established the figure

73. ANTOINE-LOUIS BARYE *Lion Crushing a Serpent*, 1833. Bronze, length 5'10" (1.78 m). Louvre, Paris.

A key work of France's July Monarchy (1830–48), Barye's group is an allegorical celebration of the July Revolution, in which the French people finally overturned the Bourbon dynasty. It reveals Barye's abiding interest in scientific naturalism, engendered by many visits to the Parisian zoo known as the Jardin des Plantes.

as something of a Romantic prototype, although David's own artistic sentiments elsewhere remained firmly classicizing. In managing to evoke a universal idea which transcends its apparent specificity of historical place and time, it achieved a powerful and lasting resonance.

Political bodies were not always human bodies. The sculptor Antoine-Louis Barye (1796–1875), the most celebrated animal sculptor of the nineteenth century, thanks to days spent sketching the animals at the great Parisian zoo, the Jardin des Plantes, turned his acute understanding of animal anatomy to deft political ends. His *Lion Crushing a Serpent* (FIG. 73) neatly metaphorizes the outcome of the July Revolution of 1830 in which the reptilian legacy of the Bourbon dynasty was finally crushed by the might of the people. The work impressed visitors to the Salon of 1833 and duly won Barye the Légion d'Honneur for his efforts.

Sculpture was deployed not only to articulate the dominant political ideology of the ruling regime; it could also be used to express dissent against the prevailing structures of power and even occasionally to lament the passing of empire. The Dijon-born sculptor François Rude (1784–1855) won the Prix de Rome in 1812, the year after David d'Angers, and, like the Revolutionary painter Jacques-Louis David, spent the years of Bourbon rule in self-imposed exile in Brussels. Ever a staunch supporter of Napoleon, Rude eventually became disillusioned with the July Monarchy of Louis-Philippe, during which the remains of Napoleon were returned to France for interment in the Palais des Invalides. This event served to galvanize those hoping to solidify support for Louis-Napoleon's bid for power and gave rise to Rude's most haunting work of this period – the monumental bronze *Napoleon Awakening to Immortality* (FIG. 74) – a private commission from his friend Claude Noisot.

Noisot had been a loyal officer and later close associate of Napoleon, having accompanied him to Elba. His collaboration with Rude – Noisot financed the work and provided the site on his private estate at Fixin, while Rude worked without a fee

74. FRANÇOIS RUDE
Napoleon Awakening to Immortality, 1845–7.
Bronze, length 8′3″ (2.51 m).
Parc Noisot, Fixin, Dijon.

Although best known for his *Departure of the Volunteers* of 1833–6 on the Arc de Triomphe in Paris, Rude was also capable of more elegiac themes such as the private monument to his revered Napoleon for the Parc Noisot. The composition has affinities with Etruscan painted terracotta sarcophagi of the Classical period.

– became a virtual shrine to the Emperor and an emotional rallying point for supporters of Louis-Napoleon, then biding his time in London. As Napoleon peels back the shroud, his body seems to levitate clear of its terrestrial moorings, at once both a glorious apotheosis and a macabre resurrection, the wings of the imperial eagle now reduced to decomposing carrion below.

This was a fitting epitaph to a man who understood only too well the power of the public monument to stir the emotions of the people. The Vendôme Column in Paris (FIG. 75) offers an exemplary instance of the susceptibility of the public monument to the winds of political change that swept through France during the nineteenth century. The column – Napoleon's own domestic version of Trajan's ancient Roman monument – was raised in 1810 to celebrate the victory of the imperial army over the combined forces of Russia and Austria at Austerlitz. However, when the Bourbon monarchy resumed power in 1815, Chaudet's statue of Napoleon was replaced with the white flag of the Bourbon dynasty, only to be itself removed by the exiled emperor on his return from Elba. Napoleon's subsequent defeat at

75. The Vendôme Column, topped by the statue of Napoleon by Dumont after Chaudet, 1862–3. Paris.

The column became a barometer of political agitation throughout the nineteenth century. To the revolutionary Communards of 1871 it was a repellent symbol of monarchy and empire, its destruction the symbolic revenge of the people on a reviled body politic.

76. *The Fall of the Column in the Place Vendôme*, May 1871. Wood engraving.

Waterloo in turn precipitated the melting down of Chaudet's statue by the Bourbons for use in Lemot's equestrian statue of Henry IV on the Pont Neuf – again, as much an act of royal vengeance as of practical expediency. Matters did not end there, however, for right through the Second Empire and beyond the column continued to function as the prime site through which both sides of the ideological divide could exact vicarious political vengeance. The replaced statue of Napoleon by Seurre, installed by Louis-Philippe's administration in 1831, was itself substituted following Emperor Louis-Napoleon's *coup d'état* for a new replica of Chaudet's original, before the entire column was felled by the members of the Commune in 1871 (FIG. 76). In an act of what might seem like extraordinary recklessness given its chequered past, it was rebuilt by the Third Republic in 1873, complete with Bonaparte after Chaudet, thus closing a turbulent cycle of political strife. We need only turn to our own immediate history (FIG. 77) for a reminder of how the body continues to fall prey to the muscular forces of political circumstance.

77. A dismantled statue of Lenin in Vilnius, Lithuania, 23 August, 1991.

With the demise of Communism in the Eastern Bloc from 1989 onwards, the people expressed their latent resentment with the old regime by destroying its remaining political monuments. Paradoxically, the embalmed body of Lenin, lying in state in Moscow, has survived such vicissitudes and remains the focus of pious reverence.

This chapter has travelled from the Baroque rhetoric of Bernini, inherited and adapted by Roubiliac and other European sculptors, to the restrained grammar of Neo-classicism issuing from a revival of interest in antiquity, which became the dominant style of the late eighteenth and early nineteenth centuries. The promotion of the "ideal" body so central to Neo-classical aesthetics and so strictly monitored by the European state-controlled academics was continually susceptible to challenge, however. Just as the academy had sought to foster a theoretical, rule-based system of art education emphasizing the intellectual component of art making, so those same principles eventually served to bring about its demise as artists began to rebel against its suffocating strictures and limiting formulae. As the nineteenth century progressed, Romanticism began steadily to undermine the rational, universalizing precepts upon which Neo-classicism had been based, replacing them with a more individual, subjective response to nature in which the expressive powers of the imagination were given freer rein. The next chapter sets out to map some of these changes in attitude as they affected the representation of the body during the nineteenth century.

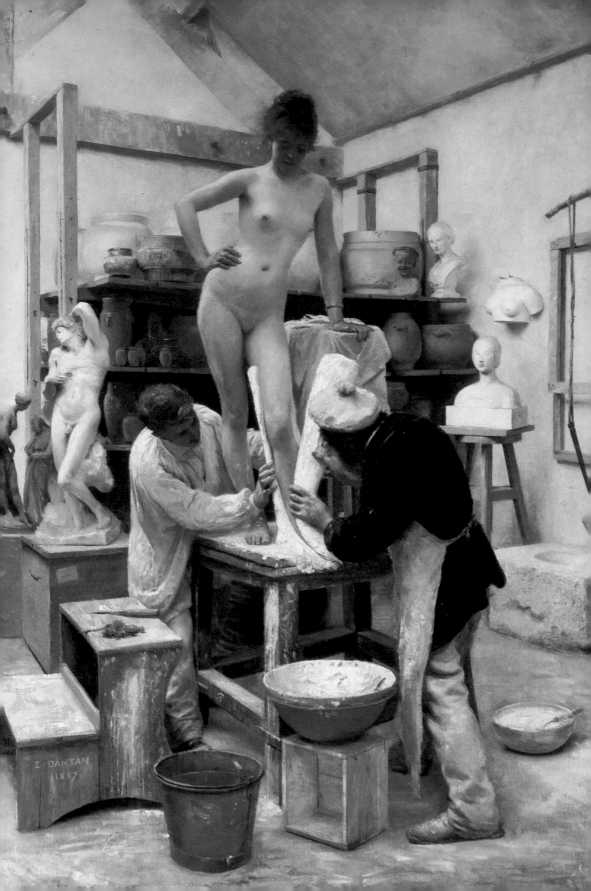

The Body in Colour: The Nineteenth Century

I often smile at the extravagance of the sculptor Donatello,
when he gave the finishing stroke of his chisel to the celebrated
Zuccone [Habakkuk], and apostrophizing the bloodless, sight-
less effigy, exclaimed, in frantic egotism, "Speak!"

T he "frantic egotism" to which the nineteenth-century
British writer Thomas Colley Grattan refers in relating
Vasari's anecdote about Donatello turns out to be a more
pertinent way of describing the psychological investment of sculp-
tors in their work than perhaps Grattan himself realized. It defines
a recurrent theme in writings about sculpture which extends from
Ovid's ancient legend of Pygmalion – who falls in love with his
own statue which then comes to life – to the numerous Pygmalion-
inspired painted and sculpted self-portraits produced by the French
artist Jean-Léon Gérôme in the 1890s (see FIG. 4).

If the naturalism which Donatello achieved in the eyes of
his contemporaries became a benchmark of excellence during
the Renaissance – "To the marble he has given life, emotion, move-
ment," said Vasari, "what more can nature give, save speech?" –
for early nineteenth-century academics and critics such natural-
ism was acceptable only if contained within the boundaries of the
ideal as handed down from antiquity and taught in the academies.
However, although the broad legacy of Neo-classical theory endured

throughout the nineteenth century, its primacy began to weaken as new models of the body emerged with greater relevance to a rapidly changing, increasingly industrialized, increasingly commercialized world. Henceforward, the vestiges of the Enlightenment model of the body, inspired by antiquity, had to compete with alternative historical precedents supplied by the Middle Ages or the Italian Renaissance, or by contemporary treatments dictated by rapidly changing social and political forces.

Edouard Joseph Dantan's oil painting *A Casting from Life* (FIG. 78) seems to draw on the authority of the Renaissance tradition to legitimate the modern move towards naturalism. A sculptor and his assistant remove the plaster cast from the leg of a young nude model, a woman, while in the background can be glimpsed casts of two celebrated Renaissance works: Michelangelo's *Dying Slave* of 1513 and the *Portrait of a Woman* of 1472–74 by the Dalmatian sculptor Francesco Laurana (1430–1502), known to have worked from plaster casts and death masks and to have coloured his sculpture.

"The Warmth of Life": Colour and Controversy

It was around the contested parameters of naturalism that much nineteenth-century criticism of sculpture revolved, which explains why the myth of Pygmalion enjoyed a particular and enduring relevance throughout the century. Naturalism taken to extremes might indeed achieve the illusion of a living, breathing body – and be applauded by some for its dexterity in doing so – but elevated academic theory continued to dictate that such were not the true ends to which the sculptor should aspire. Instead of stimulating the mind of the beholder into pondering more elevated notions, such works, it was felt, all too often excited base bodily passions.

If the ancient world had provided the inspiration for the pure, uncoloured white marble body around which the various theories of Neo-classicism had been constructed, it was paradoxically that same ancient world which supplied the nineteenth century with its obverse – the painted, tinted, and mixed media sculpture revealed by the developing discipline of archaeology. The Parthenon sculptures, or Elgin marbles as they became known – acquired by the British Museum in 1816 – seemed, to a European tradition steeped in theories of the ideal body, to represent the paradigm of the High Classical sculpture produced by Pheidias and others in Periclean Athens in the fifth century BC. What made the Elgin marbles so successful in the eyes of the sculptor John

Flaxman (1755–1826) and other like-minded members of London's Royal Academy, was that such works stopped short of an exact representation of nature and thereby allowed room for imaginative contemplation.

Admiring the horses of the Elgin frieze, Flaxman observed that: "The horses appear to live and move, to roll their eyes, to gallop, prance and curvet; the veins of their faces and legs seem distended with circulation … we can scarcely suffer reason to persuade us they are not alive." That final persuasion was all-important, for a limb "distended with circulation" is a matter of form, with which sculpture is primarily concerned, rather than a matter of colour which, in academic theory, was the true realm of the painter. It would seem from Flaxman's reaction that the naturalism displayed in the horses through formal means was approaching the limits of acceptable representation; not quite overstepping them, but stretching them certainly.

Flaxman's admission that "we can scarcely suffer reason to persuade us they are not alive" anticipates the reaction of French critics to Jean-Baptiste Clésinger's (1814–83) *Woman Bitten by a Serpent* (FIG. 79), which proved a *succès de scandale* at the Paris Salon of 1847. Clésinger's all too real body is not the sort of object one might expect from an artist schooled, however briefly, under the arch Neo-classicist Thorwaldsen in Rome; indeed, its subtle tinting and uncompromising naturalism prompted some commentators towards the notion that it was transmogrifying into its model – Madame Sabatier, Clésinger's lover – before their very eyes. "One senses the blood of youth circulating beneath the pulsating skin and colouring the marble," said the critic Théophile

79. Jean-Baptiste Clésinger, *Woman Bitten by a Serpent*, 1847. Marble, length 31″ (78.7 cm). Louvre, Paris.

Clésinger's figure, which was a critical success at the Salon of 1847, coincided with a growing male bourgeois fear of female sexuality as the source of decadence and death. What made the *Woman Bitten by a Serpent* so provocative was its uncompromising naturalism and its lack of a clear historical or mythological source, making her seem like a modern woman languishing naked.

80. John Gibson, *Tinted Venus*, 1850. Tinted marble, height 5′8″ (1.5 m). Walker Art Gallery, Liverpool.

This statue was a pivotal contribution to the fierce debate about polychromy. Gibson aimed to show that a marble could be painted in the manner of the Greeks without distracting from the purity of the subject. Not everyone agreed. The figure has now lost almost all of its oiriginal subtle colouring.

Thoré: "If you dare place your hand on this white siren you will feel the warmth of life." Such reactions reveal the straight-foward erotic frisson which these works generated and which provided the grounds for much of the negative criticism they invited, another commentator, Gustave Planche, describing Clésinger's technique as being to statuary what the photograph is to painting: "M. Clésinger's work has not the character of a figure modelled, but of a figure cast."

By the time the *Woman Bitten by a Serpent* was unveiled, even those exemplary fragments of the ancient world, the Elgin marbles, had become subject to authoritative scrutiny to detect traces of pigment. Gradually the monochrome myth began to unravel, incontrovertible scientific and archaeological evidence pitting the champions of colour, led by the German architect–archaeologist Jacob Ignace Hittorff (1792–1867) – who wished to reveal the ancient world in all its dazzling polychromy – against the proponents of ideal, Neo-classical whiteness.

Paradoxically, as it turned out, it was those very exponents of text-book Neo-classicism who undertook some of the more radical experiments into coloured and mixed media sculpture around 1850, usually justifying their tentative interventions into this area as attempts to address the true nature of ancient practice. That staunch defender of the Neo-classical faith in France, Quatremère de Quincy, had re-opened the debate about the ancient gold and ivory mixed media technique with his *Jupiter Olympien* published in 1815 (see FIG. 68), while the English Neo-classical sculptor John Gibson (1790–1866) – who spent the majority of his career in Rome, where he studied under Canova – undertook one of the century's most celebrated excursions into the colouring of marbles when he produced the so-called *Tinted Venus* (FIG. 80) at the London International Exhibition of 1862.

This work revealed that even an otherwise well-behaved Neo-classicist could occasionally be seduced by the illusionistic effects that resulted from a little light polychromy; despite his own best efforts, Gibson entered into a Pygmalion-like transaction with the sculpted object. Having tinted the flesh "like warm ivory," in "a fashion unprecedented in modern times," he said to himself: "Here is a little nearer approach to life – it is therefore more impressive – yes – yes indeed she seems an ethereal being with her blue eyes fixed upon me! At moments I forgot that I was gazing at my own production; there I sat before her,

long and often. How was I ever to part with her?" Gibson's compatriots in Rome applauded his efforts but shrank from following his example, "lest we might not sell our works."

It is clear from Gibson's account that as far as the sculptors were concerned, it was the market, governed by the vagaries of contemporary taste, which militated against such innovations. Inevitably, Gibson's figure invited its share of invective, one critic seeing her as representing "a naked, impudent English woman … but in no respect a Venus." As one writer on coloured sculpture had noted in the 1840s: "Hitherto, no distinction has been drawn between the real and the ideal in this branch; a shiny painted figure, and a great wax doll with real silk or velvet, real lace and real glittering trinkets, are equally objectionable; but a sober, harmonious, well-balanced application of colour and metal to sculpture is likely to meet with a very different result."

Waxworks and Auto-icons

As this contemporary comment demonstrates, what troubled many nineteenth-century opponents of excessive naturalism in sculpture, and of polychromy in general, was the proximity of such works to the disturbingly realistic bodies constructed specifically for medical instruction (FIG. 81) or to the figures common in popular forms of entertainment such as waxwork displays, fairground automata, and dolls. Waxworks had been gaining in popularity since the mid-eighteenth century and by 1800 there were hundreds of such exhibitions in England, which continued to draw large audiences.

The design and manufacture of such products required a variety of skills, often including sculpting and modelling, thus adding to a range of practices which together served to erode the boundaries that hitherto had circumscribed the profession of sculptor. The wax figure, the toy, the automaton, and later the robot all belong within the realm of what Freud described as "the uncanny,"

81. Anatomical female figure with detachable front torso, eighteenth century. Beeswax, length 31″ (79 cm). Science Museum, London.

Anatomical models were designed for the teaching of medical students and thus required a high degree of realism and accuracy in their representation of the body. Although attempts were made to keep such realism separate from sculpture proper, the two occasionally came together, as in the wax model of the *Medici Venus* exhibited in London in 1826 which opened to reveal the functions of the body.

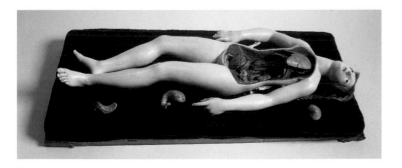

82. DR SOUTHWOOD
SMITH AND JACQUES
TALISCH
*The Auto-Icon of Jeremy
Bentham*, 1832, restored
1981. Natural materials,
wax, and textiles.
University College,
London.

Although Bentham's
promotion of the didactic
"auto-icon" – the
embalmed body
preserved for posterity –
never became popular, it
still survives in the form
of Lenin's and Mao's
"iconic" bodies,
immured in their
mausoleums, to which
the faithful pay homage.

that group of artefacts which historically had incited fears and superstitions among those for whom art and science were separate and discrete areas of cultural activity. At the centre of these anxieties was a desire to maintain the sovereignty of the living human body over its diverse representations. Anything which threatened to blur the boundary between the natural body and its representation assumed the qualities of the grotesque and seemed liable to contravene a series of deeply held cultural taboos.

One of the most curious incursions into the realm of bodily propriety during the nineteenth century – and one which, had it caught on, would have violated a whole range of social protocols – was the case of the so-called "auto-icon" promoted by the English philosopher, social reformer, and founder of utilitarianism, Jeremy Bentham (1748–1832). Drawing on post-Reformation Puritan moralism which saw the deceased natural body as a source of impurity and contagion, Bentham advocated transforming the corpse into a permanent "icon" of the deceased, the physical remains serving as the basis on which to construct a realistic re-creation of the body which could then be displayed for didactic ends. As is clear from Bentham's own "auto-icon," still on show at University College London (FIG. 82), such composites of the natural and the artificial seem to occupy a zone between the living and the dead to which not even waxworks have access. Thus, paradoxically, as a mixed category defying easy classification, Bentham's body qualifies for what the social anthropologist Mary Douglas has famously described as "matter out of place" – those troubling instances when potentially polluting bodily materials appear in locations other than those traditionally allocated them, thereby defying taboos regarding the maintenance of social hygiene and the containment of disease.

If Bentham's auto-icon and Madame Tussaud's waxwork displays represented nineteenth-century sculpture's shadowy double, there were other more acceptable avenues open to ambitious sculptors wishing to engage with techniques of colour and polychromy. One artist who achieved particular success at the annual Paris Salons with his own brand of mixed media work was the Frenchman Charles-Henri-Joseph Cordier (1827–1905). Cordier's virtuoso technique of combining bronze with exotically coloured stones, enamelling, and other decorative techniques allowed him to appropriate the ancient practice of polychrome marble sculpture for decidedly modern ends – the representation of African types (FIG. 83). A series

83. CHARLES-HENRI-JOSEPH CORDIER
Nègre en Costume Algérien (Native Man in Algerian Costume), 1856–7. Algerian calcite "alabaster" and Algerian black and red marbles, 37¾ x 26 x 14" (95.9 x 66 x 35.5 cm) Musée d'Orsay, Paris.

Of Cordier's attempt to revive colour in sculpture, the critic Théophile Gautier commented: "He has dared to be original in an art that has little tolerance of originality."

of such "ethnographic" busts were commissioned by the Museum of Natural History in Paris and executed after a "field trip" to Africa in the 1850s, where Cordier took photographs of his subjects. They were exhibited at the Salon of 1857, where they found an enthusiastic audience among a public bewitched by the mysterious allure of colonial adventure. Cordier's fastidious and ever more luxurious technique – which employed materials such as Algerian onyx, extracted from France's African colony – eventually proved a highly prized commodity within the bourgeois culture of conspicuous consumption that characterized the Second Empire under Napoleon II.

What Cordier's ethnographic busts indirectly draw attention to is the increasing competitiveness of European nations during the mid-nineteenth century for the imperial exploitation of Africa. The representation of African peoples using indigenous raw materials imported from the colonies effectively turned such objects into trophies of colonial power. What these colonies represented above all was commercial opportunity and it was in this realm that competition between European nations was at its most acute.

Minerva in France

Among those who were sensitive to the importance of France maintaining its traditional supremacy in the so-called industries of art was the French aristocrat Duc Albert de Luynes (1802–68). As a numismatist, antiquarian, amateur archaeologist, and champion of the decorative arts, the duke had been an obvious choice to assume the role of president of the jury for precious metal products at the Great Exhibition of 1851 in London, in which capacity he compiled a report for the French government. By that time the duke had almost completed the extensive refurbishment of his château at Dampierre near Paris, for which he had engaged the skills of the painters Ingres and Gabriel-Charles Gleyre and the leading exponent of Neo-Greek architecture, Félix Duban. The centrepiece of the château's *grande galerie* was to be a work of polychrome sculpture by the Neo-classical sculptor Pierre-Charles Simart (1806–57), which the duke envisioned as a scaled-down reconstruction, some nine feet (2.74 m) high, of Pheidias's ancient lost chryselephantine statue of Athena Parthenos (FIG. 84). As a composite work combining the latest researches in ancient polychromy with modern electro-chemical techniques, the *Minerva* drew on the skills of the duke as supervisor of the diverse antiquarian sources, Simart as overseeing sculptor, and the jeweller Duponchel for the decorative work in enamel and precious stones.

84. PIERRE CHARLES SIMART *Minerva*, 1843–55. Gilt bronze, ivory, and semi-precious stones, 9' (2.74 m). Collection of the Duc de Luynes, Château de Dampierre, Seine et Oise.

Exhibited at the Paris International Exhibition of 1855, Simart's *Minerva* was an attempt to reconstruct, on a reduced scale, the ancient chryselephantine *Athena Parthenos* made by Pheidias in Periclean Athens in the fifth century BC.

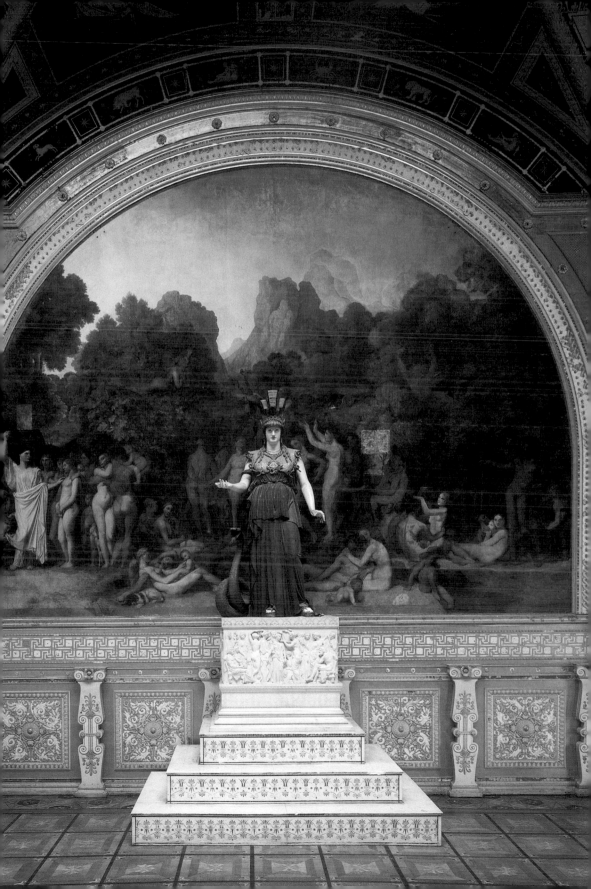

If the duke had been hoping that the *Minerva* would reinforce the argument for polychrome sculpture while standing as an emblem of France's pre-eminence in luxury manufactures he was to be disappointed. Despite its appeal to the authority of a noble ancient precedent, the *Minerva* met with a chilly reception at the Paris International Exhibition of 1855 where it was dismissed as an uncomfortable concatenation of antique and modern sources, neither art nor industry. Furthermore, to opponents of polychrome sculpture it was a reminder that just because the ancients had mixed their materials it did not mean that such techniques were ripe for revival – "had we not reliable data for the practice, we could hardly have believed that such a people as the Greeks would have so wrought," said one contemporary critic of the chryselephantine technique. Paradoxically, given its ostensibly antique subject matter, Simart's *Minerva* illustrates the extent to which the central tenets of Neo-classical doctrine had become subject to widespread challenge by mid-century.

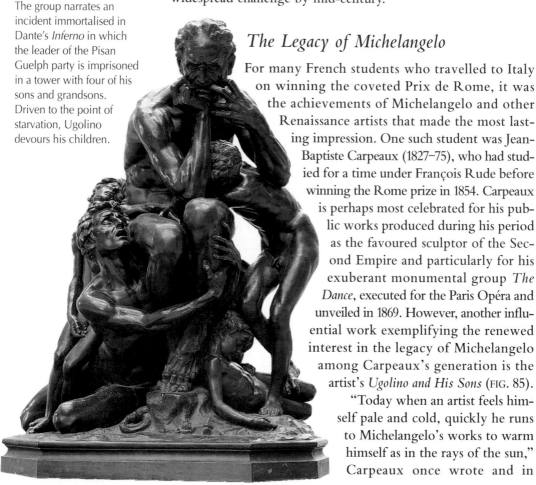

85. JEAN-BAPTISTE CARPEAUX *Ugolino and His Sons*, 1863. Patinated plaster. Musée d'Orsay, Paris.

The group narrates an incident immortalised in Dante's *Inferno* in which the leader of the Pisan Guelph party is imprisoned in a tower with four of his sons and grandsons. Driven to the point of starvation, Ugolino devours his children.

The Legacy of Michelangelo

For many French students who travelled to Italy on winning the coveted Prix de Rome, it was the achievements of Michelangelo and other Renaissance artists that made the most lasting impression. One such student was Jean-Baptiste Carpeaux (1827–75), who had studied for a time under François Rude before winning the Rome prize in 1854. Carpeaux is perhaps most celebrated for his public works produced during his period as the favoured sculptor of the Second Empire and particularly for his exuberant monumental group *The Dance*, executed for the Paris Opéra and unveiled in 1869. However, another influential work exemplifying the renewed interest in the legacy of Michelangelo among Carpeaux's generation is the artist's *Ugolino and His Sons* (FIG. 85).

"Today when an artist feels himself pale and cold, quickly he runs to Michelangelo's works to warm himself as in the rays of the sun," Carpeaux once wrote and in

drawing on a subject from Dante (Michelangelo's favourite author) he was able to perform a double genuflection. Carpeaux borrows the posture of Michelangelo's *Lorenzo de Medici* in the church of San Lorenzo in Florence and clenches it with nervous energy, Ugolino's knitted feet functioning, like the drooping foot of Bernini's *St. Teresa* (see FIG. 57), to underscore the central theme. Indeed, viewed from any of a number of possible angles, it is the body in all its expressive potential, whether flexed or flaccid, which conveys the universal message of the work.

Academic strictures would normally have required that such a historical group be dressed in the correct costume but, by bravely ignoring such dictates and opting instead for the nude, Carpeaux succeeded in making more explicit his genuflection to Michelangelo while intensifying the anguished plight of his protagonists through the surface articulation of anatomy. Neither can the nod to an even earlier antique precedent – the *Laocoön* (see FIG. 47) – have been lost on an erudite contemporary audience. Despite its mixed critical reception – cannibalism was hardly an orthodox subject for representation – the enduring impact of the work, and an indication of how rapidly it achieved canonical status, can be seen in the great French sculptor Rodin's later adaptation of the central figure for *The Thinker* for the "Gates of Hell" begun during the 1880s.

Taking nature as a primary point of departure, before subjecting it to exaggerated emphasis to gain maximum visual and emotional thrust, was a strategy that gained increasing currency among French sculptors during the second half of the century. It was as though the internal political and social turmoil which France had undergone during successive changes of government – changes in which the body had played an often harrowingly prominent role, both literally and symbolically – had endowed sculptors with an ability to reveal with unnerving frankness a range of more unpalatable and grisly cultural preoccupations.

The Primitive and the Prurient

Like Barye before him, Emmanuel Frémiet's (1824–1910) passion for animals and anatomy led him to study at the museum of the Jardin des Plantes in Paris and it was while working under Rude that he exhibited his first animal sculptures at the Salon of 1843. Frémiet's facility at this particular branch of art eventually led to a series of works exploring the confrontation between human beings and beasts or, more specifically, between men and bears, and between women and apes. The first plaster version

of his *Gorilla Carrying off a Woman* (FIG. 86) submitted to the Salon of 1859 was rejected outright, the poet and critic Charles Baudelaire referring to the vulgarity and prurience of its subject matter, but it was eventually accepted when re-submitted in 1887.

Coincidentally, 1859 was also the year in which the *Origin of Species* by Charles Darwin (1809– 82) was published and Frémiet's group may well have been stimulated by the interest around Darwin's theory of evolution, even though it could hardly be seen as a direct reflection of his ideas. As a habitué of the Jardin des Plantes, Frémiet was probably exposed to Darwin's thesis when it was first articulated in an essay of 1844 but, be that as it may, the later impact of the *Origin of Species* can only have paved the way for the eventual acceptance of Frémiet's provocative group. If it plays at all to any contemporary concern over the relationship between "civilized" society and more "primitive" stages of social evolution, it is perhaps to the currency of ideas expounded by Darwinian thinkers such as John McLennan, who warned of the tendency of the Australian savage who, on finding a suitable female, "forces her to accompany him by blows, ending by knocking her down and carrying her off." Such

86. EMMANUEL FRÉMIET *Gorilla Carrying off a Woman*, 1887. Painted plaster, 6'1½" (1.87 m). Musée des Beaux-Arts, Nantes.

"Only the ape," said the critic Charles Baudelaire, "sometimes shows a human craving for women." Frémiet seems to have endorsed this view of the ape's sexual proclivities in this work, the first version of which appeared in 1859, coincidentally the same year in which Darwin's *Origin of Species* was published.

ideas could also take on a more overt political colouring as when conservative critics in the 1870s rushed to liken the Communards of the 1871 revolution to gorillas and baboons.

It is often claimed that Frémiet brought an "ethnographic realism" to bear on his subjects and, having worked with naturalists, he may well have been more knowledgeable than his public about the sexual proclivities of anthropoid apes. Nevertheless, it is hard not to conclude that the sensationalist nature of the work says more about the libidinous fantasies of its sculptor than the urges of the hairy primate.

The various challenges to the centrality of the Neo-classical heritage and the embracing of unorthodox subject matter discussed so far in this chapter have been drawn largely from developments that took place in France. While it would be an exaggeration to suggest that sculpture elsewhere in Europe was undergoing a period of stagnation, nowhere else in Europe were the conditions as fertile for innovation. It was only a matter of time, however, before the enthusiastic revival of the Florentine Renaissance naturalism which had characterized so much of the French progress in sculpture was imported to England.

The New Sculpture: An English Renaissance

Certain English sculptors were instrumental in preparing the soil for a widespread adoption of a more naturalistic, Renaissance-inspired vocabulary – the work of the Rome-trained Alfred Stevens (1817–75) on the Wellington Monument (1850–75) in St. Paul's Cathedral, London, being the most notable example – but the French influence arrived by more direct means. After the collapse of the revolutionary Commune in May 1871, the sculptor Aimé-Jules Dalou (1838–1902) fled to England to escape the repercussions of his involvement in the uprising and remained until the general amnesty was granted in 1879. Having learnt modelling at the Petite École in Paris under Carpeaux, he was eventually able to impart his skills in this area to English students when in 1877 he was appointed by the National Art Training School in South Kensington as a teacher of modelling. According to Edward Lanteri, who eventually succeeded him in the post, Dalou "gave an extraordinary impetus to sculpture during the two years he was there," while a mere two or three months spent at the Lambeth School of Art in 1877 before returning to France had evidently been sufficient, in the eyes of the government commissioners for art education, for Dalou to imbue in his students a firm commitment to the "French method."

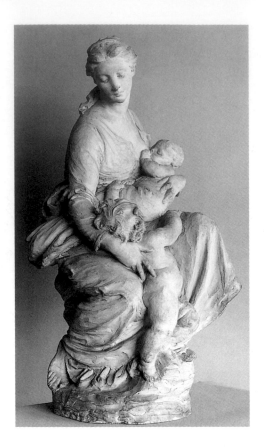

Something of the flavour of Dalou's brand of intimate naturalism can be detected in his plaster figure of *Charity* (FIG. 87), but the depth of his influence on English sculpture and the extent of the French legacy more generally can be better assessed in the work of a generation of young English sculptors. They came to represent what the critic Edmund Gosse, in an article in the *Art Journal* of 1894, was retrospectively to term the "New Sculpture." Many of the exponents of the so-called New Sculpture – Hamo Thornycroft, Alfred Gilbert, George Frampton, Alfred Drury, William Goscomb John, and Harry Bates – had learnt the "close and reverent observation of nature", which for Gosse characterized their common aims, by emulating the achievements of the French school. A seminal work often credited with communicating the possibilities of the contemporary French model to an English audience was Frederic Leighton's (1830–96) bronze figure *Athlete Wrestling with a Python* (FIG. 88). Energized by a dynamic blending of ideal form with startlingly naturalistic modelling of the nude, the *Athlete* announced a radical break with any recognizable English tradition; here, said Gosse, was something vital and nervous, something wholly new.

The vigour with which English artists took up the challenge of transforming the latent potential of English sculpture during the last quarter of the nineteenth century can be witnessed in the efflorescence of New Sculpture on buildings and monuments, and its widespread availability through the small-scale bronze statuette. The process of mechanical reduction, pioneered by Achille Collas in France in the 1830s, and exploited commercially thereafter by the Barbedienne foundry, eventually found its way to England, enabling reproduction of works in large numbers. In an echo of the means by which Giambologna's work reached a broader audience in the sixteenth century, the marriage of art and industry once again served to disseminate the New Sculpture to new markets.

87. AIMÉ-JULES DALOU *Charity*, 1877. Terracotta, height 30¼″ (77 cm). Victoria and Albert Museum, London.

Dalou's brand of intimate naturalism had a profound effect on English sculptors of the late nineteenth century, many of whom benefited from his teaching while he was resident in England as an exile following the fall of the French revolutionary Commune of 1871.

Crafting the Body: Gilbert, Gérôme, Klinger

The technical aspects of sculpture production were matters with which artists became increasingly concerned during the late nine-

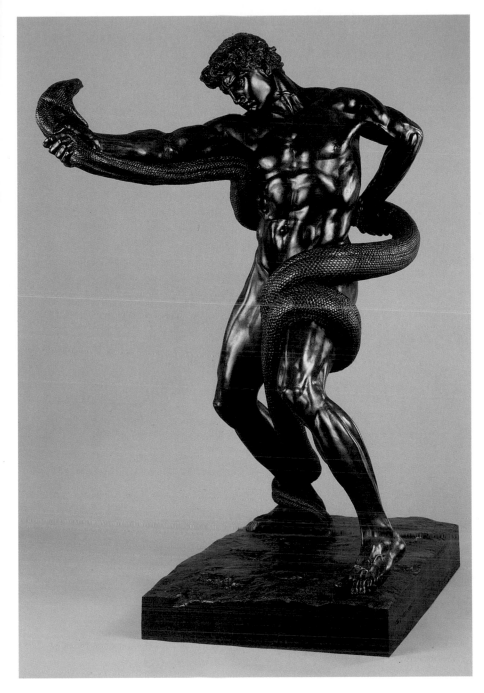

88. FREDERIC LEIGHTON
Athlete Wrestling with a Python, 1877. Bronze, 68¾ x 38¾ x 43¼" (174.6 x 98.4 x 109.9 cm).
Tate Gallery, London.

Combining the romantic-realist idioms then prevalent in France with the authority of the academic
ideal male nude, Leighton's *Athlete* marked a turning point in English sculptural aesthetics.

teenth century: many sculptors in England, France, and Belgium became as adept in the arts of jewellery, goldsmithing, and enamelling as in more traditional sculpture skills. Close supervision of the casting and foundry processes also enabled artists to experiment with innovations in the patination and chasing of the finished work.

An English artist who engaged in these creative processes with particular energy was the sculptor Sir Alfred Gilbert (1854–1934). Recognized as the most original and multi-talented artist of his generation, Gilbert received his formal education at the École des Beaux-Arts in Paris before studying under Cavelier and Frémiet. Much of his work reflects a thorough understanding of the ideal nude and an early exposure to French artists such as Gustave Doré and Marius-Jean-Antonin Mercié. Gilbert is often credited with having made a significant contribution to the English revival of the lost-wax process of bronze casting which he had learnt while in Italy – he later set up his own foundry in London – but his interest in the industrial side of sculpture production also led him to make contact with Sir William Chandler Roberts-Austen, Professor of Metallurgy at the Royal College of Mines. Roberts-Austen introduced Gilbert to current experiments in the mixing of metal alloys and encouraged him to keep abreast of developments in these fields then under discussion at the Society of Arts. Exposure to the bronze-pickling techniques he discovered through Roberts-Austen enabled Gilbert to achieve exquisite patinations and surface textures on his bronzes, and it prompted him to attempt the first large-scale public statue in aluminium – the figure of Eros for the Shaftesbury Memorial unveiled in Picadilly Circus in 1893, which remains to this day one of the most familiar London landmarks (FIG. 89).

The increasing diversity of skills demonstrated by European sculptors in their work during the 1890s was due to a range of factors. For Gilbert in England it was a product of his passion for the Renaissance tradition of goldsmith-sculptors such as Cellini (see FIG. 49) and was fostered by the contemporary alliances being forged between the arts and crafts. Meanwhile, French pre-eminence in the decorative arts and luxury trades was grafted during the 1890s onto the enduring tradition of classicism: the renewed interest in the chryselephantine sculptures by Pheidias gave artists such as Jean-Léon Gérôme a licence to combine traditional sculpture techniques with practices borrowed from the decorative arts. Gérôme's *Corinth* (FIG. 90) encapsulates the artist's preoccupation with the shimmering mixed media work practised in Periclean Athens and can be seen as the immediate progeny of Simart's

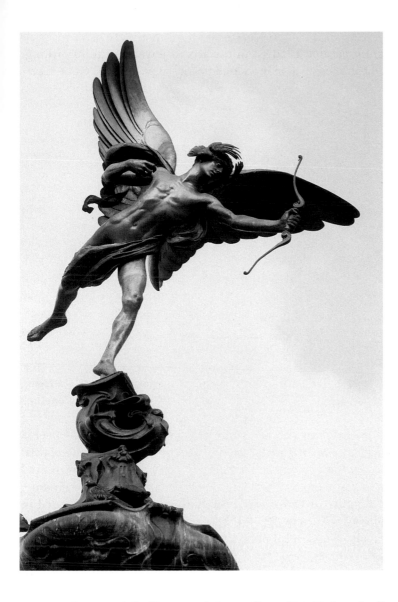

89. Sir Alfred Gilbert
Memorial to the Seventh
Earl of Shaftesbury (Eros),
1886–93. Aluminium, life-
size. Piccadilly Circus,
London.

Gilbert had intended his
monument to symbolize the
Earl of Shaftesbury's life and
work as a philanthropist
and factory reformer and his
choice of figure represented
Christian Charity "sending
forth his missile of
kindness." The use of
aluminium reflects Gilbert's
interest in metallurgy,
allowing him to achieve
different patinas in the
various components.

Minerva (see FIG. 84). "I entered the atelier of M. Delaroche,"
Gérôme recalled of his student days; "he prescribed the study
of Pheidias, nothing but Pheidias."

A different, but not entirely unrelated, approach to mixed
media sculpture was the imposing figure of *Beethoven* (FIG. 91)
by the Leipzig painter, etcher, and sculptor Max Klinger (1857–1920),
produced for the 14th Exhibition of the Vienna Secession in 1902.
The exhibition was designed in praise of Beethoven, who had
achieved cult status in the preceding decades. Housed in a build-
ing designed by the Secessionist architect Joseph Maria Olbrich,
Klinger's statue formed the centrepiece of the exhibition and was

90. JEAN-LÉON GÉRÔME
Corinth, 1899. Gilt bronze
and semi-precious stones,
height 29″ (73.7 cm).

Strongly influenced by the
example of Pheidias,
Gérôme was among the
foremost experimenters in
exotic combinations of
materials in sculpture.

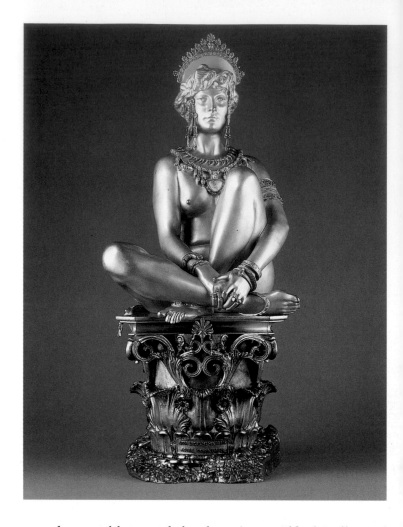

Opposite
91. MAX KLINGER
Beethoven, 1897–1902.
Bronze, marble, ivory, and
mixed media, height 10′2″
(3.1 m). Museum der
Bildenden Künste, Leipzig.

Klinger's statue was the
central focus of the
Gesamtkunstwerk – the
complete, integrated work
of art combining music,
painting, sculpture, and
architecture – devised for
the 14th Exhibition of the
Vienna Secession in 1902,
which celebrated the life
and work of Beethoven.

complemented by murals by the painters Alfred Roller and
Gustav Klimt. As has been noted of the exhibition: "If ever
there was an example of collective narcissism, this was it: artists
(Secessionists) celebrating an artist (Klinger) celebrating a hero of
art (Beethoven)." One might add the names of Rodin and Pheidias
to the hagiography, for the *Beethoven* surely bows as much to
the former's *Thinker* and to the latter's *Zeus* at Olympia as to
the great Romantic composer.

Rodin: The Unity of Fragments

We began this chapter by drawing attention to the Italian Renais-
sance as an increasingly prominent source of inspiration to nine-
teenth-century artists. Ten years before Dantan executed *A
Casting from Life* (see FIG. 78), the sculptor Auguste Rodin (1840–1917)

92. AUGUSTE RODIN
L'Age D'Airain (The Age of
Bronze), 1876. Bronze,
5'11¼" (1.81 m). Tate
Gallery, London, on deposit
to the Victoria and Albert
Museum, London.

Having expended so much
emotional energy on the
figure – "I
was in the
deepest
despair ... I
worked so
intensely on
it" Rodin said
later – it came
as a dispiriting
blow to receive
accusations that
*The Age of
Bronze* had been
cast from life.

completed his first major work in bronze, *The Vanquished*, later
to become known as *The Age of Bronze* (FIG. 92). Although inspi-
ration for the figure is not ascribable to any single historical prece-
dent, it was around this time, 1875, that Rodin had begun to assess
the legacy of Michelangelo, whose work he saw on a trip to
Italy during a break from work on *The Age of Bronze*. After
visiting Italy it was almost obligatory for every sculptor searching
for recognition to complete a single monumental male
nude in response to the seemingly insurmountable chal-
lenge of Michelangelo; in this respect Rodin's figure
follows earlier achievements such as Carpeaux's *Ugolino*
(see FIG. 85).

Two factors, neither wholly without prece-
dent, coloured the negative critical response
which *The Age of Bronze* solicited when
first exhibited at the Brussels Artistic and
Literary Circle in 1877. In eschewing any
overt mythological, historical, or bib-
lical subject, Rodin's figure concentrated
attention on the body itself and there
critics encountered an all too faithful
attention to nature; such a figure, they protested, must
surely have been cast from life rather than mod-
elled. Although Rodin was eventually able to counter
this criticism, it has nevertheless persisted in the
mythology of *The Age of Bronze*, lending it a cer-
tain notoriety and thereby marking it out as a sem-
inal moment in the development of the three-dimen-
sional body in nineteenth-century sculpture.

Rodin's preoccupation with re-emphasizing plas-
tic values, with treating the body as above all a volu-
metric entity, constitutes his main achievement, neces-
sitating the deconstruction of the human form (FIG.
93). Paradoxically, this process of fragmentation, which
involved dismantling the idea of sculpture as a discipline
in service to the body as intact and complete, served
merely to redirect attention to the integrity of each of the
body's component parts as though any individual mem-
ber were capable of standing for the plenitude of the
whole. As the German poet and secretary to
Rodin, Rainer Maria Rilke, put it: "Each of
these fragments is of such a peculiarly striking
unity, so possible by itself, so little in need of
completion that you forget they are only parts."

93. Auguste Rodin
Iris, Messenger of the Gods,
1890–91. Bronze, 32¼ x 34
x 20½" (82.1 x 86.3 x 52
cm). Musée Rodin, Paris.

Rilke's comments offer an apt note on which to conclude a chapter which has witnessed the gradual deconstruction of the strict, rule-based foundations upon which sculpture had for so long depended. By the early years of the twentieth century the notion of coloured sculpture was no longer new and neither was the prospect of the sculpture without a base or pedestal. As for the process of fragmentation explored by Rodin, this too enabled the following generation of sculptors to achieve a fresh unity of purpose, partly by extending his achievements, but also by rebelling against them. The state of fragmentation to which Rilke referred therefore stands as an appropriate metaphor through which to confront the treatment of the body in the twentieth century to which we now turn.

Abjection and Assemblage: The Body in the Twentieth Century

94. CONSTANTIN BRANCUSI *Male Torso*, 1917. Brass, 18¼″ (46.7 cm). The Cleveland Museum of Art, Ohio.

Beginning his career in the sudio of Aristide Maillol, Brancusi went on to forge an individual aesthetic of uncompromising formal purity, exemplified in this work, from which all traces of the artist's subjective involvement have been banished.

D espite his reluctance to have any of his substantial body of sculptures cast in bronze in his lifetime, and notwithstanding his lowly estimation of his own sculpture, the painter Edgar Degas (1834–1917) nevertheless bequeathed one of the most celebrated sculptures of the nineteenth century – the *Little Dancer Aged Fourteen* (FIG. 95), first exhibited at the Sixth Impressionist Exhibition in Paris in 1881. Degas's words are revealing not merely for their rather gloomy assessment of his own worth, but for what they express of his attitude to "the art of sculpting." As it turned out, however, it was precisely its achievement in breaking with the sort of "perfection" to which, in Degas's eyes, sculpture had seemingly always aspired, that made the *Little Dancer* such a resounding, if critical, contemporary success and which has endowed it with lasting relevance. To some critics, the use of polychromed wax with real hair and fabric for the *Little Dancer* evoked earlier Spanish polychrome sculpture such as the figure of Christ at Burgos (see FIG. 33), but it also connected it

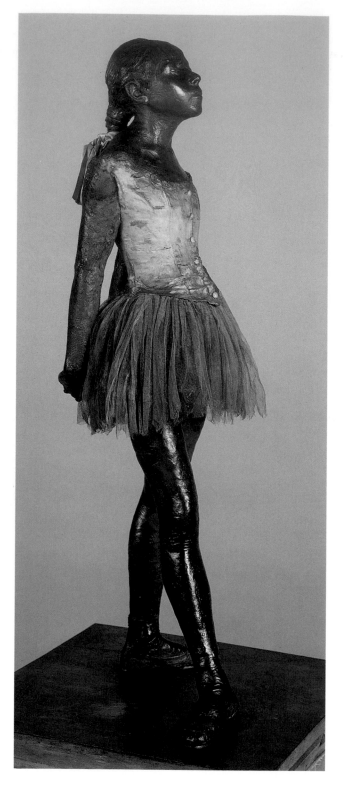

with more grotesque, carnivalesque forms of body-making such as waxworks and dolls. Hence, while the *Little Dancer* marked a daring departure from the pure surfaces of the classical tradition, it simultaneously betrayed an association with primitive artefacts. As "the very type of horror and bestiality," the work belonged, in the opinion of one contemporary commentator, not in an art gallery but "in a zoological, anthropological, or medical museum."

In evoking the spectral bodies originating from an often indefinable "elsewhere" – medicine, ethnography, the body's own morbid predicaments – the *Little Dancer* announces many of the later preoccupations of twentieth-century body art practitioners whose work stages a direct confrontation with the forbidden, taboo realities of the body and its various excretions and emissions.

95. EDGAR DEGAS
Little Dancer Aged Fourteen, 1881.
Polychromed wax and mixed media,
height 39" (99 cm). Collection Mr &
Mrs Paul Mellon, Upperville, USA.

Degas's introduction of diverse materials marked a seminal moment in the development of modern sculpture, its introduction of organic components denying easy classification and thereby troubling the critics. The defying of the "proper" boundaries between substances went on to inform much contemporary art.

Expanding Horizons

Degas's *Little Dancer* is not alone among late nineteenth-century objects in prefiguring certain concerns traditionally associated with twentieth-century sculpture. Another nineteenth-century artist better known for his painting than his sculpture but who, like Degas, left at least one memorable treatment of the three-dimensional body is Paul Gauguin (1848–1903). Like the *Little Dancer*, Gauguin's *Oviri* (FIG. 96) is an object which reverberates with the later Modernist fascination with the art of "primitive cultures." In its use of the unorthodox sculptural medium of stoneware, *Oviri* (the Tahitian word for savage) is an emblem of Gauguin's affinity for the geographical and cultural periphery which drove him to leave France for Tahiti in 1891 and stands as a monument to his commitment to a primitivist avant-garde. In accordance with his wishes, a bronze version of *Oviri* was erected on his tomb.

What these two examples of late nineteenth-century sculpture represent above all are the first tentative steps towards destabilizing the dominance of the Western classical canon. While Degas's *Little Dancer* was deemed of "appalling ugliness" and "at once refined and barbarous," Gauguin advised: "Have before you always the Persians, the Cambodians, and a little of the Egyptian. The great error is the Greek, however beautiful it may be." Henceforward, artists would search beyond the constraining confines of the Western tradition – to African, Far Eastern, and pre-Columbian art and to naive or folk art – to express their alienation from an increasingly industrialized world.

It was not only from innovations in the plastic arts that sculpture derived its direction during the early decades of the twentieth century. Baudelaire's identification of the Modernist *flâneur*, the urban dweller whose experience is dissolved in "the ebb and flow, the bustle, the fleeting and the infinite" ways of city life, found its visual expression in the compositions of Manet and the Impressionists that mimed the cut-off framing of the photographic eye. Meanwhile, Cézanne's deconstructive project laid the foundation for the relentless exploration of pictorial structure undertaken by the Cubists in the period immediately before the First World War.

The themes of fragmentation and disruption which have come to be regarded as the defining markers of the Modernist

96. PAUL GAUGUIN *Oviri* (Savage), 1894. Partly glazed stoneware, painted, height 29¼" (74 cm). Musée d'Orsay, Paris.

Interest in stoneware techniques was revived following Western exposure to Japanese decorative arts in the second half of the nineteenth century. Gauguin developed his interest in the medium in Tahiti in the late 1860s.

sensibility can also be detected in the continuing sense of fragmentation which characterized the forms of the three-dimensional body during the early years of the twentieth century. In 1936 the philosopher and critic Walter Benjamin wrote that: "A generation that had gone to school on a horse-drawn streetcar now stood under the open sky in a countryside in which nothing remained unchanged but the clouds, and beneath these clouds, in a field of force of destructive torrents and explosions was the tiny, fragile, human body." The cataclysmic effect of the First World War, to which Benjamin poetically refers, which shattered established structures of belief in the progress of civilization and which seemed to undermine the stability of human affairs, was mirrored in representations of the body.

It has often been remarked that the generation of sculptors who succeeded Rodin responded to his work in an essentially negative way, reacting against his central concerns rather than adopting and developing them. It is certainly true that the crop of young sculptors who came to prominence during the early decades of the twentieth century rejected outright his reliance on the model, his passionate, expressive involvement in his materials, the whiff of the Salon lingering around the titles of his works, his essential Romanticism. However, there were other aspects of Rodin's vision which insinuated themselves into the consciousness of the succeeding generation and which eventually came to provide the foundation for their most significant achievements. These can be summarized as an adoption of the body fragment as a viable subject in its own right and, to some extent evolving from that development, a new approach to the base or pedestal, whose function could either be integrated into the work itself, or dissolved altogether.

Notwithstanding the fact that Rodin's attention to the partial body may have been inspired by classical antiquity and the vicissitudes to which ancient sculpture had been subjected over time, the assertion that the body part was a valid subject can be seen as an important stage in the development of abstraction. More importantly, where might that process of wilful reduction, subtraction, severance, diminution, end? Once the body part was liberated from overtly recognizable, external subject matter beyond itself, it was free to become a thing in its own right related merely to the here and now – in short, pure abstract form. What is more, this process, if properly exploited, had the potential to replace the traditional method of "reading" a work through a gradual, sequential absorption of its various components. Henceforth, it was felt, the work would be apprehended with greater immediacy, thereby achieving a greater internal unity and coherence.

Welcome to the Machine

As radical a revolution in sculptural aesthetics as that which took place in the first decade of the twentieth century cannot be treated in exhaustive detail in a book of this size, so attention will be focused on one or two key achievements. An important further stage in the process of liberation from traditional constraints can be glimpsed in the work of the Romanian sculptor Constantin Brancusi (1876–1957). *Male Torso* (see FIG. 94) betrays a lingering fidelity to natural forms (the original wooden version came from a naturally forked branch of a tree) while shifting the emphasis onto the purified planes which, for Brancusi, better evoked the immutable, the spiritual, the unchanging essences to which the world had lost access. The *Torso* hovers between that part of the body to which its title refers and that ancient symbol of male sexuality, the phallus, here barely sublimated, but reinforcing Brancusi's avowed aim during this period "to bring back to the world of the senses that eternal type of ephemeral forms."

If Brancusi's *Torso* essentially revealed a lingering interest in the volumetric concerns which had preoccupied Rodin, his refinement of the surface into a series of impersonal planes, seemingly free of the hand-made element of subjective artistic involvement, bespoke a new sensibility, one grounded in the machine age. The machine in its increasingly diverse manifestations and its ever more ubiquitous incursions into human affairs was to have a profound impact on the evolution of sculpture during the first two decades of the twentieth century. Just as new developments in digital technology and cybernetics have exerted an impact in our own period, significantly affecting the ways in which human beings interact with one another and with their environment, so advances in mechanization and automation in the first quarter of the twentieth century brought about a change in the way that artists viewed the world and in the way in which they expressed that view.

The Futurist movement, founded in Italy in 1909 by the poet Filippo Marinetti – and later attracting the artists Giacomo Balla, Gino Severini, and Umberto Boccioni – sought means of overturning the ossified, orthodox structures of academicism and replacing them with the dynamic modalities of a machine aesthetic which celebrated speed, power, modernity. Three years before his death in the First World War, one of the key figures in the movement, Umberto Boccioni (1882–1916), produced a bronze figure entitled *Unique Forms of Continuity in Space* (FIG.

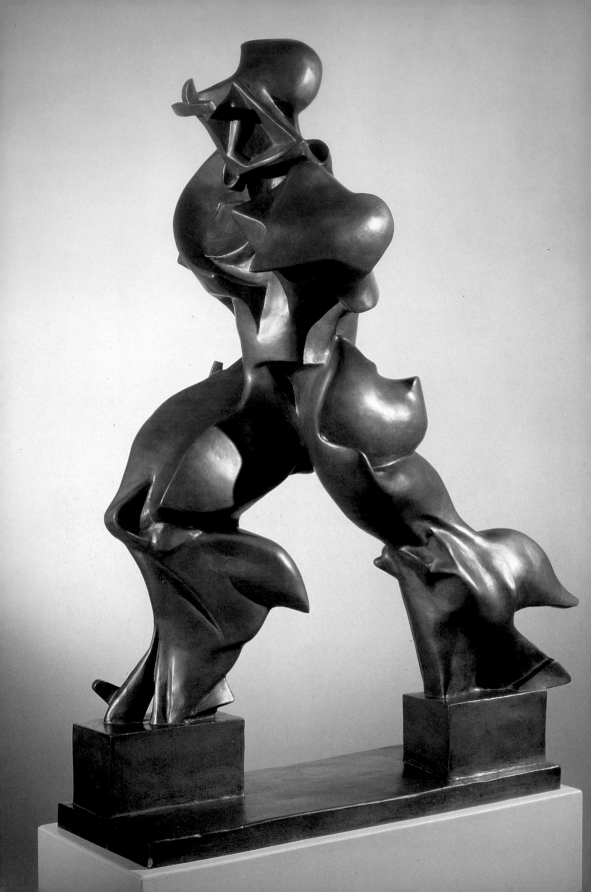

97), which embodies many of the Futurists' central concerns. As a body born from a fusion of the organic and the technological, the man as a machine moving through space, the figure can almost be read as a not-so-distant ancestor of the cyborg, or cybernetic organism, we know today: the quintessential twenty-first-century body.

The formal vocabulary of Boccioni's *Unique Forms* can be related to late nineteenth-century experiments in contemporary photography, but above all to aspects of Cubism and Pointillism or Divisionism. From Cubism comes its concern with abstract planar surfaces, while Divisionism offered the means by which elements of the image are treated separately on the surface so as to be apprehended and combined in the optical processes of the viewer. Hence *Unique Forms* makes visible as a series of planes the streamlined aerodynamics of bodily movement which together aim to contradict optically the static predicament of sculpture. Best viewed in profile, Boccioni's figure succeeds in translating the visual data of fleeting action into plastic values, distilling back into three dimensions the separated, sequentialized stages of human movement captured in the 1880s and 1890s by the photographic experiments (FIG. 98) of the French physiologist and photographer Etienne Jules Marey (1830–1904) and his exact coeval, the Englishman Eadweard Muybridge.

97. UMBERTO BOCCIONI *Unique Forms of Continuity in Space*, 1913. Bronze, 46¼ x 34½ x 14½" (117.5 x 87.6 x 36.8 cm). Tate Gallery, London.

Boccioni's Futurist approach to sculpture involved incorporating the optical effects of movement into the volumetric substance of the work.

98. ETIENNE JULES MAREY *Walk*, from *The Human Figure in Motion*, 1891. Gelatin silver chronophotograph, 4¾ x 3½" (12 x 9 cm). Collège de France, Paris.

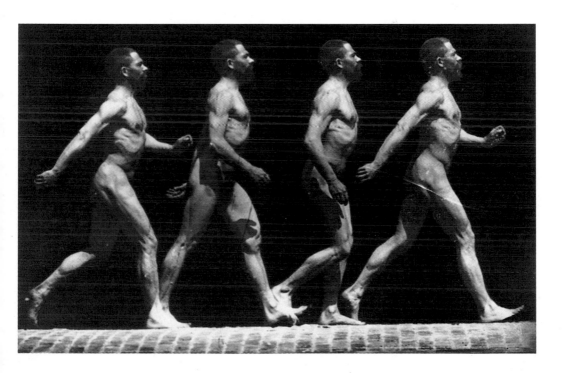

99. ANTOINE PEVSNER
Torso, 1924–6.
Construction in plastic
and copper, 29½ x 11⅝ x
15¼" (74.9 x 29.4 x 38.7
cm). The Museum of
Modern Art, New York.

Appearing a few years
after Karel Capek's play
R.U.R. coined the term
"robot," Pevsner's *Torso*
mirrors the prevailing
interwar fascination with
the mechanised human
form.

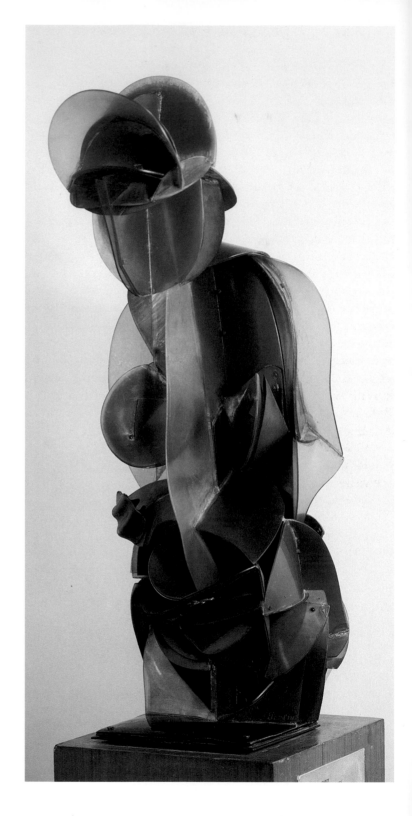

Space as a Sculptural Element

The interest in the planes and surfaces of which objects and bodies are constructed and their relationship with the space they both inhabit and interrupt became the overriding preoccupation of the Constructivist movement. This emphasis on volume rather than mass can be traced back to Picasso's analytical Cubist assemblages such as his *Guitar* of 1912, but it was most fruitfully developed, as part of a broader political aesthetic agenda, in revolutionary Russia by a group of artists including Vladimir Tatlin and the brothers Naum Gabo and Antoine Pevsner.

By constructing a series of planes between what had traditionally comprised the formal elements of the body, the space between those planes was now made to articulate the volume. "Up to now," Gabo explained, "sculptors have preferred the mass and neglected or paid little attention to such an important component of mass as space ... we consider it as an absolute sculptural element." This principle, essentially scientific in its inspiration, can be seen embodied in Pevsner's *Torso* (FIG. 99), which is realized in terms of structural, architectonic elements alone. To modern eyes, Pevsner's *Torso* has a certain robot-like appearance and it is worth remembering that it appears just a few years after the Czech writer Karel Capek coined the term "robot" from the Czech word for "serf." Constructivist sculpture eventually moved away from anthropomorphic form altogether to address a more rigorous abstraction in which the subsidiary, purely supportive function of the base was all but dissolved, only to be incorporated into the structural logic of the work itself.

Another sculptor confronting, if only briefly, the aggressive dynamism of the machine age as a means by which to forge a new mode of expression relevant to the modern world was the New York-born British sculptor Jacob Epstein (1880–1959). Epstein is mainly remembered for his monumental public projects and portrait sculpture, but one work which has achieved a singular status in the annals of twentieth-century European sculpture is the *Rock Drill* (FIGs 100 and 101). The original version of this work comprised in Epstein's words, "a machine-like robot visored, menacing, and carrying within itself its progeny, protectively ensconced," which towered on stilts of rock drills. Epstein eventually discarded the drills, but the surviving bronze version retains much of its alienating power. No doubt its impact today derives from its anticipation of the indeterminate organisms that populate science fiction cinema, its mother and child reference calling to mind the maternal monster of the *Alien* films.

100. JACOB EPSTEIN
The Rock Drill, 1913–4.
Bronze, 27¾ x 23 x 17½"
(70.5 x 58.4 x 44.5 cm).
Tate Gallery, London.

"Here is the armed sinister figure of today and tomorrow," said Epstein of his robot-like construction, "the terrible Frankenstein's monster we have made ourselves into."

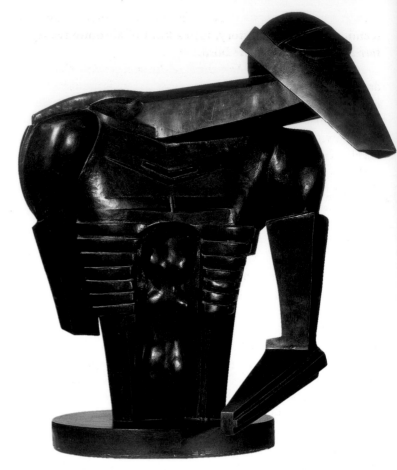

101. Photograph of Jacob Epstein's plaster cast of *The Rock Drill* complete with drill.

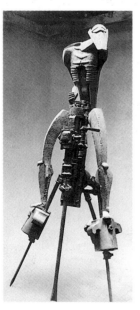

Dream, Reality: Surreality

Thus far we have been dealing with what remain recognizable treatments of the human body, albeit a body pushed, in the case of Brancusi, towards the boundary between figuration and abstraction, or subject to structural scrutiny in the case of Gabo and Pevsner. Both projects were underpinned by a fundamentally rational approach to the human body, or at any rate to the means by which certain properties of the body and its meanings might be comprehended by a rational viewer.

The central project of the Dada movement that came to prominence between 1916 and 1923 was to destabilize those processes of rational comprehension which, its adherents maintained, no longer held any relevance in the aftermath of the First World War. This was essentially the legacy passed on to the Surrealists whose aim, theorized in 1924 by one of the movement's chief protagonists, the French poet and essayist André Breton, was "the future

resolution of these two states, dream and reality, which are seemingly so contradictory, into a kind of absolute reality, a *surreality*." Surrealism was born.

Given its interest in Freudian psychoanalysis, its reliance on dream and the "purely psychic automatism" which would bypass rational thought, Surrealism marked a moment at which the body no longer figured as a subject for consciously ordered exploration and analysis. That is not to say that the body was excluded, or failed to appear in Surrealist art; it continued to figure prominently as a vehicle through which to express subconscious desire, emotion, fantasy, fear, although more often assuming a subliminal or subtextual presence in the work as a body implied rather than as a body coherently described.

In the First Manifesto of Surrealism (1924), Breton described an occasion when, before sleep, he "perceived" the sound of a phrase which came to him "without any apparent relationship to the events in which, my consciousness agrees, I was then involved." The phrase, which he recalled as "There is a man cut in two by the window," was accompanied by a "faint visual image" that in some sense illustrated the thought. This dream-like process, in which ideas are generated both by and yet seemingly beyond the subject, provided the point of departure for the Surrealist object.

One can sense some of Breton's aspirations for the Surrealist project in a work by the Swiss sculptor and painter Alberto Giacometti (1901–66), who became associated with the movement during the 1930s. The *Woman with her Throat Cut* (FIG. 102) retains only vestigially an image of the body but the juxtaposition of vaguely female forms with sharp, crustacean-like protuberances somehow serves to infuse it with implied sexual violence, an increasingly central component of the Surrealist object. The single hinged element of Giacometti's *Woman*, inviting but denying manual rearrangement (the artist intended it to evoke the disorientating fear of one's own hand

102. ALBERTO GIACOMETTI *Woman with her Throat Cut*, 1932. Bronze (cast 1949), 8½ x 34½ x 21" (22 x 87.5 x 53.5 cm). The Scottish National Gallery of Modern Art, Edinburgh.

Dispensing with a traditional base or pedestal, Giacometti's skeletal object sits on the floor, impinging upon the same space as that occupied by the viewer and thereby forcing a more direct psychological engagement with its various components.

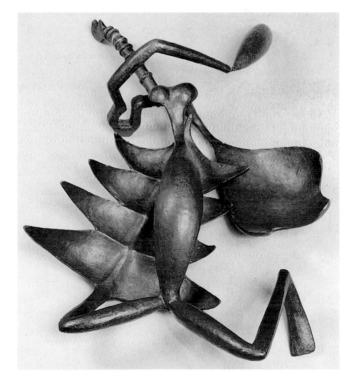

103. Arno Breker standing before his figure of *Prometheus*, 1941/2.

"In this way a great country honours its artists and their work, its intellectual culture, and the dignity of human existence" was how the French sculptor Bouchard described his 1941 visit to the studios of Arno Breker and Joseph Thorak, sculptors to the Nazi Third Reich.

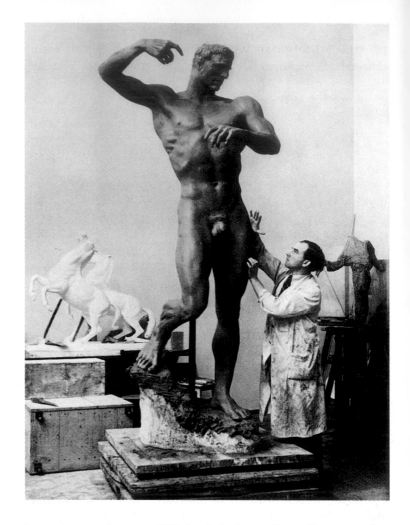

becoming too heavy to lift), lends it the quality of latent motion as though it might at any moment stir and scuttle away. The fact that it shares its base – the floor – with that of the viewer concentrates its impact.

If the body in the hands of the Parisian avant-garde had begun to resemble merely another piece of psychic junk salvaged from the subconscious mind, in Germany the National Socialist (Nazi) government was about to reaffirm the potency of the colossal body as a symbol of the will to power. Disillusioned with painting, Hitler turned to sculptors in 1937 to embody the eugenic aspirations of the Third Reich and to complement an architectural project on a scale appropriate to his ambitions. To these ends he solicited the assistance of the sculptors Joseph Thorak (1889–1952) and Arno Breker (1900–91; FIG. 103). Between them they were responsible for forging an approach to the three-dimensional body that borrowed

heavily from antique example and was intended to symbolize what the Nazi art historian Walter Horn described as "the manly character of National Socialism, the forces of order, courage, and heroic struggle." Some sense of the importance of sculpture to the Nazis and the extent to which it virtually usurped painting as a carrier of their political ideas was demonstrated in the "Great German Art Exhibition" which opened in Munich in 1937 and which included 200 works of sculpture. By 1940 that number had more than doubled to 440 works by 237 sculptors.

Despite the regressive approach to human form adopted by the Nazi propagandists, the avant-garde body continued to thrive elsewhere in Europe and in America. Giacometti's *Woman with her Throat Cut* would surely have qualified as "unfit" had Goebbels (the Nazi head of propaganda) got his hands on it, but instead it found its way into Peggy Guggenheim's pioneering New York gallery space "Art of This Century," which provided a spiritual home for many members of the displaced European avant-garde and which consecrated an entire room to Surrealism.

Surface and Structure

Two other artists associated with Surrealism between the wars were the English sculptors Barbara Hepworth (1903–75) and Henry Moore (1898–1986), both of whom had absorbed the Constructivist interest in volume and been moved by the "vitalism" they had encountered in the work of the French sculptor and painter Jean Arp (1887–1966). Hepworth explained that: "Vitality is not a physical, organic attribute of sculpture – it is a spiritual inner life" and this was expressed in her own work in what became a relentless exploration of the relationship between surface and implied internal structure.

Unlike Hepworth, Moore took the human figure as his point of departure, combining an avowed aim of "truth to materials" – in which the form of the work remains faithful to the specific, individual properties of the medium – with a traditional commitment to carving straight from the block. In this respect he invested his work with a sensual, haptic quality – that which can be communicated through, and which invites, touch – which until then had been marginalized within sculptural practice. It has been remarked that Moore's military service informed the development of his sculptural vision, "its sub-themes of an injured and godless landscape, of man's inhumanity and of the redemptive power of artistic form." This may partly account for Moore's preoccupation with maternal symbols and the importance

104. HENRY MOORE
Reclining Figure, 1951. Plaster, 41½ x 89½ x 35" (105.5 x 227 x 89 cm). Tate Gallery, London.

Moore believed that "A hole can have as much shape meaning as a solid mass", a notion explored in his reclining figures which encourage contemplation of voids as much as solids.

150 *Abjection and Assemblage: The Body in the Twentieth Century*

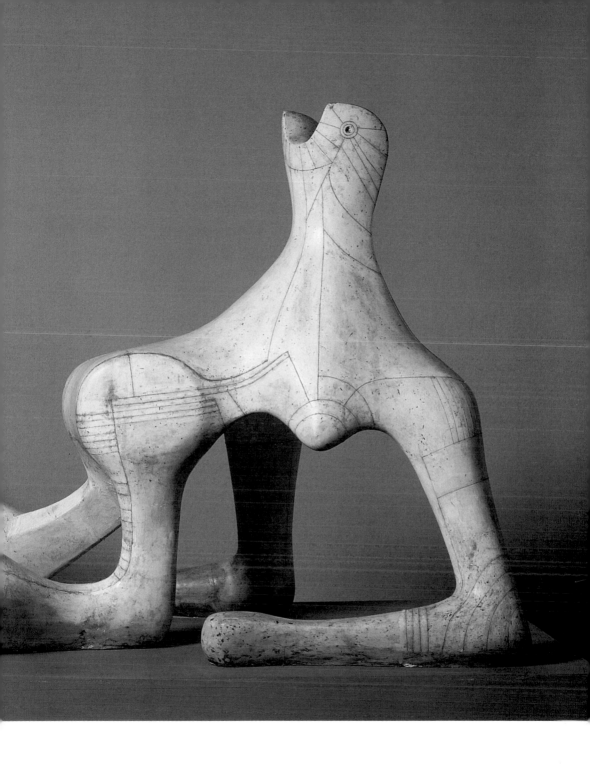

he attached to locating his sculpture in the open air, as though the landscape might in some way be fructified by the nurturing presence of the Great Mother. Occasionally, Moore's expressed intention of rendering space and mass as interchangeable entities gave rise to works of profound emotional intensity such as the *Reclining Figure* (FIG. 104) commissioned by the Arts Council of Great Britain for the 1951 Festival of Britain. Gentle undulations juxtaposed with more aggressively flexed elements inject a sense of ambiguity into the stock motif of the reclining woman, while the cobweb-like inscriptions on the original plaster serve to map the topography of the body while reinforcing the sense of structural tension.

If the three-dimensional body had become somewhat marginalized during the interwar years by the subversive strategies associated with the Surrealist object, it reasserted itself with startling diversity in the period following the Second World War. The optimistic plenitude of Henry Moore's women – symbols of fecundity in the natural landscape – provided a stark counterpoint to the existentialism of Giacometti, whose post-war bodies stood frail and filamented like charred remains after some terrible conflagration.

A younger generation of post-war British sculptors – Lynn Chadwick, Reg Butler, Elizabeth Frink, Kenneth Armitage, and Moore's erstwhile assistant Bernard Meadows – moved by Moore's example, continued to exploit the human figure by building on the immediately preceding developments, but without any particularly notable innovation. Although the ideas of Moore and Hepworth had been germinated in the interwar culture of Surrealism, their own work exerted such a powerful impact on the succeeding generation that the originary source became somewhat obscured from view.

Truth in Refuse: The Body Assembled

The bodies discussed so far in this chapter have been formed chiefly through techniques of carving, or modelling for later casting in bronze. However, in the mid- to late-1950s sculptors began to concern themselves with a process of assemblage which, through its frequent incorporation of painting and adoption of certain earlier strategies of appropriation exploited by Cubism, Dada, and Surrealism, took sculpture, and the body, into a hitherto uncharted territory. The three-dimensional assembled body functions as an acknowledgement of the living, human body as an assemblage of separate components.

Celebrated in the seminal exhibition "The Art of Assemblage" at the Museum of Modern Art in New York in 1961, the term "assemblage" was to be considered, according to its curator William Seitz, as "a generic concept that would include all forms of composite art and modes of juxtaposition." Already retrospectively applied to Robert Rauschenberg's and Jasper Johns's pioneering mixed media paintings and constructions from the mid-1950s, the term eventually came to encompass various strains of Pop Art activity which grew from a fascination on both sides of the Atlantic with the imagery and techniques of consumer culture.

The American West Coast proved to be the most fertile environment for assemblage during the late 1950s and through the 1960s, offering a "garage" for *ad hoc* construction to counter the New York "laboratory" of abstract painting. The strategies of appropriation and redeployment adopted by the Californian counter-culture of Beat poets and underground writers found its three-dimensional equivalent in assemblage, which offered artists a powerfully direct means of expressing their disillusionment with prevailing cultural values and their opposition to the Vietnam War (heavy fighting began in 1964). Locating the body within a matrix of junk salvage and reconstitution enabled artists to dramatize directly the alienation that was the natural condition of the avant-garde – as though enacting the French philosopher Roland Barthes's remark that "the truth of things is best read in refuse." Neither was it always necessary for the body to be recognizably described in three-dimensional form in order to address body-related ideas, issues, and anxieties: like the Surrealist object, much 1960s body art chose to refer to the body obliquely rather than through direct representation.

One of the most provocative American practitioners of assemblage was the San Francisco artist Bruce Connor (b. 1933) whose "phobic objects" often exploit body-orientated anxieties in order to draw attention to wider political, social, or sexual issues. In their use of everyday detritus and "low" materials, objects such as *Medusa* (FIG. 105) – constructed from wax, painted rubber tubing, wood, string, cardboard, hair and beads, and covered with

105. BRUCE CONNOR *Medusa*, 1960. Wax, painted rubber, wood, string, hair, and other media, 10 x 11 x 22" (25.4 x 27.9 x 56.3 cm). Whitney Museum of American Art, New York.

Connor is one of a number of contemporary artists whose work challenges dominant ideas about the body and which attempts to undermine orthodox categorisations of materials and substances by drawing attention to what is normally excluded from the social order. The title of this work plays on the idea of that which is prohibited from view.

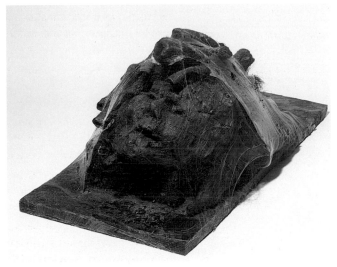

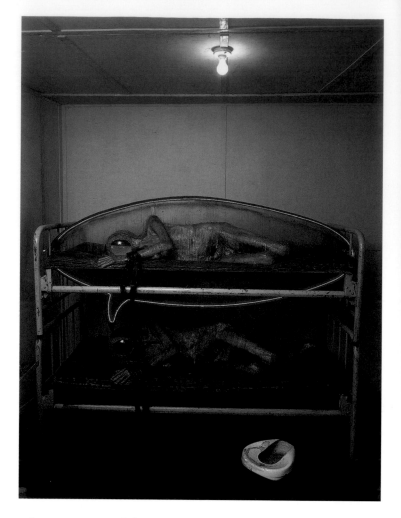

106. ED KIENHOLZ
The State Hospital, 1966.
Mixed media, 8′ x 12′ x
9′7″ (2.44 x 3.66 x 2.94 m).
Moderna Museet,
Stockholm.

The influence of a brief
period Kienholz spent
working in a mental
hospital in 1948 may be felt
in this tableau. Viewed
through the door of a "cell,"
the work settles
uncompromisingly on the
hopeless condition of
incarceration, the lower
figure reduced to eternal
contemplation of its own
abject condition. Each face
has been replaced by a
goldfish bowl containing
two black fish.

nylon – represented the conceptual opposite of the "pure" project
of two-dimensional abstraction then being pursued on the east-
ern seaboard of America.

Another West Coast assemblage artist employing the discarded
paraphernalia of industrial and consumer culture was Ed Kienholz
(1927–94), whose composite constructions of the late 1950s even-
tually expanded to become tableaux or life-scale "environments"
in which fabricated elements – degraded bodily forms, plaster casts,
mannequins – were unexpectedly juxtaposed with everyday objects
(FIG. 106). Eschewing overt political posturing in favour of a more
visceral form of social satire, Kienholz's work often relies upon
the viewer's empathetic response to the body and its material
predicament.

A contrasting but not unrelated approach to the three-dimen-
sional body was that explored by the New York-trained artist

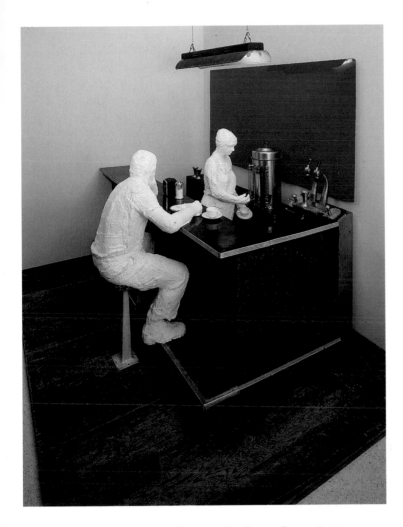

107. GEORGE SEGAL
Diner, 1964–6. Plaster,
wood, chrome, laminated
plastic, masonite,
fluorescent lamp, 7'7¾" x
12'¼" x 8' (2.38 x 3.66 x
2.44 m). Walker Art
Center, Minneapolis.

The real urn, soda
fountain, etc., serve to
emphasize the manifestly
manufactured nature of the
figures in the interior. "I
don't care about any
specific soap opera that
might be taking place,"
Segal has said, "you can
imagine forty-eight
different plots."

George Segal (b. 1924), whose early figurative painting grew
out of the influence of Abstract Expressionism. In 1958, frustrated
by the constraints of two-dimensional painting, and inspired by
department store mannequins, Segal began to make his own three-
dimensional figures from armatures of wire mesh covered in burlap
dipped in plaster. Three years later he started casting from life using
medical bandages applied with plaster, placing the finished, unpainted
figures within environments furnished with real furniture, declar-
ing himself fascinated by the plastic, or sculptural, interaction
between the bodies and surrounding objects. Over the next decade
Segal refined his formats to arrive at more sophisticated but no
less alienating evocations of urban living (FIG. 107).

If Segal's figures relied for their impact upon their self-explana-
tory composition and denial of verisimilitude, the opposite was
true of the work of two other American sculptors who came to

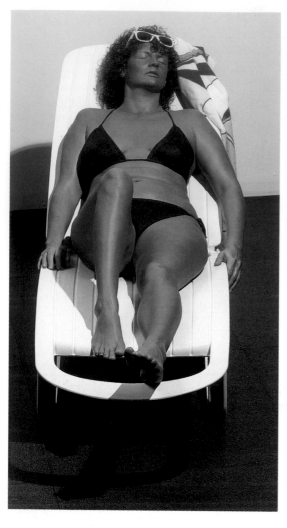

prominence during the 1960s – John De Andrea (b. 1941) and Duane Hanson (1925–96). Both artists' work has been related to the movement known as Super Realism, but it is better considered, at least in the case of Hanson (FIG. 108), within the context of Pop Art and particularly Pop's incorporation of the Duchampian "Ready-made" or found object. Although there are similarities in the means and materials by which they arrived at their counterfeit representations of the body – employing polyester, polyvinyl acetate, fibreglass, real hair, and glass eyes – De Andrea and Hanson differed markedly in their aims and intentions. While De Andrea concentrates on the nude model so as to render it in all its precise specificity as a project of illusionism in and of itself, Hanson's figures deploy that illusionism in the service of more directed social commentary, the sheer plenitude of the resulting figures becoming analogous to the material excesses of American consumerism. Neither De Andrea nor Hanson have managed, however, to pull their work entirely free of the negative comparisons with waxwork displays. This, as we have seen, has dogged realist sculpture for centuries. Hanson's contribution to body realism finds its echo in some of the work produced during the 1990s by young contemporary artists such as the Chapman Brothers (see FIG. 52), Charles Ray, Jeff Koons, and Abigail Lane, all of whom have adopted and subverted the simulacrum in the service of the sexually shocking.

108. DUANE HANSON
Sunbather with Black Bikini, 1989. Polychromed bronze, with accessories, life-size. The Saatchi Collection, London.

Although Hanson's realism deprived him of the enduring respect which some believed was his due, his work appears to have inspired a number of young contemporary artists who are busy turning his example to more subversive ends.

Disturbing Identity: The Abject and the Uncanny

A certain amount of assemblage work produced during the 1960s has subsequently been considered in psychoanalytic writing as belonging to the category of what the French thinker Julia Kristeva has theorized as "the abject." For Kristeva, the abject is that which "disturbs identity, system, order. What does not respect borders, positions, rules. The in-between, the ambiguous,

the composite." Those artists whose work has been retrospectively embraced by the theory of the abject include Bruce Connor, Lee Bontecou, and Lucas Samaras, as well as the pioneers of what has been termed "Eccentric Abstraction," most notably the work of Louise Bourgeois (see FIG. 20) and Eva Hesse (1936–70), who exploited the connotative potential of unorthodox materials and transgressive substances. The term has continued to prove a fruitful means of understanding contemporary feminist and homosexual art practice such as the monstrous bodies produced by Cindy Sherman and Kiki Smith (see FIG. 2) and the uncanny body parts made since the 1990s by Robert Gober (b. 1954).

Kiki Smith's art subjects the body and its biological processes to unblinking scrutiny. In placing the body's natural functions centre stage, works such as *Pee Body* remind us that we are our bodies and our bodies are us and that by denying the body's base realities we become estranged from ourselves. The figure in *Pee Body* crouches, apparently self-absorbed, the yellow glass beads of urine reinforcing the sense of fragility communicated by the beeswax body. Wax, for so long the quintessentially "low" medium in the hierarchy of sculpture materials, and traditionally associated with extreme realism, has become for many late twentieth-century artists a powerful means of alluding to the transience of the human body. Smith's *Pee Body* makes no attempt to exploit the material's potential for realism, however, the uneven nature of the modelling instead evoking the unidealized irregularity of human flesh.

Wax has also appeared prominently in the work of Robert Gober, whose "dressed" leg sculptures (FIG. 109) – constructed with painstaking realism from wood, wax, fabric, and real human hair – were prompted by composite memories and experiences. The artist's mother used to relate an occasion when she was handed an amputated leg whilst working as a nurse in an operating theatre, while Gober himself recalled being fixated by the partly revealed leg of a businessman sitting beside him on a plane flight, something which he in turn connected to "the sight you see if you glance under a stall

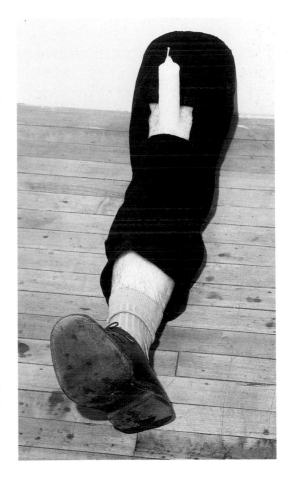

109. ROBERT GOBER *Untitled* ("Dismembered" leg), 1991. Wood, wax, leather, cotton, and human hair, life-size. Private collection.

Gober's hyperreal fragments, dislocated from the body and occupying unlikely positions in the gallery space, have a disturbing, de-familiarising effect on the spectator.

in a men's room." While the objects Gober constructs are informed by his homosexuality, and thereby function as a corrective to the normative expectations of a dominant heterosexual culture, they also draw attention to the extent to which the body, even in fragmented form, organizes human experience. Occasionally Gober's body parts incorporate additional components – the insertion of plastic plugholes, for example – which allude to the body's fluid elements and operative functions. This has lent his work an added resonance within the context of the AIDS crisis in America, which has given the body a renewed cultural significance, as an organism vulnerable to invasion by the virus itself and as a site of contested moral positions. By addressing, either obliquely or directly, the body's natural functions, the work of both Smith and Gober has helped to redirect attention beyond the body's external appearances towards more visceral concerns.

Body and Self

A number of contemporary body projects, many of them disturbingly radical in nature, derive their power from their use of the artist's own body, entered, altered, acted upon. The use of the living body has its roots in the Happenings and performance art of the early 1960s, but it was the American artist Bruce Nauman (b. 1941) who around 1966 effected the crucial shift in emphasis which gave rise to an autonomous, fully reflexive approach, in which the artist's own body became the site, source, and subject of the work. Much recent body art has extended these developments by moving beyond the parameters of sculpture *per se* into a range of practices which treat the body as a territory for subcutaneous exploration. In a video installation of 1994 entitled *Corps étranger* (Foreign Body), the Lebanese-born British artist Mona Hatoum (b. 1952) undertook an endoscopic journey into the body's orifices with the aid of fibre-optic camera technology, allowing access to both the horror and the beauty of the body's internal landscape – "the hidden profane" as it has been called.

Still more uncompromising in its reflexivity is the work of the French multi-media artist Orlan, who treats her own body as raw material for "cosmetic" manipulation and remodelling. Orlan subjects herself to body surgery as a means of subverting the patriarchal regimes of "beauty" which underpin the Western cultural tradition (FIG. 110). Her work is part of a ten-year project, the so-called "Reincarnation of St. Orlan," in which she has undergone cosmetic alteration to her face while under local

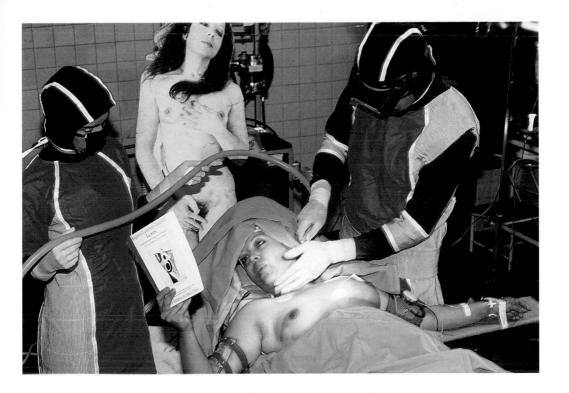

anaesthetic in order to draw attention to "the diktats of beauty standards which are impressed upon our bodies." This process of prosthetic self-portraiture ("my body is my software," she has said of her work) will culminate in Japan in the year 2000 when surgeons will provide her with the largest nose her face can sustain. On such occasions the artist turns the operating theatre into a theatre of artistic performance, reading aloud during surgery from the psychoanalytic writings of Jacques Lacan, Antonin Artaud, and Julia Kristeva and transmitting the readings and the operation via video-link conferencing to selected galleries around the world.

Radical millennial body projects occasionally look back to earlier body obsessions, the Middle Ages providing a point of reference for some AIDS-related art practice which equates homophobia and the fear of contamination with a medieval fear of the body and its abject emissions – blood, excrement, saliva. The British performance artist Ron Athey (b. 1962) – who is himself HIV positive – delivered a theatre piece called *Deliverance* (1995) in which his body was suspended on meat hooks embedded in his flesh before being ritually buried in a body-bag.

What all these projects have in common is an awareness of the body's singular identity; by using his or her own body the artist aims to communicate more directly that sense of the body

110. Orlan undergoing facial surgery, 2 April 1996.

Orlan's project of cosmetic disfigurement – a kind of prosthetic self-portraiture – shocks and fascinates in equal measure. Her ten-year performative project culminates in Japan in 2000 when surgeons will construct and fit the largest nose her face can support.

111. ANTONY GORMLEY
Angel of the North,
1995–6. Maquette, 5 x 11 x
7¾" (12.99 x 28.2 x 20
cm), for bronze statue, 63'
(19.2 m). Gateshead,
England.

Antony Gormley hopes that
his *Angel of the North* will
"bring life and activity" to
the north-east region of
England where it will be
installed.

as "self." Since 1981 the English sculptor Antony Gormley (b. 1950) has used his own body as the model for his lead figure sculpture. "My body is the location of my being," Gormley has said, "I turn to the body in an attempt to find a language that will transcend the limitations of race, creed, and language, but which will still be about the rootedness of identity." Scale is one means by which Gormley attempts to make us "feel our bodies in the world." However, his *Angel of the North* project (FIG. 111) of a bronze winged figure erected in Gateshead, England, met with fierce local opposition when proposed. The statue was "too reminiscent of large statues used by totalitarian states from time immemorial," said one councillor, signalling the continuing propensity of the colossus to incite passionate sentiments.

Gormley's reminder that the body is the location of one's being has particular resonance in a period when the body has acquired renewed visibility as a cultural sign. A series of body-related issues, from the battle against the HIV and AIDS viruses to controversies surrounding genetic engineering, body manipulation, and cybernetic technologies have subjected the body and its constituent parts to fresh scrutiny. Among the more uncanny excursions into the body in recent years has been that undertaken by the English artist Mark Quinn (b. 1964), who has appropriated the body's essential fluid – blood – to produce a work that dramatizes the precarious nature of embodiment (FIG. 112). The self-portrait head entitled *Self* was modelled in 1991 from nine pints of Quinn's own blood (the human body's entire quota) drawn off over a period of five months. Maintaining its three-dimensional stability through controlled refrigeration, Quinn's head functions as a kind of *memento*

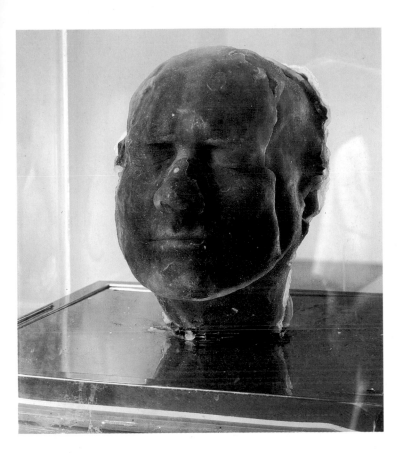

112. MARK QUINN
Self, 1991. Frozen blood, life-size. The Saatchi Collection, London.

Quinn's head, made from his own blood kept stable through refrigeration, subtly undermines assumptions about how identity and "self" are bound up in, and constrained by, the body's natural boundaries. As an organic material capable of returning at any moment to mere formless liquid, it also operates as a kind of *memento mori*, a reminder of the body's essential instability.

mori. It also refers to the body's seemingly miraculous ability to reconstitute its essential fluid while providing the raw material for another organic body separate from itself. The name of the work, *Self*, draws attention to the problematic status of that concept and provides us with an appropriate note upon which to close: where, precisely, does "self" reside if not within the boundaries of one's body?

Conclusion

T he central concern of this book has been to survey some of the more significant forms in which the three-dimensional body has appeared throughout history. Although by necessity somewhat limited in its scope, with inevitable omissions from the canon of sculpture history, it has nevertheless revealed the body in a varied array of environments, fulfilling a multitude of functions and generating a diverse range of meanings. It has appeared as a symbol of fertility and maternity, as an object to be disciplined into perfection, as a source of sensual pride and as a site of fear, anxiety, and moral panic. At times, it has been witnessed naked and unadorned as a thing to be celebrated while at other times it has required covering and obscuring as an object of shame. Above all, it has survived as the central means through which to express what it is to be human.

What this diversity of images and meanings demonstrates is the body's mutability, its susceptibility to the pressures of social, political, and religious circumstance, all of which leave their marks on its representational history. The body has also shown a capacity to attract exploration and scrutiny whilst denying those processes any prospect of full comprehension or explanation. In the late twentieth century the body retains a core element of mystery that is resistant even to the incursions of science and medicine. Hence, we still lack a complete and all-embracing theory of the body. These seemingly "magical" characteristics invest the body with an almost totemic significance and account for the pivotal role it has occupied in visual culture throughout history.

One theme which has been ever-present throughout the preceding pages is the shifting boundary separating the three-dimensional representation of the body from its living human counterpart. That sculpture already enjoys a close physical correspondence to the body by virtue of its three-dimensional status has been both its blessing and its curse. Western aesthetics, grounded in Platonic theory, which insists upon the primacy of

ideal forms, proscribes the exact representation of the natural world as seen, and has therefore at times attached a negative value to verisimilitude. Nevertheless, despite the classical tradition espoused by the academies, which promoted the ideal over the exact representation of appearances, the history of sculpture has been a continuous dialogue between these divergent positions.

The preceding pages have also demonstrated that the body allows access both to the beautiful and to the grotesque, but always as an expression of a broader set of prevailing social and political forces. The heroic *kouroi* of ancient Athens reflect the extent to which the body became an object of veneration within the cultural fabric of Greek society, while the ravages of famine and plague which swept across Europe during the fourteenth century gave rise to an iconography of bodily emaciation and torment. Occasionally, the beautiful body has prospered on account of improved knowledge of its interior structure, as in the sensuous bodies which grew from an interest in anatomy and dissection during the High Renaissance, while in other periods it operated as a means of denying the body's grotesque realities, as in the Neo-classical movement of the eighteenth century, when its pure surfaces functioned as a metaphor for social and political cohesion. Church and state have also influenced the development of the three-dimensional body. The resurgence of the Catholic Church following the Reformation stimulated the progress of the Baroque, characterized by a grandiosity of expression in which sculpture was often combined with architecture and painting. The affective potential of this flamboyant grammar of representation was soon recognized by European royalty, who appropriated it as a means of consolidating political power. Scale has been another recurrent theme throughout these pages: diminutive size allows the body to appear as a tactile object to be privately handled and treasured, while colossal dimensions increase the visibility of the body, making it the favoured subject of public monuments and the most potent symbol of political power.

As the final chapter has made clear, the body remains as vital in the modern period as at any point in history, but perhaps only now will its essential ambivalence finally come into its own. While the three-dimensional body continues to offer itself within the shifting domain of art practice as the most direct medium through which to interrogate the limits of identity and the volatility of political, social, and sexual orthodoxies, it may be re-invented elsewhere by advances in digital technology. Only then might Pygmalion realize his dream – a three-dimensional Galatea fully embodied within a simulated "virtual reality."

Historical events

c. 40,000 BC	First appearance of Homo sapiens sapiens in Europe
c. 8000 BC	Development of farming, allowing great increase in human population
c. 2780 BC	Foundation of Old Kingdom in Egypt
c. 2134 BC	Foundation of Middle Kingdom in Egypt
c. 1570 BC	Foundation of New Kingdom in Egypt
c. 1200 BC	Establishment of Jewish religion
c. 563 BC	Birth of the Buddha
509 BC	Foundation of First Roman Republic
c. 490 BC	Greeks defeat the Persians at the Battle of Marathon
c. 462 BC	Ascendancy of Pericles as ruler of Athens
431–404 BC	Peloponnesian War between Athens and Sparta
336 BC	Succession of Alexander the Great
44 BC	Julius Caesar assassinated, Rome
27 BC	Augustus becomes first emperor, Rome

c. 0	Birth of Jesus
c. 30	Crucifixion of Jesus
79	Destruction of Pompeii and Herculaneum
306	Constantine becomes emperor, Rome
324	Foundation of Constantinople
476	Goths sack Rome; Fall of Western Roman Empire
c. 570	Birth of Muhammad
c. 622	Foundation of Islam
800	Charlemagne crowned Emperor of the Romans

1066	Norman invasion of England – Battle of Hastings
1095–99	First Crusades
c. 1100	Foundation of Benin kingdom, West Africa
1309	Papal schism – one papacy moves to Avignon under French control
1337	Beginning of the Hundred Years War between France and England
1348	Beginning of the Black Death
1415	Battle of Agincourt
1434–64	Cosimo de' Medici rules Florence
1452	Beginning of Habsburg rule of Holy Roman Empire
1453	Hundred Years War ends
1469–92	Lorenzo de' Medici rules Florence
1492	Arabs and Jews expelled from Spain
1498	Columbus lands in South America
1517	Martin Luther protests against indulgences
1519	Charles V elected Holy Roman Emperor
	Cortés conquers Mexico
1522	First circumnavigation of the world, begun under Ferdinand Magellan
1527	Sack of Rome by German and Spanish mercenaries
1534	Foundation of Jesuit Order
	Church of England splits from Rome
1545–63	Council of Trent
1576	Dutch provinces revolt against Spanish rule
1598	Edict of Nantes – Protestants tolerated in France
1620	Puritans land in New England, North America
1625	Charles I becomes king of England
1642	Beginning of English Civil War
1643	Louis XIV becomes king of France
1649	Charles I beheaded, England becomes a Commonwealth
1660	Restoration of English monarchy under Charles II
1666	Great Fire of London
1685	Revocation of the Edict of Nantes, emigration of French Protestants

,000–25,000 BC	Limestone figure of a woman, Willendorf, Austria
	Ivory figure of a man, Brno, Czechoslovakia
00 BC	Cycladic figure sculpture, Greece
00–1400 BC	Figures in hippopotamus ivory, rock crystal, and gold, Knossos, Crete
40 BC	Tutenkhamun mummy-case, Egypt
0 BC	First marble sculpture appears, Greece
0–625 BC	"Auxerre Goddess", Greece
0–575 BC	*Kleobis and Biton*, Greece
0 BC	*Artemis* of Ephesus, Greece
0 BC	*Kritios Boy*, Greece
0 BC	Riace *Warrior "A"*, Greece
0 BC	*Doryphoros* by Polykleitos of Argos, Greece
7–430 BC	*Athena Parthenos* by Pheidias, Athens
0 BC	*Apollo Belvedere*
BC	*Victory of Samothrace*

AD	*Laocoön*
	Colossal statue of Constantine, Rome

3–1013	Reliquary effigy of St. Foy, Conques, France
45–50	Jamb figures, Chartres Cathedral, France
35–37	*The Bamberg Rider*, Bamberg, Germany
55–65	*Annunciation*, Rheims Cathedral, France
57–59	Pisano, Pisa Baptistry pulpit
5–1403	Sluter, portal of the church of the Chartreuse de Champmol, *Moses Fountain*, Dijon, France
30–50	Donatello, *David*, the Gattamelata equestrian monument
7–1500	Michelangelo, *Pietà*
4–04	Michelangelo, *David*
2 18	Torrigiano, *Tomb of Henry VII*
3	Michelangelo, *Dying Slave*
9–43	Cellini, salt-cellar for Francis I
4–62	Giambologna, *Samson Slaying a Philistine*
00	Montañés, *Cristo de la Clemencia* crucifix
5–52	Bernini, *Ecstasy of St. Teresa*
2–03	Legros the Younger, *Blessed Stanislas Kostka on his Deathbed*
3	Roubiliac, *George Frederick Handel*

c. 4000 BC	Bronze casting begins in the Middle East
c. 3500 BC	Invention of the wheel and the plough
c. 2100–2000 BC	Stonehenge built, England
c. 2050 BC	Emergence of Minoan civilization on Crete
c. 2650 BC	Sphinxes and pyramids, Egypt
c. 1500 BC	Development of Linear B script in Greece and Crete
c. 1000 BC	Alphabetic script developed by Phoenicians
c. 447–430 BC	Parthenon, Athens
310 BC	Alexander sarcophagus

c. AD 80	Colosseum, Rome
c.100–650	Aztec city of Teotihuacán, Mexico
320–30	Basilica of St. Peter, Rome
532–37	Church of Hagia Sophia, Constantinople
715–976	Great Mosques built at Damascus (715), Kairouan (722–863), Samarra (848–52), Cairo (877–79), Cordoba (961–76)
c. 800	*Book of Kells*

1015	Hildesheim Cathedral
1063	St. Mark's Cathedral begun, Venice
1073–83	Bayeux Tapestry
1140–44	Church of St. Denis, Paris
1194–1220	Chartres Cathedral
1308–11	Duccio, *Maestà* altarpiece, Siena
1309–20	Dante, *Divine Comedy*
1353	Boccaccio, *Decameron*
1387	Chaucer, *Canterbury Tales*
1413–16	Limbourg Brothers, *Très Riches Heures du duc de Berry*
1420–36	Brunelleschi, dome of Florence Cathedral
1424–52	Ghiberti, "Gates of Paradise" for the Baptistry, Florence
1425–27	Masaccio, *Holy Trinity* fresco, Florence
c. 1432	Van Eyck, *Ghent Altarpiece*
c. 1445	Piero della Francesca, *Baptism of Christ*
1445	Gutenberg Press prints first book in Europe
1495–98	Leonardo da Vinci, *Last Supper*
1500	Dürer, *Self-Portrait*
1503–06	Leonardo da Vinci, *Mona Lisa*
1505	Bosch, *Garden of Earthly Delights*
1508–12	Michelangelo, Sistine Chapel ceiling, Rome
1510	Leonardo's anatomical studies
1509–11	Raphael, *Vatican Stanze*
1510–15	Grünewald, *Isenheim Altarpiece*
1543	Vesalius, *De Humani Corporis Fabrica*
1546–64	Michelangelo, St. Peter's, Rome
1567	Palladio, *Villa Rotonda*
1616	Death of William Shakespeare
1642	Rembrandt, *Night Watch*
1656	Velásquez, *Las Meninas*
1667	Milton, *Paradise Lost*
1672	Isaac Newton discovers laws of gravity
1675–1710	Wren, St. Paul's Cathedral, London

Historical events

1751–1850

1774	Louis XVI becomes king of France
1776	American Declaration of Independence
1789	French Revolution
	George Washington becomes first president of United States
1793	Execution of Louis XVI
1799	Napoleon Bonaparte becomes First Consul of France
1800–15	Napoleonic Wars, involving France, England, Spain, Portugal, German States, and Russia
1830	Revolution, France, beginning of the July Monarchy under Louis Philippe
1837	Victoria becomes queen of United Kingdom
1848	Revolution, France; Fourth Republic

1851–1900

1861–65	American Civil War
1865	Assassination of Abraham Lincoln
1870	Beginning of Franco–Prussian War
1871	Fall of Paris Commune
1880–81; 1899–1902	Boer Wars between British and Boers in South Africa

1901– present

1901	Death of Queen Victoria
1914–18	First World War
1917	USA enters War; Russian Revolution
1923	Establishment of USSR
1929	Wall Street Crash; The Depression
1933	Hitler becomes German Chancellor
1936	Spanish Civil War begins
1939–45	Germany invades Poland; Second World War
1941	USA enters War
1945–48	Eastern European Bloc established as Soviet satellite countries
	Germany divided
1950–53	Korean War involves United Nations troops
1953	First hydrogen bomb; Death of Stalin
1963	Assassination of President John F. Kennedy
1964	USA enters Vietnam War
1968	Assassination of Martin Luther King
1973	Vietnam War ends
1976	Death of Mao Zedong
1985	Gorbachev gains power in USSR
1989	Fall of Communist regimes in Eastern Europe
1990	Reunification of Germany
	Wars begin in former Yugoslavia
1991	The Persian Gulf War, involving Kuwait, Saudi Arabia, and Western allies against Iraq
1995	European Union (ex-European Economic Community) expands to 15 states; plans for former Eastern European countries to join
1997	Death of Diana, Princess of Wales
	Death of Mother Theresa of Calcutta

The body in sculpture

Other artistic and cultural landmarks

The body in sculpture	Other artistic and cultural landmarks
757–61 Roubiliac, *Monument to Joseph Gascoigne and Lady Elizabeth Nightingale* and *Monument to Major General William Hargrave*	1751–72 Diderot and d'Alembert, *Encyclopédie*
753–56 Pigalle, *Monument to Maréchal de Saxe*	1764 Winckelmann, *History of Art*
754 Falconet, *Milo of Croton*	1784–85 David, *Oath of the Horatii*
781 Houdon, *Voltaire Seated*	1791 Paine, *Rights of Man*
808 Canova, *Pauline Borghese as Venus Victorious*	1792 Wollstonecraft, *Rights of Women*
817 David d'Angers, *Grand Condé*	1804 Beethoven, *Eroica Symphony*
832 "Auto-Icon" of Jeremy Bentham	1807 British abolition of slave trade
833–36 Rude, *Marseillaise (Departure of the Volunteers of 1792)*	1815 Quatremère de Quincy, *Jupiter Olympien*
843 Powers, *Greek Slave*	1818 Wollstonecraft Shelley, *Frankenstein*
845–47 Rude, *Napoleon Reawakening to Immortality*	1819 Géricault, *Raft of the Medusa*
847 Clésinger, *Woman Bitten by a Serpent*	1821 Constable, *Haywain*
850 Gibson, *Tinted Venus*	1825 Stockton to Darlington Railway, England
843–55 Simart, chryselephantine *Minerva*	1830 Delacroix, *Liberty Leading the People*
	1837 Invention of Photography
	1841 Courbet, *Burial at Ornans*
	1848 Marx and Engels, *Communist Manifesto*
867–69 Carpeaux, *The Dance*	1859 Darwin, *Origin of Species*
876 Rodin, *Age of Bronze*	1863 Manet, *Déjeuner sur l'herbe*
881 Degas, *Little Dancer Aged Fourteen*	1867 Marx, *Kapital*
887 Leighton, *Athlete Wrestling with a Python*	1874 First Impressionist Exhibition
886–1893 Gilbert, *Memorial to the Seventh Earl of Shaftesbury* (Eros)	1876 Bell's telephone and Edison's phonograph
897–1902 Klinger, *Beethoven*	1878 Eadweard Muybridge, series photographs
	1885 First skyscraper, Home Insurance Building, Chicago
	1885–87 Cézanne, *Mont Sainte-Victoire*
	1889 Van Gogh, *Artist's Room*
	1892–93 Horta, Hotel Tassel, Brussels
	1893 Munch, *Scream*
	1894 Dreyfus Affair, France
	1895 Marconi's wireless and Lumière's cinematograph
	1900 Freud, *Interpretation of Dreams*
913 Boccioni, *Unique Forms of Continuity in Space*	1903 First powered flight; Gaudí, Sagrada Familia, Barcelona
913–14 Epstein, *Rock Drill*	1905–07 Einstein, Theory of Relativity
916 Brancusi, *Torso of a Young Man*	1907 Picasso, *Demoiselles d'Avignon*
917–20 Gabo, *Head of a Woman*	1909 Diaghilev's *Ballets Russes* arrive in Paris
932 Giacometti, *Woman with her Throat Cut*	Futurism founded by Marinetti
951 Moore, *Reclining Figure*	1913 International Exhibition of Modern Art, Armory Show, New York
966 Kienholz, *State Hospital*	1917 Duchamp, *Fountain*
968 Segal, *The Subway*	1919 Foundation of the Bauhaus in Weimar
969 Hanson, *Bowery Derelicts*	1920 First International Dada Fair, Berlin
991 Quinn, *Self*	1922 Joyce, *Ulysses*
995–Present *The Reincarnation of St. Orlan*	1924 "First Surrealist Manifesto" published
	1926 Baird's television
	1937 Picasso, *Guernica*; Nazi "Degenerate Art" exhibition
	1938 International Exhibition of Surrealism, Paris
	1948 Jackson Pollock's drip paintings; Abstract Expressionism
	1949 Orwell, *1984*
	1952 Beckett, *Waiting for Godot*
	1954–55 Jasper Johns, *Flag*; Pop Art
	1956 "This is Tomorrow" exhibition, Whitechapel Art Gallery, London
	1960 Klein, *Anthropométries de l'epoque bleue*
	1961 USSR puts first man in space; Discovery of DNA molecule
	1962 Warhol, *Campbell's soup cans* paintings
	1968 International student uprisings; Conceptual art develops
	1969 First landing on the moon by USA Apollo crew
	1970 Smithson, *Spiral Jetty*, land art
	1978 André, *Equivalent VIII* (the Tate "Bricks")
	1981 Serra, *Tilted Arc*
	1992 Whiteread, *House*

Bibliography

GENERAL

ADLER, KATHLEEN, and POINTON, MARCIA (eds), *The Body Imaged: The Human Form and Visual Culture Since the Renaissance* (Cambridge: Cambridge University Press, 1993)

APTER, EMILY, and PIETZ, WILLIAM (eds), *Fetishism as Cultural Discourse* (Ithaca and London: Cornell University Press, 1993)

DOUGLAS, MARY, *Purity and Danger: An Analysis of the Concepts of Pollution and Taboo* (1966; London and New York: Ark, 1984)

DUTTON, KENNETH R., *The Perfectible Body: The Western Ideal of Physical Development* (London: Cassell, 1995)

FALK, PASI, *The Consuming Body* (London: Thousand Oaks; New Delhi: Sage, 1994)

FEATHERSTONE, MIKE, and BURROWS, ROGER, *Cyberspace, Cyberbodies, Cyberpunk: Cultures of Technological Embodiment* (London: Thousand Oaks; New Delhi: Sage, 1995)

FEHER, MICHEL (ed.), *Fragments for a History of the Human Body*, Part One (New York: Zone, 1989)

FREEDBERG, DAVID, *The Power of Images: Studies in the History and Theory of Response* (Chicago and London: University of Chicago Press, 1989)

GENT, LUCY, and LLEWELLYN, NIGEL (eds), *Renaissance Bodies: The Human Figure in English Culture, c.1540–1660* (London: Reaktion, 1990)

ISAAK, JO ANNA, *Feminism and Contemporary Art: The Revolutionary Power of Women's Laughter* (London and New York: Routledge, 1996)

KRISTEVA, JULIA, *Powers of Horror: An Essay on Abjection* (New York: Columbia University Press, 1982)

PENNY, NICHOLAS, *The Materials of Sculpture* (New Haven and London: Yale University Press, 1993)

SHILLING, CHRIS, *The Body and Social Theory* (London: Thousand Oaks; New Delhi: Sage, 1993)

— and MELLOR, PHILIP A., *Re-Forming the Body: Religion, Community and Modernity* (London: Thousand Oaks; New Delhi: Sage, 1997)

STAFFORD, BARBARA MARIA, *Body Criticism: Imaging the Unseen in Enlightenment Art and Medicine* (Cambridge, Mass., and London: MIT Press, 1991)

STALLYBRASS, PETER, and WHITE, ALLON, *The Politics and Poetics of Transgression* (Ithaca, NY: Columbia University Press, 1986)

SULEIMAN, SUSAN RUBIN (ed.), *The Female Body in Western Culture: Contemporary Perspectives* (Cambridge, Mass., and London: Harvard University Press, 1985)

CHAPTER ONE

BARING, ANNE, and CASHFORD, JULES, *The Myth of the Goddess: Evolution of an Image* (London: Penguin, 1993)

BERNAL, MARTIN, *Black Athena: The Afro-Asiatic Roots of Classical Civilisation* (London: Vintage, 1991)

BLUNDELL, SUE, *Women in Ancient Greece* (London: British Museum Press, 1995)

BOARDMAN, JOHN, *Greek Sculpture: The Archaic Period* (London and New York: Thames and Hudson, 1993)

— *Greek Sculpture: The Classical Period* (London and New York: Thames and Hudson, 1985)

DONOHUE, A. A., *Xoana and the Origins of Greek Sculpture* (Atlanta: Garland, 1988)

EASTERLING, P. E., and MUIR, J. V. (eds), *Greek Religion and Society* (Cambridge: Cambridge University Press, 1985)

HERINGTON, C. J., *Athena Parthenos and Athena Polias* (Manchester: 1955)

PAUSANIAS, *Guide to Greece*, 2 vols (London: Penguin, 1985)

POLLITT, J. J., *The Art of Ancient Greece: Sources and Documents* (Cambridge: Cambridge University Press, 1965)

— *Art and Experience in Classical Greece* (Cambridge: Cambridge University Press, 1972)

RAMAGE, N. H., and RAMAGE, A., *Roman Art* (Cambridge: Cambridge University Press, 1991)

RICHTER, G. M. A., *The Sculpture and Sculptors of the Greeks* (New Haven and London: Yale University

Press, 1950)

— *A Handbook of Greek Art: A Survey of the Visual Arts of Ancient Greece* (London: Phaidon, 1992)

SENNETT, RICHARD, *Flesh and Stone: The Body and Civilisation in Western Civilisation* (London: Faber and Faber, 1994)

SPIVEY, NIGEL, *Understanding Greek Sculpture: Ancient Meanings, Modern Readings* (London: Thames and Hudson, 1996)

STEWART, ANDREW, *Greek Sculpture: An Exploration*, 2 vols (New Haven and London: Yale University Press, 1990)

VERNANT, JEAN-PIERRE, *Mortals and Immortals: Collected Essays* (ed. Froma Zeitlin), (Princeton: Princeton University Press, 1991)

CHAPTER TWO

BAXANDALL, MICHAEL, *The Limewood Sculptors of Renaissance Germany* (New Haven and London: Yale University Press, 1980)

BINSKI, PAUL, *Medieval Death: Ritual and Representation* (London: British Museum Press, 1996)

BRANNER, ROBERT (ed.), *Chartres Cathedral* (New York and London: W. W. Norton, 1969)

BURCKHARDT, JACOB, *The Civilisation of the Renaissance in Italy* (London: Phaidon, 1955)

BURCKHARDT, TITUS, *Chartres and the Birth of the Cathedral* (Ipswich: Golgonooza, 1995)

BYNUM, CAROLINE WALKER, *The Resurrection of the Body in Western Christianity* (New York: Columbia University Press, 1995)

CAMILLE, MICHAEL, *The Gothic Idol: Ideology and Image-Making in Medieval Art* (Cambridge: Cambridge University Press, 1989)

GIMPEL, JEAN, *The Cathedral Builders* (London: Pimlico, 1993)

MALE, EMILE, *The Gothic Image* (London: Collins, 1961)

MILES, MARGARET, *Carnal Knowing: Female Nakedness and Religious Meaning in the Christian West* (Boston, 1989)

MORAND, KATHLEEN, *Claus Sluter: Artist at the Burgundian Court* (London: Harvey Miller, 1991)

STEYAERT, JOHN W., *Late Gothic Sculpture: The Burgundian Netherlands* (Ghent: Ludion Press, 1994)

STODDART, WHITNEY S., *Art and Architecture in Medieval France* (New York and London: Harper & Row, 1972)

VASARI, *Lives of the Artists* (London: Penguin, 1965)

WILLIAMSON, PAUL, *Gothic Sculpture: 1140–1300* (New Haven and London: Yale University Press, 1995)

CHAPTER THREE

ASHBEE, C. R. (trans.), *The Treatises of Benvenuto Cellini on Goldsmithing and Sculpture* (New York: Dover, 1967)

AVERY, CHARLES, *Giambologna* (London: Phaidon, 1987)

BAROLSKY, PAUL, *Michelangelo's Nose: A Myth and its Maker* (Pennsylvania: Pennsylvania State University Press, 1990)

BULL, GEORGE, *Michelangelo: A Biography* (London: Penguin, 1996)

CARERI, GIOVANNI, *Bernini: Flights of Love, the Art of Devotion* (Chicago and London: University of Chicago Press, 1995)

CELLINI, BENVENUTO, *The Life of Benvenuto Cellini: Written by Himself* (London: Phaidon, 1951)

ENGGASS, ROBERT, and BROWN, JONATHAN, *Italian and Spanish Art: 1600–1750 – Sources and Documents* (Illinois: Northwestern University Press, 1992)

HIBBARD, HOWARD, *Bernini* (London: Pelican, 1965)

LLEWELLYN, NIGEL, *The Art of Death: Visual Culture in the English Death Ritual c.1500–c.1800* (London: Victoria and Albert Museum/Reaktion, 1991)

MONTAGU, JENNIFER, *Roman Baroque Sculpture: The Industry of Art* (New Haven and London: Yale University Press, 1989)

SAWDAY, JONATHAN, *The Body Emblazoned: Dissection and the Human Body in Renaissance Culture* (London and New York, Routledge, 1995)

STEINBERG, LEO, *The Sexuality of Christ in Renaissance Art and in Modern Oblivion* (Chicago: University of Chicago Press, 1996)

STOICHITA, VICTOR, *Visionary Experience in the Golden Age of Spanish Art* (London: Reaktion, 1995)

TRUSTED, MARJORIE, *Spanish Sculpture: A Catalogue of the Collection in the Victoria and Albert Museum* (London: Victoria and Albert Museum, 1996)

CHAPTER FOUR

BINDMAN, DAVID, and BAKER, MALCOLM, *Roubiliac and the Eighteenth Century Monument: Sculpture as*

Theatre (New Haven and London: Yale University Press, 1995)

COOK, B. F., *The Townley Marbles* (London: British Museum Publications, 1985)

CROW, THOMAS E., *Painters and Public Life in Eighteenth Century Paris* (New Haven and London: Yale University Press, 1985)

DE CASO, JACQUES, *David d'Angers: Sculptural Communication in the Age of Romanticism* (Princeton: Princeton University Press, 1992)

HARVEY, ANTHONY, and MORTIMER, RICHARD (eds), *The Funeral Effigies of Westminster Abbey* (Woodbridge: Boydell Press, 1994)

HARGROVE, JUNE (ed.), *The French Academy: Classicism and its Antagonists* (Newark: University of Delaware Press, 1990)

HASKELL, FRANCIS, and PENNY, NICHOLAS, *Taste and the Antique: The Lure of Classical Sculpture 1500–1900* (New Haven and London: Yale University Press, 1981)

HERBERT, R. L., *David, Voltaire, Brutus and the French Revolution: An Essay in Art and Politics* (London: Penguin/Allen Lane, 1972)

LAVIN, SYLVIA, *Quatremère de Quincy and the Invention of a Modern Language of Architecture* (Cambridge, Mass: MIT Press, 1992)

LEVEY, MICHAEL, *Painting and Sculpture in France: 1730–1789* (New Haven and London: Yale University Press, 1993)

POTTS, ALEX, *Flesh and the Ideal: Winckelmann and the Origins of Art History* (New Haven

and London: Yale University Press, 1994)

TUFTS, ELEANOR, "An American Victorian Dilemma, 1875: Should a Woman be Allowed to Sculpt a Man?" *Art Journal* 51, no. 1(Spring 1992), pp. 51–56

WHINNEY, MARGARET, *Sculpture in Britain: 1530–1830* (London: Penguin/Pelican History of Art, 1988)

CHAPTER FIVE

BAUDELAIRE, CHARLES, *Selected Writings on Art and Literature* (London: Penguin, 1972)

BEATTIE, SUSAN, *The New Sculpture* (New Haven and London: Yale University Press, 1983)

BOIME, ALBERT, *Hollow Icons: The Politics of Sculpture in Nineteenth Century France* (Kent, Ohio, and London: Kent State University Press, 1987)

— *Art and the French Commune: Imagining Paris after War and Revolution* (Princeton: Princeton University Press, 1995)

DORMENT, RICHARD, *Alfred Gilbert* (New Haven and London: Yale University Press, 1985)

EISENMAN, STEPHEN, F., *et al.*, *Nineteenth Century Art: A Critical History* (London: Thames and Hudson, 1994)

GRATTAN, T. C., *Beaten Paths; and Those Who Trod Them*, 2 vols. (London, 1862)

JENKINS, IAN, *Archaeologists and Aesthetes* (London: British Museum Press, 1992)

MIDDLETON, ROBIN (ed.), *The Beaux-Arts and Nineteenth Century French Architecture* (London: Thames and Hudson, 1984)

NOCHLIN, LINDA, *The Body in Pieces: The Fragment as a Metaphor of Modernity* (London: Thames and Hudson, 1994)

READ, BENEDICT, *Victorian Sculpture* (New Haven and London: Yale University Press, 1982)

SCHORSKE, CARL, *Fin de Siècle Vienna: Politics and Culture* (Cambridge: Cambridge University Press, 1987)

STOCKING, GEORGE W., *Victorian Anthropology* (New York: Macmillan, Free Press, 1991)

WAGNER, ANNE, *Jean-Baptiste Carpeaux: Sculptor of the Second Empire* (New Haven and London: Yale University Press, 1986)

CHAPTER SIX

ADAM, PETER, *The Arts of the Third Reich* (London: Thames and Hudson, 1992)

ALTSHULER, BRUCE, *The Avant-Garde in Exhibition: New Art in the Twentieth Century* (New York: Abrams, 1994)

BENJAMIN, WALTER, *Illuminations* (London: Fontana, 1992)

BERNADAC, MARIE-LAURE, *Louise Bourgeois* (Paris and New York: Flammarion, 1996)

BURNHAM, JACK, *Beyond Modern Sculpture* (London: Penguin, Allen Lane, 1968)

ELSEN, ALBERT E., *Origins of Modern Sculpture: Pioneers and Premises* (New York: George Braziller, 1974)

— *Unknown Beings and Other Realities* (New York: George Braziller, 1979)

FULLER, PETER, *Henry Moore: An Interpretation* (London: Methuen, 1993)

GIEDION, SIEGFRIED,

Mechanisation Takes Command (New York and London: W. W. Norton, 1969)

GOLDWATER, ROBERT, *Primitivism in Modern Art* (Cambridge, Mass., and London: Harvard University Press, and Belknap, 1986)

HUTCHINSON, JOHN, GOMBRICH, E. H., and NJATIN, LELA B., *Antony Gormley* (London: Phaidon, 1995)

KRAUSS, ROSALIND E., *Passages in Modern Sculpture* (Cambridge, Mass., and London: MIT Press, 1981)

LORD, JAMES, *Giacometti: A Biography* (London: Phoenix Giant, 1996)

NAIRNE, SANDY, et al, *State of the Art: Ideas and Images in the 1980s* (London: Chatto and Windus/Channel Four Television, 1990)

REFF, THEODORE, *Degas: The Artist's Mind* (Cambridge, Mass., and London: Harvard University Press, and Belknap, 1987)

— "The Morbid Content of Degas' Sculpture," *Apollo* 142, no. 402 (August 1995), pp. 64–71

SHANES, ERIC, *Constantin Brancusi* (New York and London: Abbeville, 1989)

SYLVESTER, DAVID, *Looking at Giacometti* (London: Pimlico, 1995)

TUCHMAN, PHYLLIS, *George Segal* (New York and London: Abbeville, 1983)

WALDMAN, DIANE, *Collage, Assemblage and the Found Object* (London: Phaidon, 1992)

EXHIBITION AND SALE CATALOGUES

BLUHM, ANDREAS, et al., *The Colour of Sculpture: 1840–1910* (Zwolle: Waanders Uitgevers, 1996); Van Gogh Museum, Amsterdam (July–November 1996); Henry Moore Institute, Leeds (December 1996–April 1997)

DORMENT, RICHARD, et al., *Alfred Gilbert: Sculptor and Goldsmith* (London: Royal Academy of Arts/Weidenfeld & Nicolson, 1986); Royal Academy of Arts, London (March–June 1986)

FUSCO, PETER, and JANSON, H. W. (eds), *The Romantics to Rodin* (Los Angeles County Museum of Art/George Braziller, 1980); Los Angeles County Museum of Art (March–May 1980)

HOPPS, WALTER, et al., *Kienholz: A Retrospective* (New York: Whitney Museum of American Art/Thames and Hudson, 1996); Whitney Museum of American Art, New York (February–June 1996)

KENT, SARAH, *Shark Infested Waters: The Saatchi Collection of British Art in the '90s* (London: Zwemmer, 1994)

LIVINGSTONE, MARCO, *Duane Hanson* (London: The Saatchi Gallery, 1997); The Saatchi Gallery, London (April–July 1997)

PINGEOT, ANNE, et al., *La Sculpture Française au XIXe Siècle* (Paris: Galeries nationales du Grand Palais, 1986)

TUCHMAN, MAURICE (ed.), *American Sculpture of the Sixties* (Los Angeles County Museum of Art, 1967); Los Angeles County Museum of Art (April–June 1967)

WILTON, ANDREW (ed.), *Grand Tour: The Lure of Italy in the Eighteenth Century* (London: Tate Gallery, 1996); Tate Gallery, London (October 1996–January 1997)

Abject Art: Repulsion and Desire in American Art (New York: Whitney Museum of American Art, 1993); Whitney Museum of American Art, New York (June–August 1993)

The Age of Neoclassicism (London: Arts Council of Great Britain, 1972); Royal Academy and Victoria and Albert Museum, London (September–November 1972)

Chapmanworld: Jake and Dinos Chapman (London: ICA Publications, 1996); Institute of Contemporary Arts, London (May–July 1996)

Important Silver, Objects of Vertu and Russian Works of Art, Christie's, New York (11 April, 1995)

Pioneers of Modern Sculpture (London: Arts Council of Great Britain, 1975); Hayward Gallery, London (July–September 1975)

Picture Credits

Collections are given in the captions alongside the illustrations. Sources for illustrations not supplied by museums or collections, additional information, and copyright credits are given below. Numbers are figure numbers unless otherwise indicated.

frontispiece detail of picture 97 page 142
1 Christie's Images, New York
Page 7 detail of picture 4 page 12 1995
2 Courtesy of The Fogg Art Museum, Harvard University Art Museums # 1997.82. Promised gift in part to Barbara Fish Lee and Emily Rauh Pulitzer and purchase in part from the Joseph A. Baird, Jr. Francis H. Burr Memorial and Director's Acquisition Funds. Photo © 1997 Sotheby's Inc
4 © 1995 Sotheby's Inc
5 The Hulton Getty Picture Collection Limited, London
6 Schweizerisches Landesmuseum, Zurich # LM 20018, negative # CO 8791
7 Photo by Petr Josek REUTERS/Popperfoto
8 © Ben May, Canterbury
9 © 1995 Sotheby's Inc
10 Oskar Kokoscha-Dokumentation, Pöchlarn, Austria/© DACS 1998
11 François Le Diascorn/Rapho/Network
12 Museo Archeologico Nazionale, Naples/Fotografica Foglia, Naples
Page 21 detail of picture 26 page 41
13 AKG London/Eric Lessing
14 Courtesy the artist
17 photo by Alison Frantz
18 © British Museum, London # 1239
19 Museo Archeologico Nazionale, © Naples # 6278/Fotografica Foglia, Naples
20 © Louise Bourgeois, courtesy of the Robert Miller Gallery, New York
21 Nikos Kontos, Athens
22 Scala, Florence
24 Nikos Kontos, Athens
26 Courtesy Ecole Nationale Supérieure des Beaux Arts, Paris
27 © Araldo De Luca, Rome
28 Scala, Florence
Page 45 detail of picture 35 page 56
29, 30, 31 © Angelo Hornak, London
32 Courtesy of the Trustees of the Victoria & Albert Museum, London # A.98-1911
33, 34 © Paul M.R. Maeyaert, Mont de l'Enclus-Orroir, Belgium

36 Scala, Florence
37 Studio Fotografico Quattrone, Florence
38 Scala, Florence
39 © CAMERAPHOTO Arte, Venice
40 Studio Fotografico Quattrone, Florence
41, 42 Scala, Florence
43 © Paul M.R. Maeyaert
Page 67 detail of picture 55 page 83
44 © Araldo De Luca, Rome
46 Science Museum/Science & Society Picture Library, London
47 © Araldo De Luca, Rome
48 Scala, Florence
50 Courtesy of the Trustees of the Victoria & Albert Museum, London # A.7-1954
51 © Paul M.R. Maeyaert
52 Courtesy Victoria Miro Gallery, London
53, 54, 55 © Paul M.R. Maeyaert
56 Courtesy of the Trustees of the Victoria & Albert Museum, London # 250-1864
57 © Araldo de Luca, Rome
58 Canali Photobank, Capriolo, Italy
59 © Angelo Hornak, London
Page 91 detail of picture 66 page 100
60 © Paul M.R. Maeyaert
61 © RMN, Paris
62 Kunst zu Weimar Sammlungen # G.70
63 Scala, Florence
64 The Bridgeman Art Library, London
65 © 1997 by Kunsthaus Zurich. All rights reserved.
66 Canali Photobank, Capriolo, Italy
67 © Photo RMN, Paris – G.Biot/C.Jean
69 National Museum of American Art, Washington D.C./Art Resource, New York
70 Yale University Art Gallery, New Haven #1962.43, Olive Louise Dann Fund
71 Architect of the Capitol, Washington DC
72 © RMN, Paris
73 © RMN, Paris – R.G.Ojeda/P.Néri
74, 75 © Paul M.R. Maeyaert
76 AKG London

77 Popperfoto, London
78 Christie's Images, New York
Page 115 detail of picture 91 page 133
79 © RMN, Paris – Jean Schormans
80 The Board of Trustees of the National Museums & Galleries on Merseyside (Walker Art Gallery, Liverpool)
81 Science Museum/Science & Society Picture Library, London
83 © RMN, Paris – Arnaudet
84 Courtesy the Edition du Castelet and the Duc de Luynes
85 © RMN, Paris
86 Musée des Beaux-Arts, Nantes #1793, photo H. Maertens
87 Courtesy of the Trustees of the Victoria & Albert Museum, London # A.36.1934
89 © Peter Ashworth, London
90 © 1996 Sotheby's Inc
91 Museum der Bildenden Kunste, Leipzig # E 1237
92 Courtesy of the Trustees of the Victoria & Albert Museum, London # A33-1914
93 © Musée Rodin, Paris # S.1068, photo Bruno Jarret
94 © The Cleveland Museum of Art, Ohio, 1997, Hinman B. Hurlbut Collection, # 3205.1937 ADAGP, Paris and DACS, London 1998
Page 137 detail of picture 100 page 146
96 © RMN, Paris – Jean Schormans
99 The Museum of Modern Art, New York. Katherine S. Dreier Bequest. Photograph 1997 The Museum of Modern Art, New York
101 Courtesy The Henry Moore Institute, Leeds
102 © ADAGP, Paris and DACS, London 1998
103 AKG London
104 This work is reproduced by permission of the Henry Moore Foundation
105 Whitney Museum of American Art, New York. Gift of the Howard & Jean Lipman Foundation, Inc, photo Geoffrey Clements
106 Moderna Museet, Stockholm # 2094
107 Collection Walker Art Center, Minneapolis. Gift of the T.B. Walker Foundation, 1966. George Segal/DACS, London/VAGA, New York 1998
109 Courtesy the artist
110 Rex Features Ltd, London/Sipa-Press, photo Alain Dhome
111 Courtesy Jay Jopling, London and Gateshead City Council

Index